DARTMOOR RIVER

DARTMOOR RIVER

ROBIN ARMSTRONG

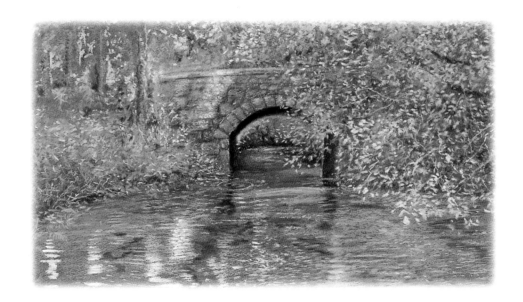

HALSGROVE

First published in 2002 by Halsgrove

British Library Cataloguing-in-Publication Data
A CIP record for this title is available from the British Library

ISBN 1 84114 202 6

HALSGROVE

Halsgrove House
Lower Moor Way
Tiverton, Devon EX16 6SS
Tel: 01884 243242
Fax: 01884 243325
email: sales@halsgrove.com
website: www.halsgrove.com

Printed and bound in Italy by Grafiche D'Auria

CONTENTS

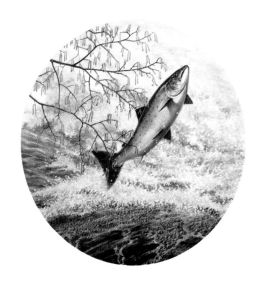

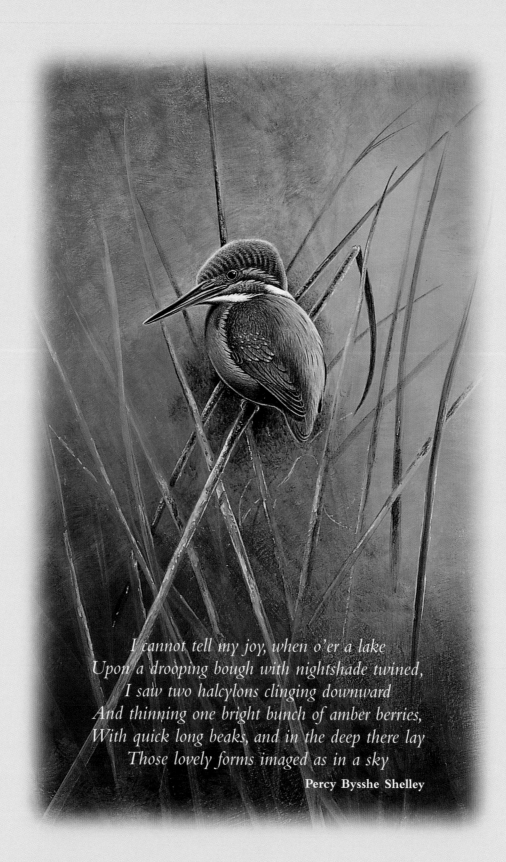

I cannot tell my joy, when o'er a lake
Upon a drooping bough with nightshade twined,
I saw two halcylons clinging downward
And thinning one bright bunch of amber berries,
With quick long beaks, and in the deep there lay
Those lovely forms imaged as in a sky

Percy Bysshe Shelley

FOREWORD

I have a painting on my office wall of two female brown hairstreak butterflies settled on a twig of blackthorn. The background is a smudge of muted shades of brown and green, suggesting that the artist has caught them unawares early on a spring morning as a mist from the River Walkham was cloaking the trees. And that's probably exactly how it did happen.

Robin Armstrong was for many years the water bailiff who patrolled the stretch of river that ran below my home on Dartmoor. It meant that my freezer was never short of freshly caught salmon, and the walls of my moorland cottage reflected much of the natural beauty around me through Robin's beautifully observed work.

As a bailiff he had the perfect opportunity to indulge his passion for wildlife and habitat, and through his natural talent as an artist, capture the very essence of the place in which he worked. Birds, fish, fungi, every creature that moves, every plant that grows in the unique 'theatre' of Dartmoor has, at some time, found its way into one of Robin's beautiful, misty watercolours.

Each work is a reflection, and a record of Dartmoor life. Which is why my hairstreaks are so poignant. They only thrive on blackthorn, and shortly after the painting was done, in April of 1981, the copse was clear felled, and so the colony has disappeared. Another creature that only thrives and lives within the confines of a picture frame, while its name is added to the endangered species list.

Which is why I see this new collection of paintings from Robin Armstrong as much more than just a reminder of his 30 years of observing wildlife. It gives us an indication of what has been lost, an opportunity to celebrate what remains, and offers a timely reminder of what we could destroy for ever.

So enjoy, and cherish. Not only these images and musings, but also the real thing.

Angela Rippon
London 2002

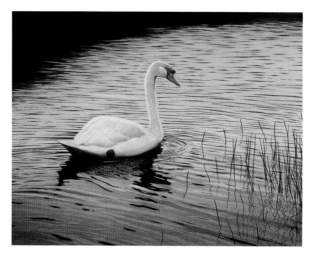

This book is dedicated to my wife Grace who is always there during the sometimes, stormy passages of creativity, and to fond memories of Andrew 'Spud' Spedding and George Villiers.

ACKNOWLEDGEMENTS

I would like to thank the following people who have helped and supported me during the production of this book, and in the past.

John Shaw, Micheal Cory Brown and Dr Mary Oakes, Paul Caton, Chris Chapman, Geoff and Joy Lakeman, Bob Mountjoy, Tamsin Blaikie, Annie Monro, Admiral Sir John Rawlins, Alistair Forbes, Chris Chapman of Spectrum Photo Labs, Bob Jones for his expertise in the avian sphere, John Kelly, Nick Moore, Tom O'Reilly, Dr Charles Reeves, Ed Jago and his daughters Kate and Rebecca, Sir Peter and Lady Whitley, Wally and Jay Parson, John and Susan Reynolds, Rob Morris, James and Alison McQueen, Ian and Jill Douglas, Nigel and Julie Goode, Colin and Victoria Calder, David and Tania Channing-Williams, Nigel and Janet Randall, Bill Strevens, Denis Wilkins, Vijay Amernani, Ian and Teresa Locke, Jane Hempel. Special thanks to Angela Rippon who despite a very busy schedule, still found the time to pen a few words for the foreword to this book, Simon Butler and Julian Davidson of Halsgrove and my mum Ivy who despite her own difficulties has always been a staunch supporter. Finally I would like to thank our dear friends Paul and Barbara Cook, for everything.

Robin Armstrong
Kingfisher Studio
Lopwell 2002

The Rivers of Dartmoor

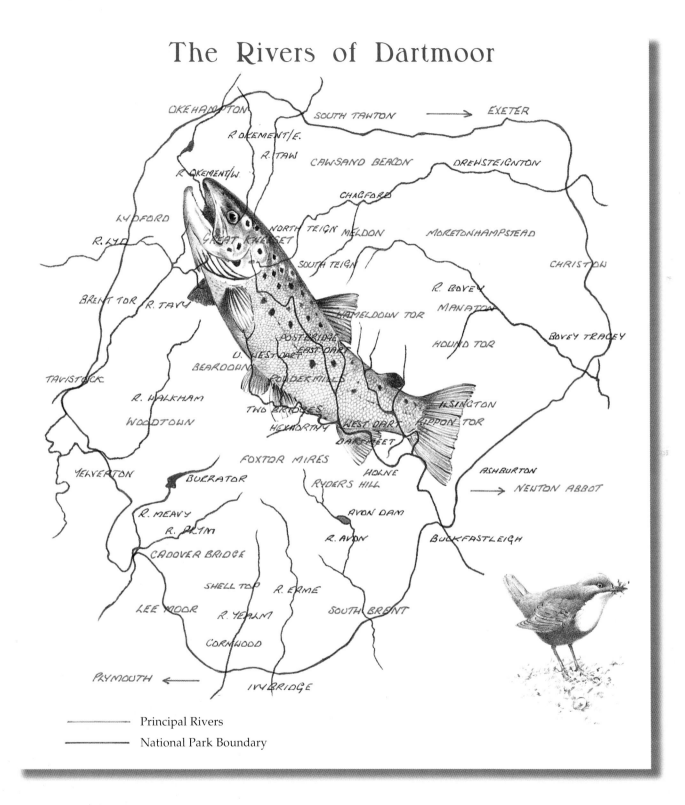

OKEHAMPTON
SOUTH TAWTON → EXETER
R. OKEMENT/E.
R. TAW
CAWSAND BEACON
DREWSTEIGNTON
R. OKEMENT/W.
CHAGFORD
LYDFORD
NORTH TEIGN
MELDON
MORETONHAMPSTEAD
R. LYD
GREAT KNEESET
SOUTH TEIGN
CHRISTON
R. BOVEY
BRENT TOR
R. TAVY
HAMELDOWN TOR
MANATON
BOVEY TRACEY
HOUND TOR
POSTBRIDGE
EAST DART
U. WEST DART
BEARDOWN
POWDERMILLS
TAVISTOCK
ILSINGTON
R. WALKHAM
TWO BRIDGES
RIPPON TOR
WOODTOWN
HEXWORTHY
WEST DART
DARTMEET
FOXTOR MIRES
HOLNE
ASHBURTON
YELVERTON
BURRATOR
RYDERS HILL
→ NEWTON ABBOT
R. MEAVY
AVON DAM
R. PRIM
BUCKFASTLEIGH
CADOVER BRIDGE
R. AVON
SHELL TOP
R. ERME
LEE MOOR
R. YEALM
SOUTH BRENT
CORNWOOD
PLYMOUTH ←
IVYBRIDGE

——— Principal Rivers

——— National Park Boundary

9

INTRODUCTION

*When, on a teenage visit from London, I caught my first wild trout in the
little River Bovey at Manaton, who could have predicted that more than thirty years later,
looking from my studio window, I would be able to watch the king of fishes – Salmo,
the leaper – ascending his way to the spawning grounds of one of
Dartmoor's premier game rivers.*

My love affair with the rivers of Dartmoor began more than thirty-five years ago when, at the age of eighteen, I found myself working in an advertising studio in London, training as an illustrator. I had already been smitten at a very early age with a passion for angling and wildlife and consequently spent every moment of my spare time either fishing or bird watching, and often both. This enthusiasm led me to submit some early drawings with a view to having them published. The usual rejections followed, but one gave me hope. It was from Bernard Venables who was well known for his cartoon strip for the *Daily Mirror* called 'Mr Crabtree Goes Fishing'. Bernard had started a quality angling journal called *Creel,* and although he was leaving the publication he passed his support for me over to the incoming editor Mike Pritchard. Mike commissioned some small drawings and published them in one or two editions of *Creel.* My fees were small but I did receive a complimentary subscription to the magazine by post. How I, a country 'innocent', looked forward each month to the teasing and fact-packed articles about fishing in wild and remote locations, and epic battles with all manner of fish from giant sharks to humble gudgeon. In those days there were no angling superstars, just enthusiastic individuals who wrote passionately and sometimes philosophically about angling and the countryside. One of these was Ewan Clarkson. His writing was tinged with a regard for both his quarry and the landscape. It would be fair to say that Ewan pioneered the way for environmental journalism in the South West. Sadly *Creel* did not last for very long, struggling I suspect to maintain its deliberately high standards. It was the magazine *Fishing* which followed *Creel* and, although much less lavish in production, it did inherit many of *Creel*'s writers and photographers, amongst them Clarkson.

During the summer of 1968 I travelled with a friend on a two-week holiday to the West Country in his very dilapidated Morris Minor. We had various adventures, but none of the fishing kind, because my companion was not an angler and

made it clear that his holiday would not be spent staring at a float. I went along with this for most of the way, except on one evening when we were in Torquay and strolling along the east pier. I noticed one or two anglers fishing into the murky waters of the inner harbour, one chap in particular employing what seemed to be quite unconventional tackle for sea fishing. So I stopped to watch for a while, telling my friend that I would see him in the pub in twenty minutes. My opening gambit was the language of angling universally: 'Have you caught anything?'

Without taking his eyes off the rod tip, the stranger answered, 'No, not yet; but as long as my bait is in the water there's hope'.

'What do you normally catch here?' I asked.

'Bass.' he answered.

There followed a few moments silence until he said, 'On holiday are you?'

'Yes, from South London.'

'Not a place I know well,' he said. 'Do you like it there?'

'No I hate it,' I said. 'I'm far happier when I'm fishing and away from all the fuss and fumes.'

'What do you do?' he enquired. And I told him that I was a trainee illustrator, and how I'd had a couple of drawings published in *Creel* magazine. He turned around for the first time, looked me up and down and said, 'Well its nice to meet a fellow contributor. My name is Ewan Clarkson, what's yours?'

The rest is, as they say, history. We chatted for an hour, exchanged names and addresses and promised to stay in touch.

Ewan's first book, *A Break For Freedom*, was a compelling tale of an escaped mink and had all the hallmarks of my favourite authors such as 'BB' and Henry Williamson. So much did I enjoy reading it that I did a painting of one of the scenes described in the book, had it framed and sent it to the Clarkson family. They must have been pleased with it because almost by return I was invited to come and stay with them at Foxworthy on the River Bovey.

I travelled down by train to be met by Ewan at Newton Abbot station. During the drive back to the cottage he explained that he and Jenny were caretaker tenants for the Hunt family who had owned Foxworthy since the 1890s. Cecil Hunt was a renowned watercolourist and had painted many scenes in and around the valley of the River Bovey. I had no preconceived ideas about what to expect, but it was everything that I had dreamed of, rural and idyllic, yet homely and comfortable. Ewan's wife was welcoming and friendly and my room had a tiny window overlooking the river. The bed

had one of those bottomless feather mattresses many of us remember from childhood, and on the bedside table beside the candle (there was no electricity other than for a limited supply provided by a Lister generator) was a small cardboard box of exquisite dry flies tied by Peter Deane, with a label reading 'For Ewan, best wishes Peter'.

I was already in heaven when Ewan called up the stairs, 'Fancy an hour's fishing, Robin?'

I was down in a flash, noting the rods were already set up and propped against the back door, only to be invited to sit down to discuss the battle-plan. Ewan explained that the banks on this part of the Bovey were overgrown and rocky, and that newcomers were more than likely to fall or stumble, especially in the dark! Ewan stood up and turned around to reveal that on the back of his fishing jacket was painted a large white cross. 'You follow that,' he said. 'If it goes up, then you go up, if it goes down then so do you. If you do lose your footing then just go with it, thrashing about will very often land you in even more trouble!' This last piece of advice has saved my bacon on more than one occasion since.

We said cheerio to Jenny and set out for the river as darkness was falling and I vividly remember feeling a true sense of place. This was where I had always wanted to be, me, a city boy, brought up among the red brick of South London, now transplanted as if by magic into the heart of a wondrous, watery paradise. It was a life changing experience. We did catch fish that evening, I think it was one each, but the real experience for me that night, as an artist and angler, was the sight and sounds of the running river in the depths of the country, it was like being born again. When we had fished through the beat we returned to the snug cottage, gutted the catch and sat down in front of a roaring log fire exchanging fishing stories and sipping on Ewan's home brew.

I went to bed that night and lay listening to the owls and, most of all, the river. I knew that I was in love with a place for the first time and that my life would never be the same again.

<div align="right">

Robin Armstrong
Lopwell, 2002

</div>

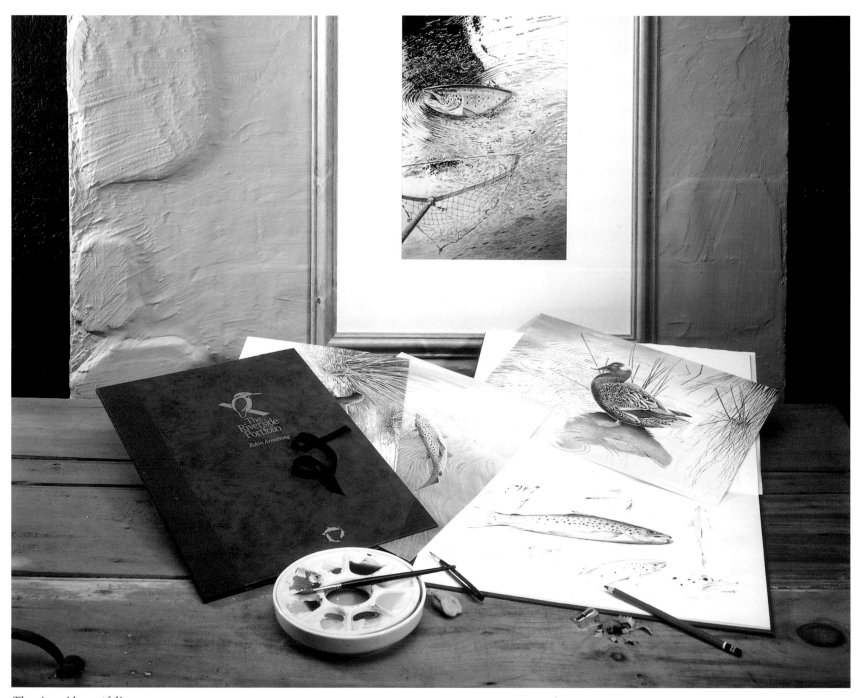

The riverside portfolio

14

My Moorland Days

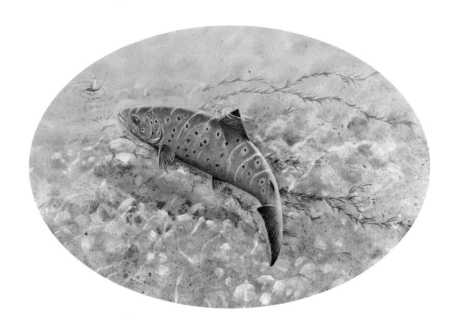

I dreamed of days from childhood years,
When time and passing clouds seemed stilled;
While yet the silver streams ran through
Enfolding fields and distant hills.

anon.

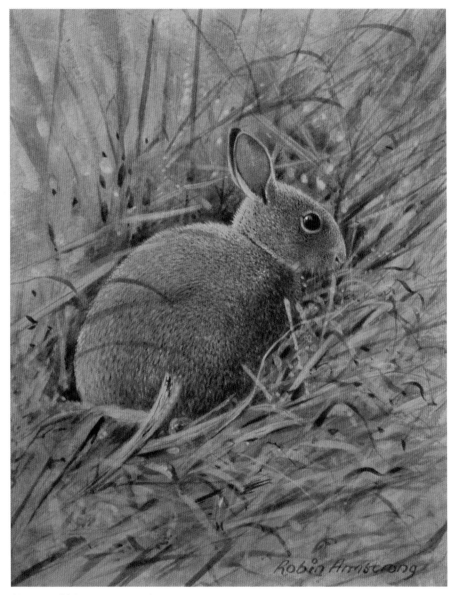

Young rabbit

Having been smitten by the world to which Clarkson had introduced me, I had to find a way, and more importantly the means, with which to embark upon my chosen, if somewhat romantic career. At first I corresponded with the Clarkson family in the usual way and was always pleasantly surprised when I received the frequent updates of Ewan's catches and other news. They had now moved from Foxworthy to Kingsteignton, a few minutes walk from the River Teign.

Eventually the desire to give up the rat race became overwhelming. I vividly remember walking out one lunchtime from Barnett-Norfolk Artists (the studio I was working in at the time); it was a very hot day in early June. My thoughts were of rivers and tranquil streams, yet here I was faced with the eternal din of the traffic in Fleet Street, in addition to the choking stench of exhaust fumes. I'd had enough! I didn't go back after lunch but rang my studio manager and told him I had a migraine coming on and was going home. I walked the mile or so to Blackfriar's station, all the while thinking about my visit to Dartmoor and the little River Bovey.

The journey home was spent with my nose pressed against the window looking at the hundreds of semis with small backyards, all the same, all boxes containing people and their belongings – Denmark Hill, Peckham, Rye, Catford – street-after-street of bricks and mortar.

The only natural haven (if that's what you'd call it) was the railway embankment itself, where grasses and weeds were left to flourish, and where the seed-eating birds would come to feed. Occasionally one might see an urban fox family basking in the sun outside an earth dug from builder's sand and rubble.

As I was early on this day I deliberately stayed on past my home station of St Mary Cray and disembarked at Eynsford, in those days little more than a village, with a picturesque bridge and a ford. I walked the mile or so from the station to the village remembering the many times I had followed this route as a child, for in my apprenticeship as an angler we would go, perhaps two or three of us, to the tackle shop in Footscray and buy maggots for bait, before getting the train from St Mary Cray to Eynsford, two stops down the line. The playing fields and cricket ground were our destination and we would fish for hours for minnows and gudgeon, with the occasional chub and dace thrown in for good measure. Such memories flooded back as I walked down the hill.

I crossed the bridge and took the right turn into what used to be our own fishing hole to be met by a steel fence on which was displayed a sign which read 'No Public Access, site acquired for development!' With dismay I peered through the mesh towards the river; even the pollarded willow tree under which I caught my first ever fish was gone, a victim of 'progress'. As I made my way back to the station I made the decision to call the Clarksons and ask if they would be willing to take a lodger until I could find a more permanent solution to my desire to relocate to Devon.

That evening I rang Ewan and put the situation to him. I needn't have been anxious, as soon as I told him my tale he said 'What's keeping you up there? Why don't you come and stay with us until you get yourself sorted.' If this was the way, then I'd cracked it, it seemed that the means didn't really matter any more.

Making the Break

The following day I handed in my notice at the studio. My employers seemed somewhat surprised that a nineteen year old should want to sacrifice the bright lights of swinging London for some rural unknown, but were nonetheless very understanding and sympathetic, even offering to keep my job open should my 'move to the sticks' be unsuccessful.

The early days living with the Clarksons' at Moss Rose Cottage, Kingsteignton, were a mixture of pleasure and frustration. The house was a veritable rabbit warren; rooms had been pegged on here and there to accommodate the regathering of the

families; both of Jenny's parents were on board plus Ewan's elderly mother and disabled brother. Then there were the two kids Bruce and Sheila. The pleasure for me was that for the first time in my life I felt as though I was part of a working unit; everyone had his or her little niche and got on with it.

As a working writer, Ewan would lock himself away in the bedroom and you could hear the somewhat ponderous tap tap of the typewriter as he gathered his thoughts and feelings together for those wonderful and passionate books he wrote about wildlife and its struggle to survive in today's environment. I still browse through them thirty-five years on, and can still pick up little snippets of insight tucked away in every chapter. The rest of the family all had daily routines except the 'new boy' from the smoke. At first I spent time fishing on one of the numerous nearby lakes, intriguingly named Tip Top, where

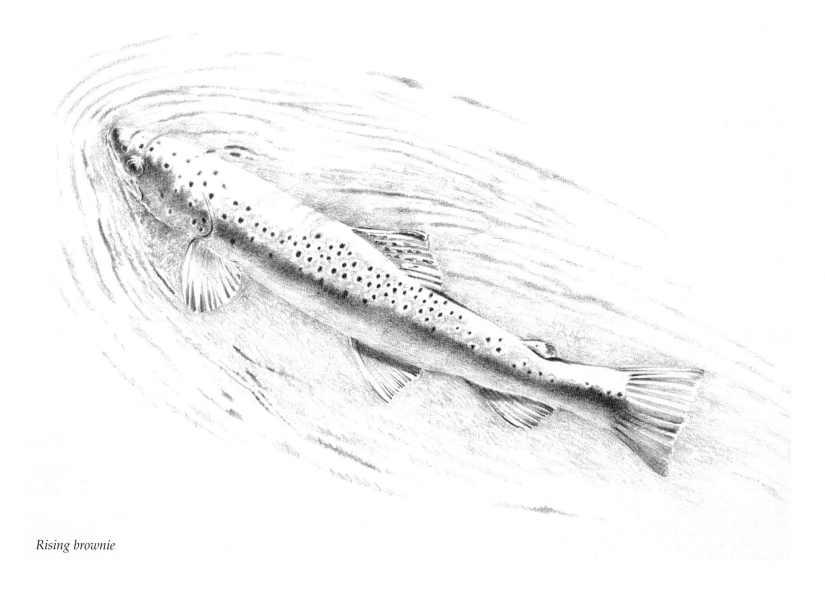

Rising brownie

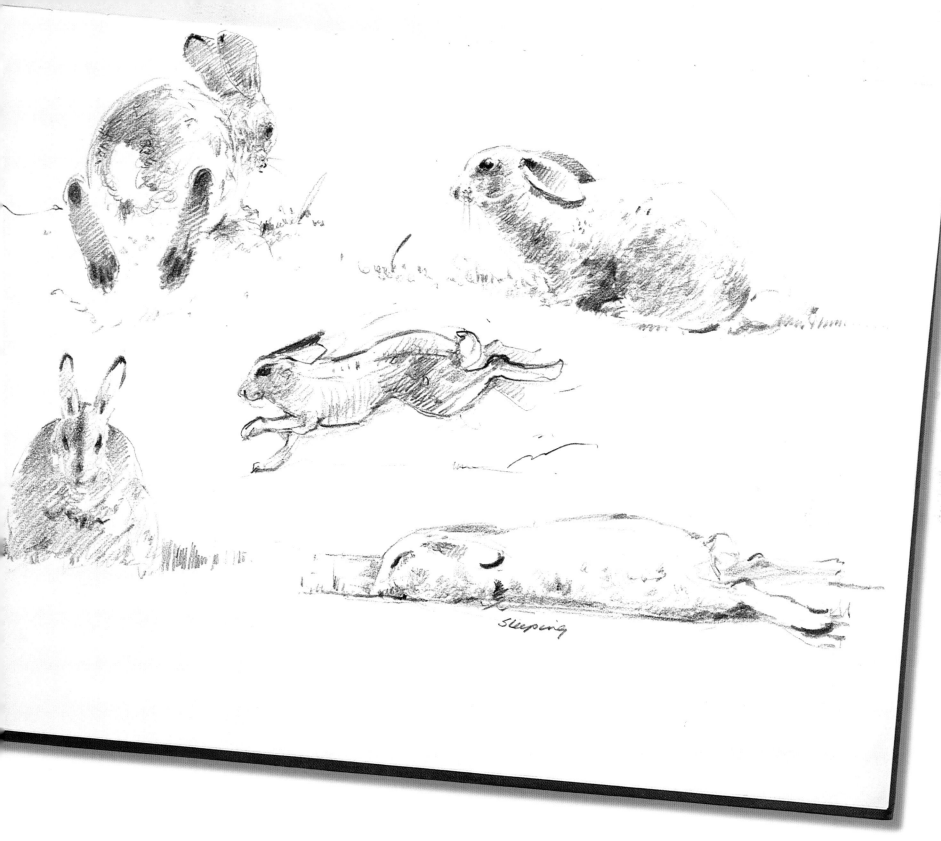

Rabbit drawings from the sketchbook

I caught rudd, tench and the occasional carp. Or I would be out on the Teign, not fishing because I was not a member of the club, but fish watching and sketching. This went on for some weeks until one day during the everyday lunch routine, Jenny said: 'Robin, isn't it about time you got down to some painting? It is after all one of the main reasons that you are here.'

There was silence, and I looked up to be met by the stare of several pairs of eyes and, judging from these, it became clear I had been the subject of an internal inquiry *en famille*. I coughed nervously and said 'Well I suppose it is, it's just that I've been finding my way around, and in any case I really haven't got anywhere to work.'

'That's all sorted,' said Jenny. 'You can have the big table in the hallway. There's plenty of light in there, and no one will disturb you!'

'Well if you're sure.'

'I'm sure' said Jenny, 'I've lived with your kind of creativity for twenty-five years and I know how to deal with it.' By this time the eyes were all smiling, I'd been voted into the team.

I set up my makeshift studio in the hallway at Moss Rose Cottage, and began drawing and painting. At first I took my work to local galleries and, as I did more, the word spread and I began to get commissions and enquiries from further afield.

Soon after I began painting I was introduced to Brian Letts, who'd been a friend of the Clarksons for some time, and by

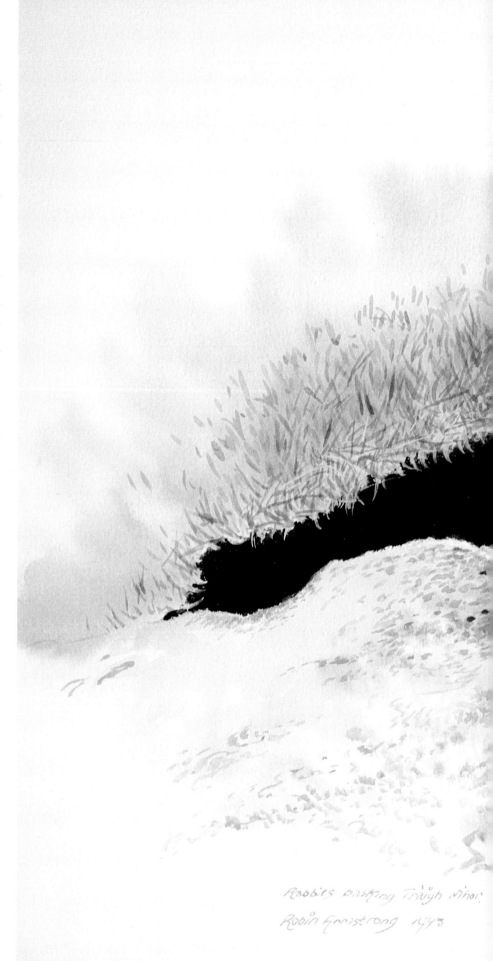

Rabbits basking Traigh Mhor
Robin Armstrong 1993

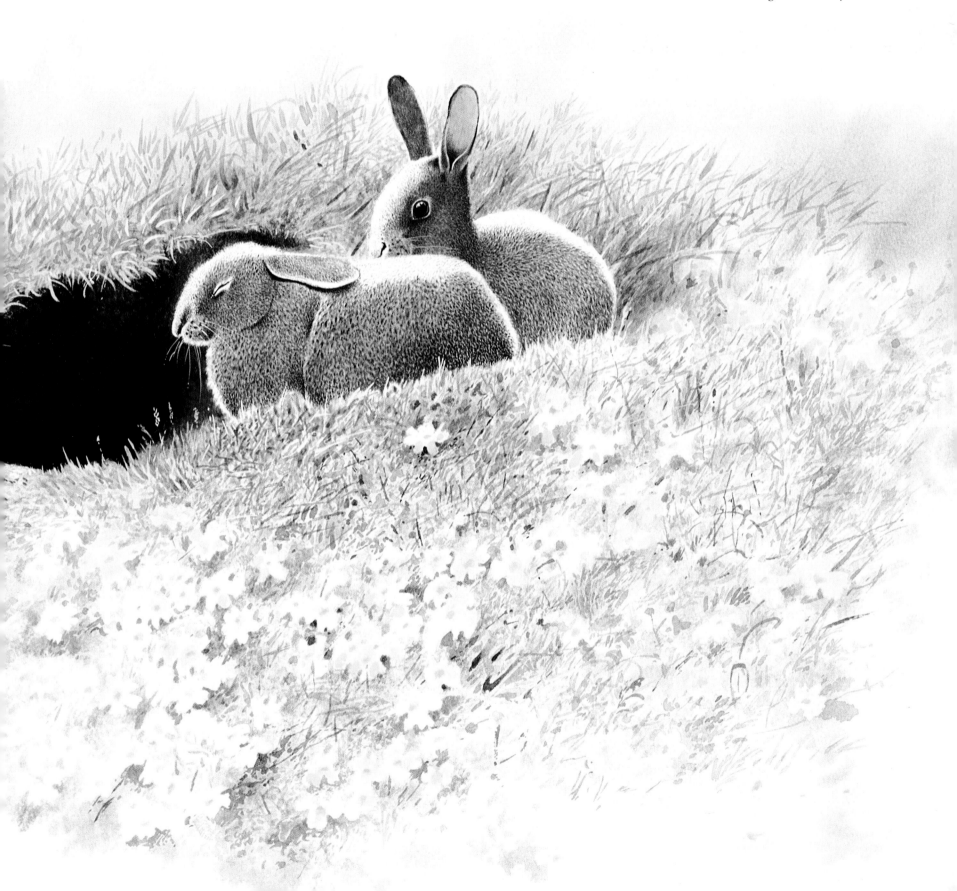

Basking rabbits and primroses

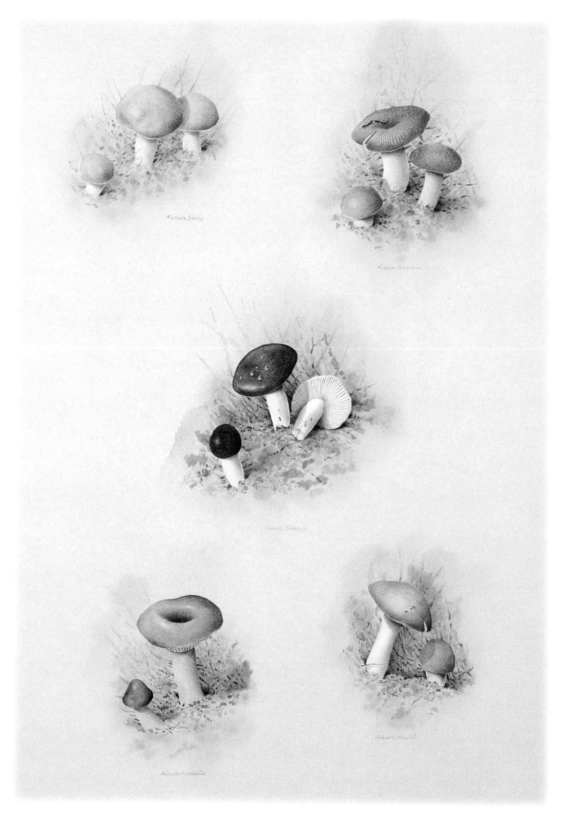

Mushroom studies

coincidence was the local river warden. Brian had a real knowledge of natural history, not just an expert on fish but on mammals, in particular weasels (he once had one as a pet!) and birds of prey. We got on really well and I started spending time out with him on the river, learning a great deal in those early days from both Ewan and Brian.

Ewan worked for the *Western Morning News* as one of the very first environmental correspondents, and in 1967 had reported at length on the first major oil pollution incident to hit Cornwall when the tanker *Torrey Canyon* went aground on rocks. This disaster received national coverage, and I vividly remember seeing the television pictures of RAF jets bombing the wreck to try to ignite and burn off the leaked oil. Sadly nearly thirty-five years on, we still have not learned from this early tragedy and every year we have an oil spillage of some magnitude or other.

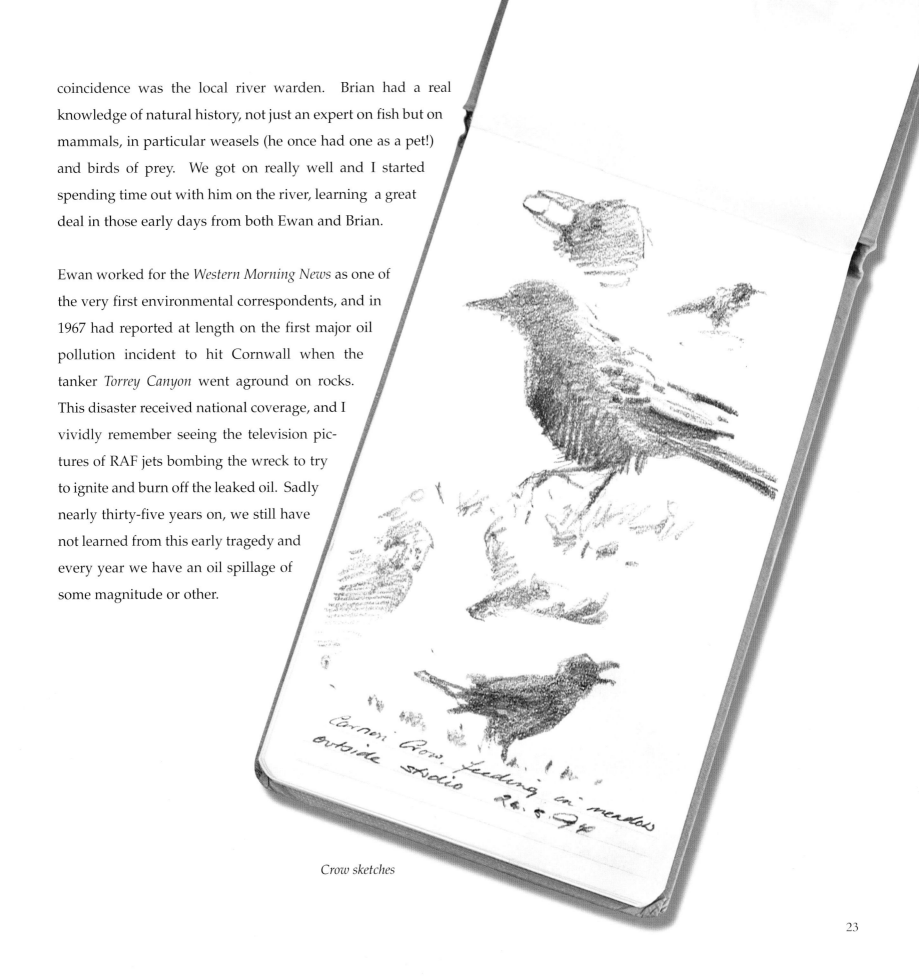

Crow sketches

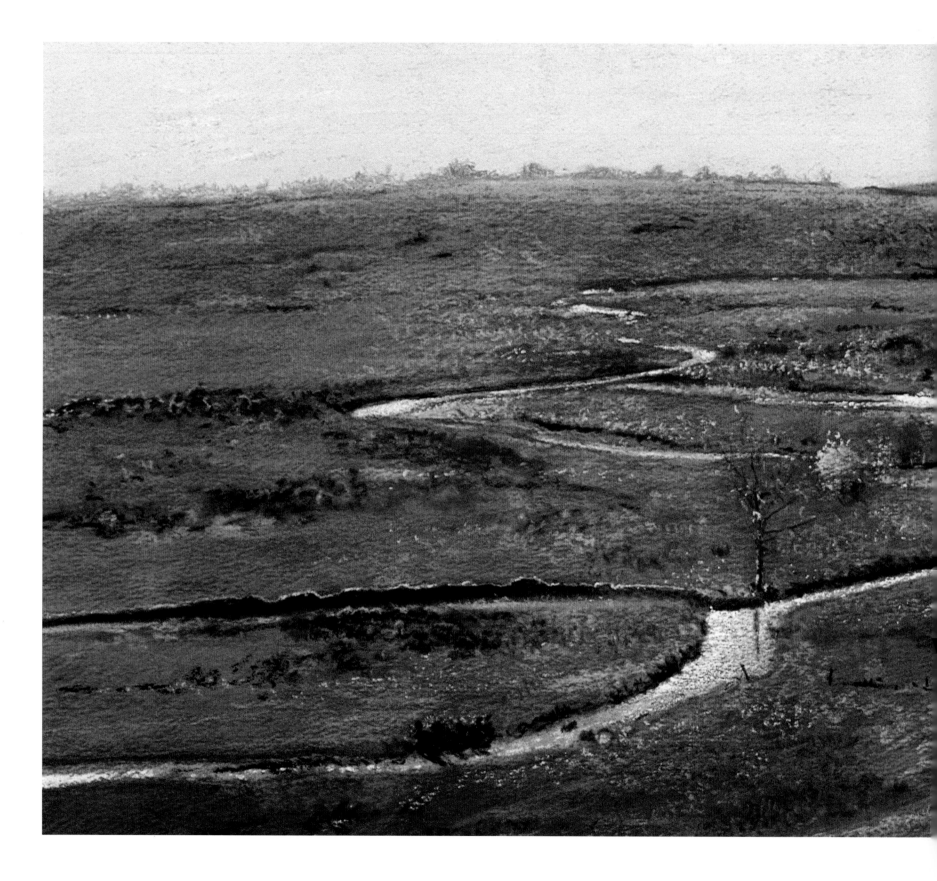

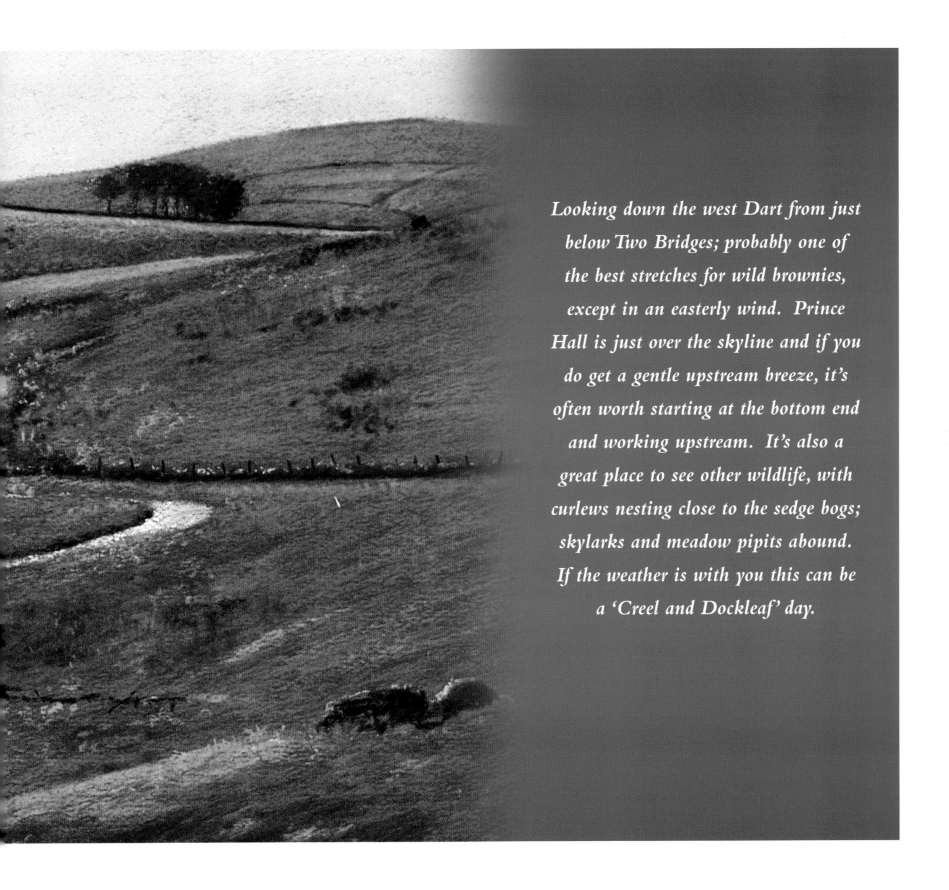

Looking down the west Dart from just below Two Bridges; probably one of the best stretches for wild brownies, except in an easterly wind. Prince Hall is just over the skyline and if you do get a gentle upstream breeze, it's often worth starting at the bottom end and working upstream. It's also a great place to see other wildlife, with curlews nesting close to the sedge bogs; skylarks and meadow pipits abound. If the weather is with you this can be a 'Creel and Dockleaf' day.

25

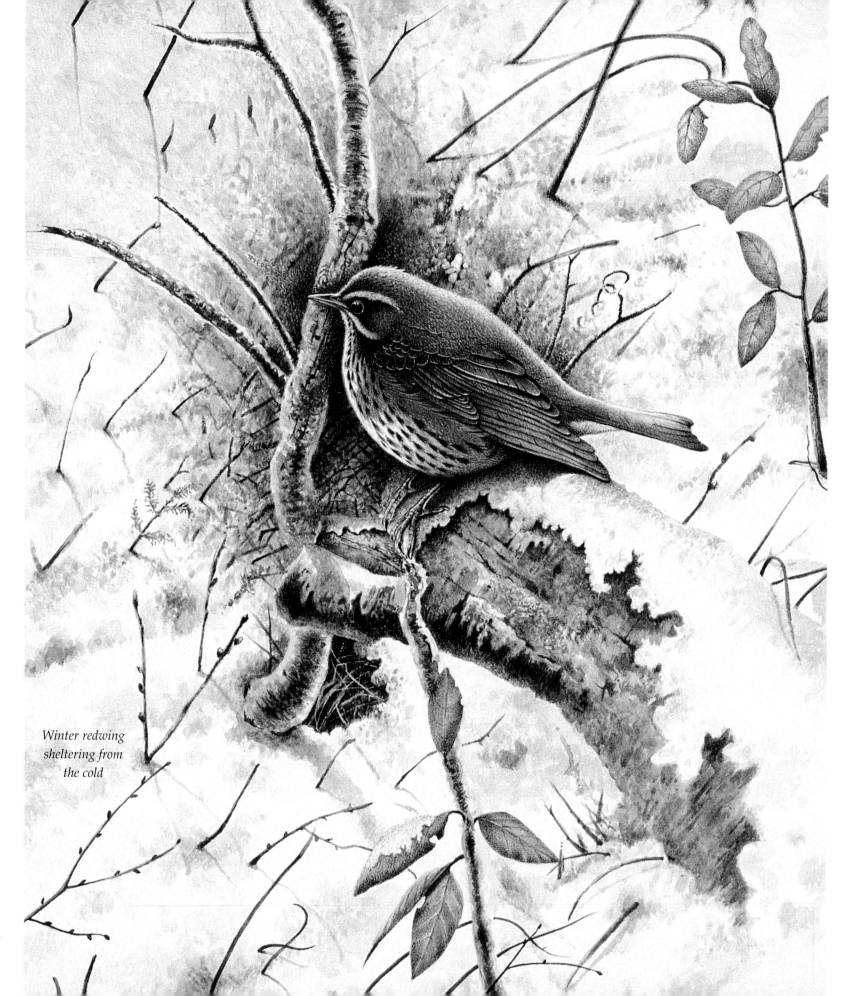

*Winter redwing
sheltering from
the cold*

26

I was out on the river one day with Brian at Fingle Bridge, when Jack Price, owner of the Angler's Rest, came out to us on the bridge to convey a message to Brian from his head office saying that someone had reported seeing dead fish in a little stream that runs through Moretonhampstead. Could Brian attend, assess the situation and report back. We drove at top speed to Moreton in Brian's little blue mini and within fifteen minutes we were walking the banks of the brook. It didn't take long to discover the cause of the pollution; the local oil merchant had his storage depot close to the banks of the stream and one of the tanks had burst, pouring 500 gallons of oil into the little river. With a combination of quick thinking and good luck we managed to grab half a dozen straw bales from a nearby farmyard and put them in the stream to form a barrier just ahead of the main slick as it made its way downstream. Then working back towards the village, we removed as much oil as we could from the surface with shovels! The damage, thank goodness, was minimal; we found only six dead fish, two of which were well over 2lbs in weight, and two dippers, both of which had become so oiled that we had to put them down, a penalty that this lovely little bird has to pay for being so territorial. The clearing up took us all day, even with reinforcements from the River Board Pollution Department.

When Brian ran me back to Moss Rose Cottage that night all I wanted was a hot bath and a pint of Ewan's home brew. I was quite surprised when I bumped into Jenny and got a glare and, having had my bath, I went through to the dining room to find out what I'd done (or not as the case turned out to be). 'Why

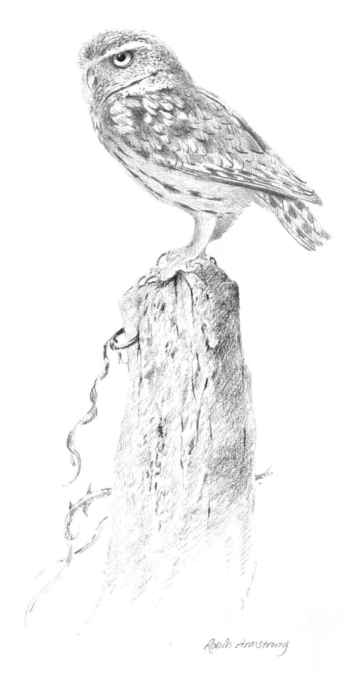

Robin Armstrong

Little owl

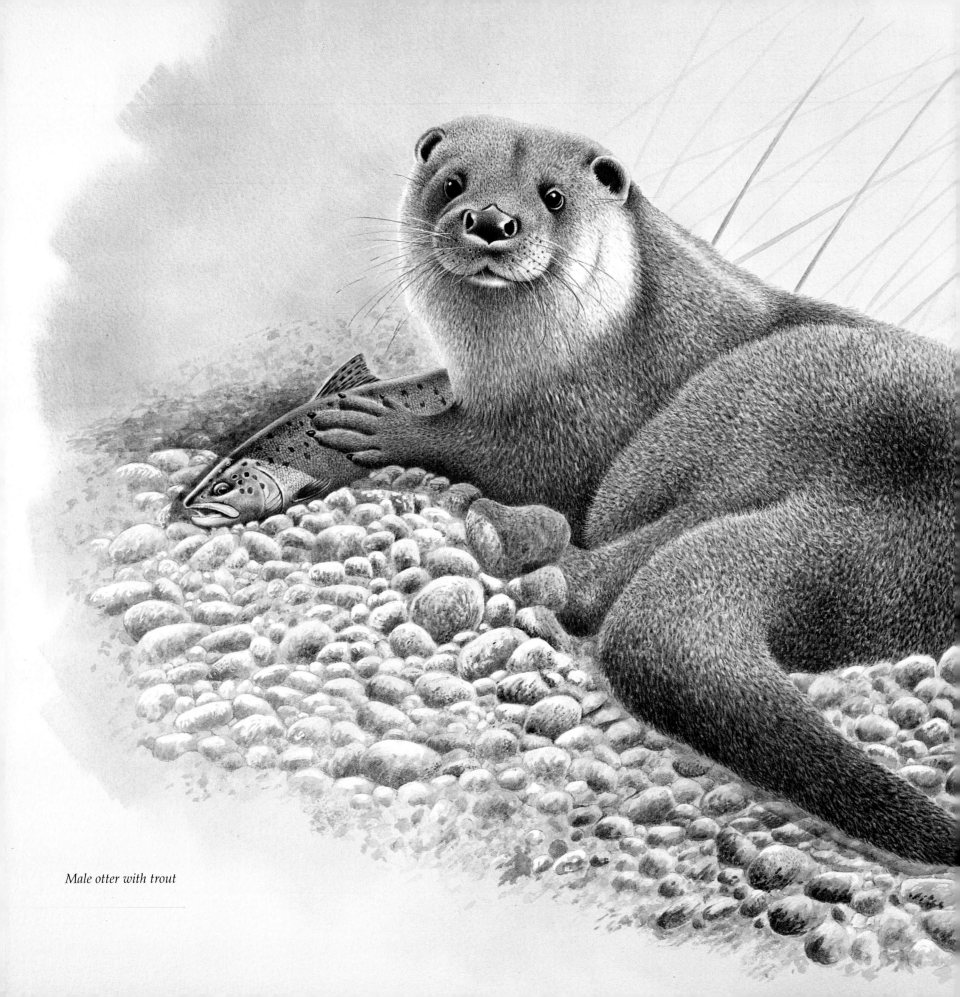

Male otter with trout

on earth did we have to find out about the pollution at Moretonhampstead on the local radio? Why didn't you ring and tell us, Ewan could have covered it for the *Morning News*.'

I thought about making some lame excuse about not being able to get to a phone, but the truth is I just didn't think and I felt so ashamed. Here were two people who had taken me in, fed me, watered me and guided me into a new way of life, and I had rewarded them by not giving them a second thought!

I think it was this incident that brought things to a head at Moss Rose and soon after this I found myself a tiny flat in Moretonhampstead. I left the Clarksons with some trepidation because I had never lived on my own before; however I needn't have worried, Brian and his wife Phyllis were very supportive and before long I made a number of friends, many of whom I still see today.

The flat in Moretonhampstead was terrific, with one room, a small (tiny) kitchen and a bathroom. The main room immediately became my studio, my few material possessions comprising my fishing gear, painting materials and a few clothes; flared jeans and tee shirts were the order of the day. My landlords, the Underhills, were splendid people. Having a daughter of about my age helped them, I'm sure, to understand the vagaries of youth, and not only did we get on well but they allowed me to paint the flat any colour I choose, and I chose a hideous shade of magenta, influenced by a Pink Floyd record sleeve. I then strategically placed three posters of Jane Fonda as Barbarella. Each time that Don Underhill came to see me he couldn't resist giving Barbarella a pat on the thigh before he left.

Having established a base, I continued to paint and draw for local galleries. It was also at this time that Brian and Phyllis set up and opened a small gift-shop-cum-gallery beneath their flat beside the Bell Inn. Brian's father Jimmy had been the landlord of the Bell and had managed to secure the use of the flat and shop next door. They asked me if I would like to look after the shop and actually work on the premises. I agreed, although with some small hesitation.

For a while I ran the Three Ravens, as it was called, but it wasn't a thriving business and, while Brian and Phyllis were both working full-time elsewhere, I found myself getting easily distracted by people when they came in just to browse. Also, at about this time, I had met the last of a long line of gentlemen farmers, one Crispin Athorpe. A nice chap, if a little confused about his role in life, who farmed at a place called Laployd Barton, a couple of miles outside Moreton.

29

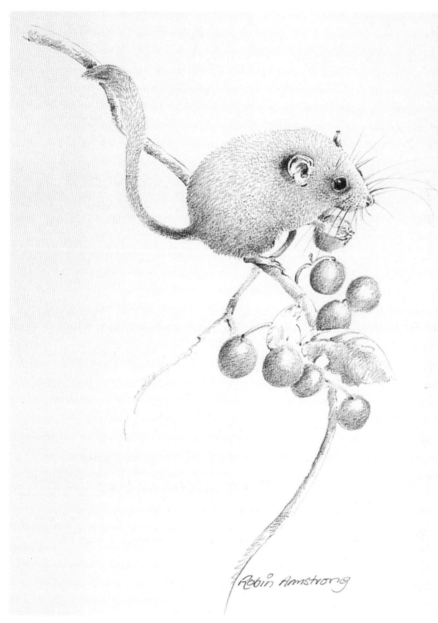

Dormouse

In the meantime, Brian and I continued our ramblings on the rivers and I learned a great deal about country lore and wildlife under his guidance. He introduced me to many interesting people who had shaped their entire careers around nature and the countryside, one such being Lawrence Shore, a pioneer in the field of recording bird song. Lawrence lived just outside the little village of Christow, and used his home as a headquarters for the many sojourns he would make to different parts of the country to capture the songs and calls of British birds. Eventually the various recordings were collected together, along with his commentary, and produced on a vinyl record, sponsored by Shell.

One such trip took Lawrence to the North, to one of the last breeding sites of that lovely bird of old English farmland, the corncrake. I've only heard and seen these birds in the Hebrides, and have been fortunate enough to be able to draw them from life. One day maybe we will have them back in the fertile river valleys of the moor. Certainly there are reintroductions elsewhere that are successful.

Meanwhile I continued to gain a great deal from being in the countryside with both Brian and Ewan. I even became partly self-sufficient in feeding myself by catching or shooting for my supper. I had bought a rather rusty Spanish shotgun for pigeon and rabbit and had a permanently simmering stock pot on the go in the tiny little kitchen at the flat.

The rivers though, especially during the summertime, were always the major source of inspiration. The Teign, the Bovey, and then later on the little Cherrybrook, became my total focus, for both my study of the flora and fauna and my painting. On hot summer days we would take the bones of a picnic and drive up to the head of the Teign, armed only with a little brook rod and a few dry flies. Brian would go in one direction and I in the other (leaving the girls to bask in the sun and make base camp). We would fix a time to meet back at camp and then just fish and watch the world go by.

The upland wildlife was always exciting for me as a budding wildlife artist. I would watch in wonder as a raven flew high overhead on its way to who knows where, amazed at how that deep-throated 'cronk' would carry on the air and be received by the human ear like a bomb blast. Even today, when I am working at Lopwell and a raven flies overhead, I still receive that 'cronk' above the sound of Sunday revellers!

One day, whilst fishing near Teignhead, I put up a family of grouse. The young birds were fully fledged and flying but not yet the deep burgundy colour of the adult birds. I've seen these birds many times since on Dartmoor, but I will never forget the clattering excitement of putting up that first covey.

After a few hours Brian and I would meet back at our campsite and trade stories, boasting about how many monster brownies had eluded us. The truth is we would empty our creels of usually about half a dozen little quarter-pounders, spotted like jewels in the summer sunshine. Just on the odd occasion, one or other of us would present a real monster, perhaps even a pound in weight, but these were few and far between. Having built a small fire ringed by rocks from the river, we would put the fish into baking foil and gently cook them over the embers. They were just delicious, as sweet and moist as manna from heaven.

I briefly mentioned the girls. Phyllis, Brian's wife, and Pat, my new-found romance, had become quite good friends and would always enjoy these trips up to the high moor. While Brian and I fished, they would sunbathe and generally enjoy the clean air. Eventually Pat and I were to marry and, although it wasn't to last, we of course didn't know that at the time. Together we decided we needed somewhere bigger to live, the little flat becoming too cramped for us both, and in any event it seemed increasingly obvious that, if I was going to make a serious attempt to make my living as a wildlife artist, I would need a studio.

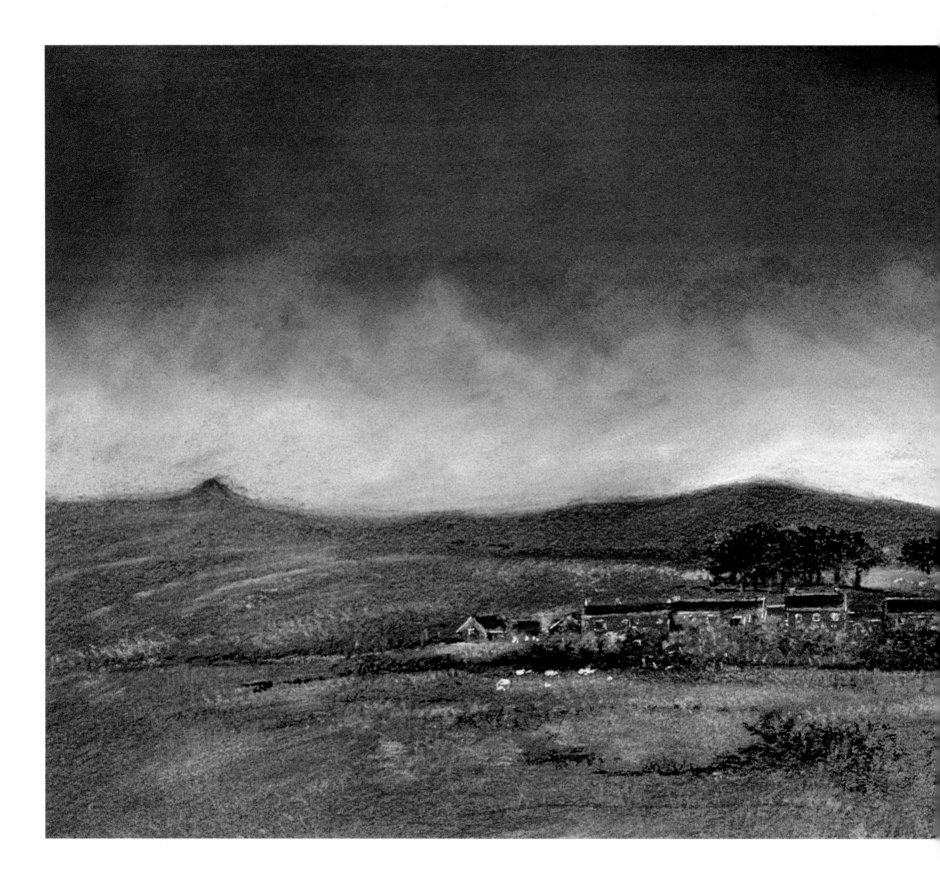

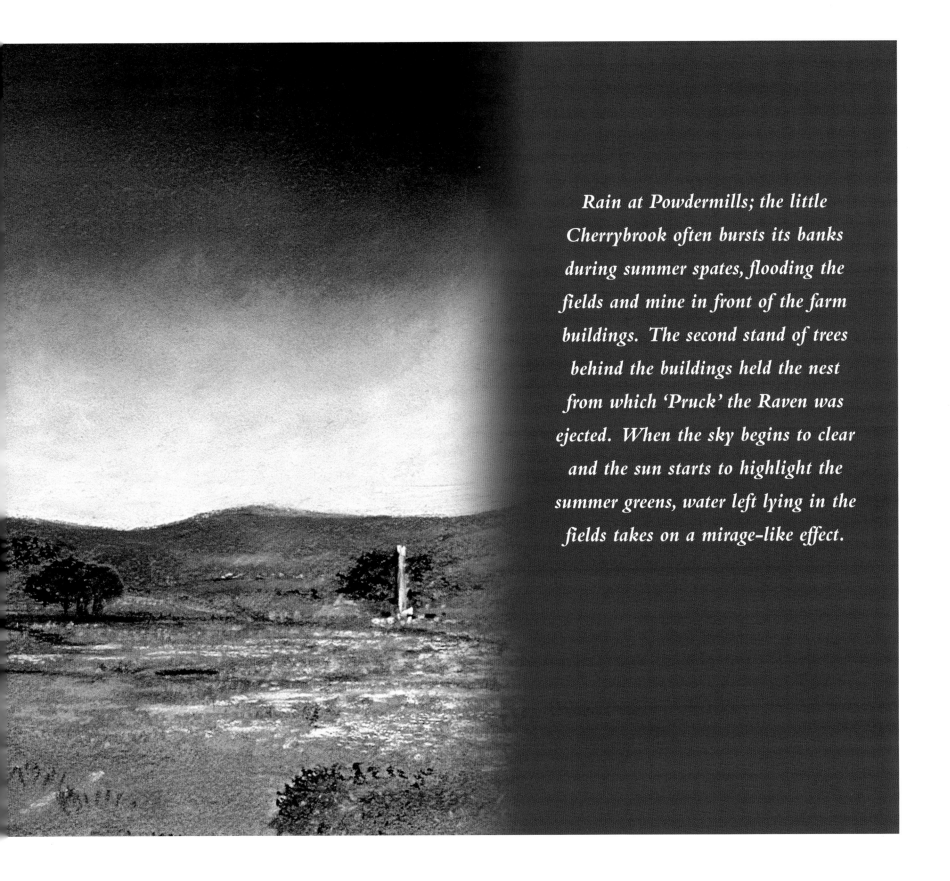

Rain at Powdermills; the little Cherrybrook often bursts its banks during summer spates, flooding the fields and mine in front of the farm buildings. The second stand of trees behind the buildings held the nest from which 'Pruck' the Raven was ejected. When the sky begins to clear and the sun starts to highlight the summer greens, water left lying in the fields takes on a mirage-like effect.

Crispin Athorpe happened to have a vacant cottage at Laployd Barton and asked Pat and I if we'd like it, in exchange for me helping out part-time on the farm. I forget the exact arrangements, but it must have seemed like a good deal because within a few weeks we had said goodbye to the flat, and to the Underhills, and moved to Laployd Barton.

This move took us to the middle reaches of the Teign and to a whole new wealth of wildlife; the deeply wooded valleys between Steps Bridge and Fingle bridge harbored new and exciting creatures to draw and paint. I maintained the contact with Brian as this was still his 'patch' as a warden, and was introduced to dormice for the very first time, being shown the cosy little daynests in the coppices of the middle river valley. These beautiful little creatures have always been uncommon, never more so than now.

Raptors such as sparrowhawks could be seen regularly amongst the deciduous trees and would always remain an event, especially if you were close enough to be treated to that vivid yellow. I always think that sparrowhawks look at you as though you've just stolen their wallet!

More dippers could be seen at these lower levels, although still just as territorial as the uplands birds, and, of course kingfishers, especially farther down, where some sandy banks could be found to allow them to nest.

Woodcock study

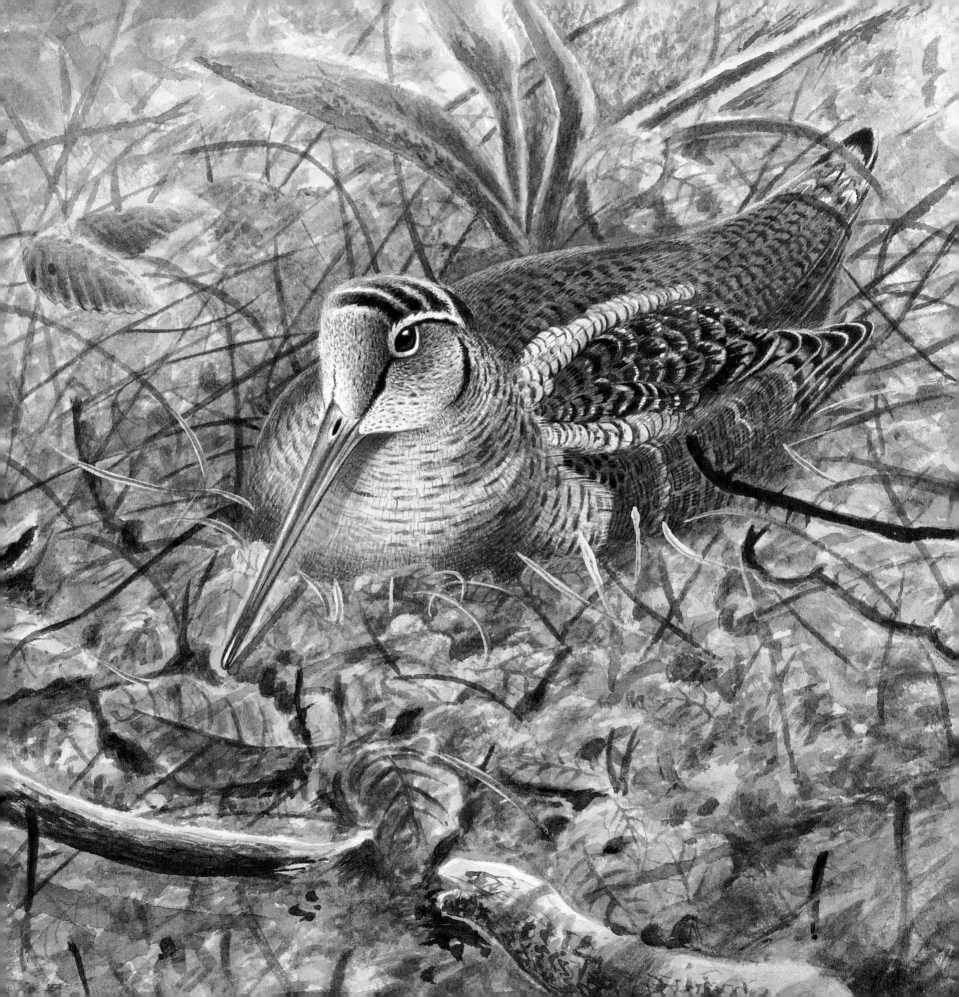

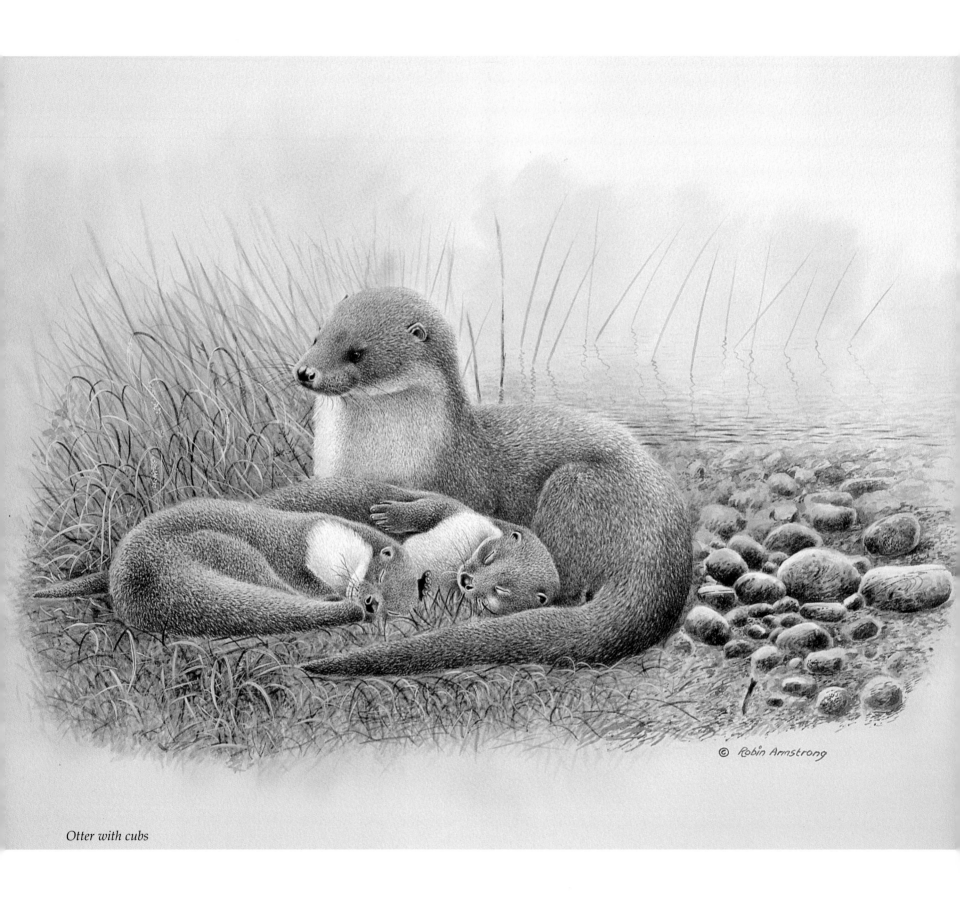

Otter with cubs

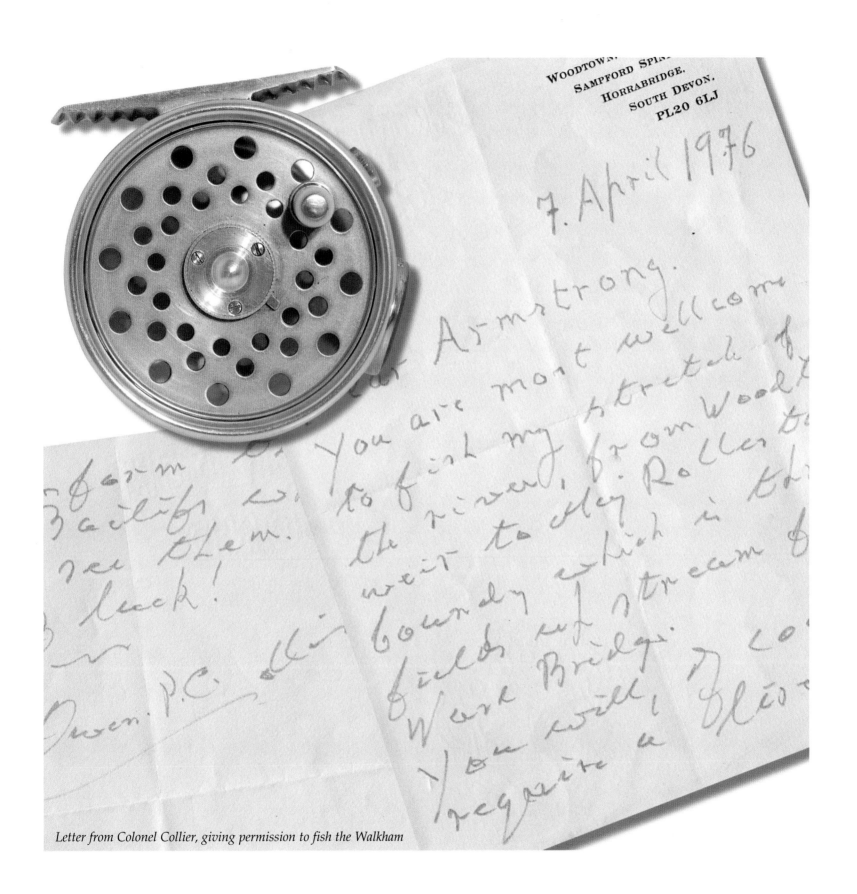

WOODTOWN
SAMPFORD SPIN
HORRABRIDGE.
SOUTH DEVON.
PL20 6LJ

7. April 1976

Dear Armstrong.

You are most welcome
to fish my stretch of
the river, from Woodt
weir to the Rollers the
boundry which is the
fields at stream b
Ware Bridge. co
You will, of flies

regards a flies

Letter from Colonel Collier, giving permission to fish the Walkham

37

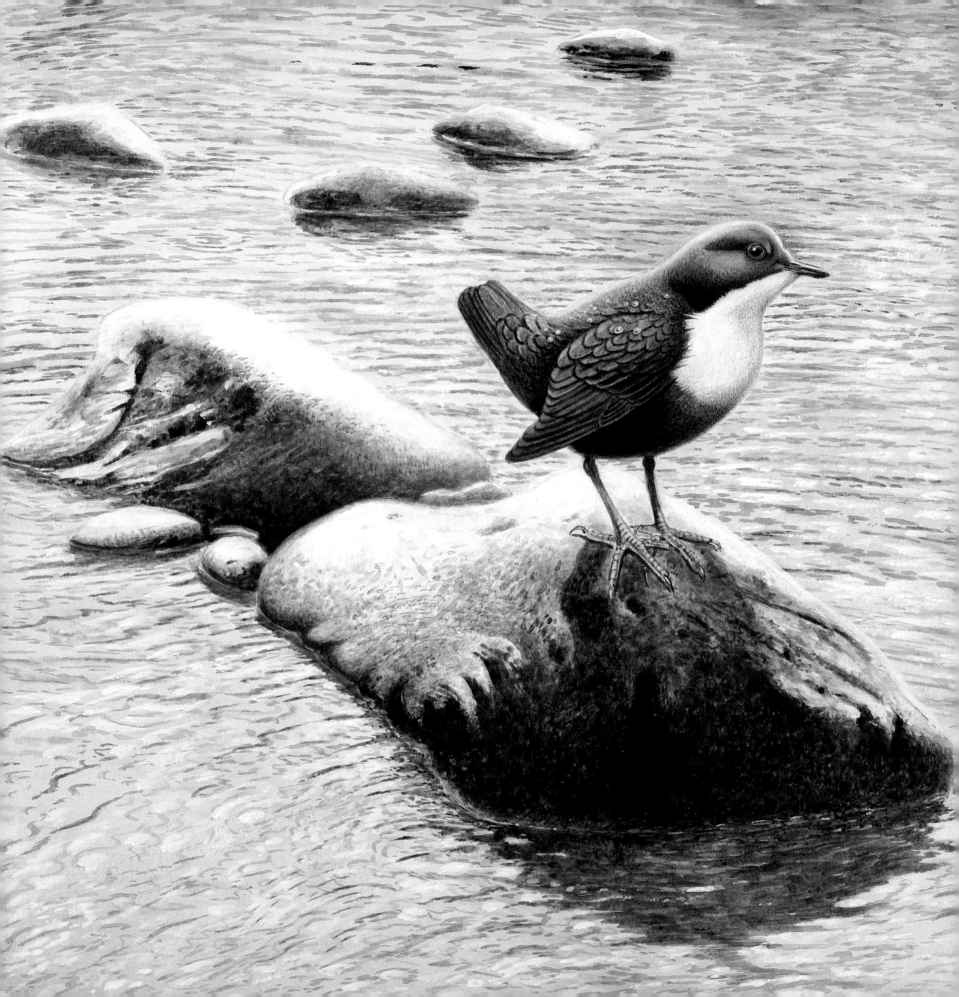

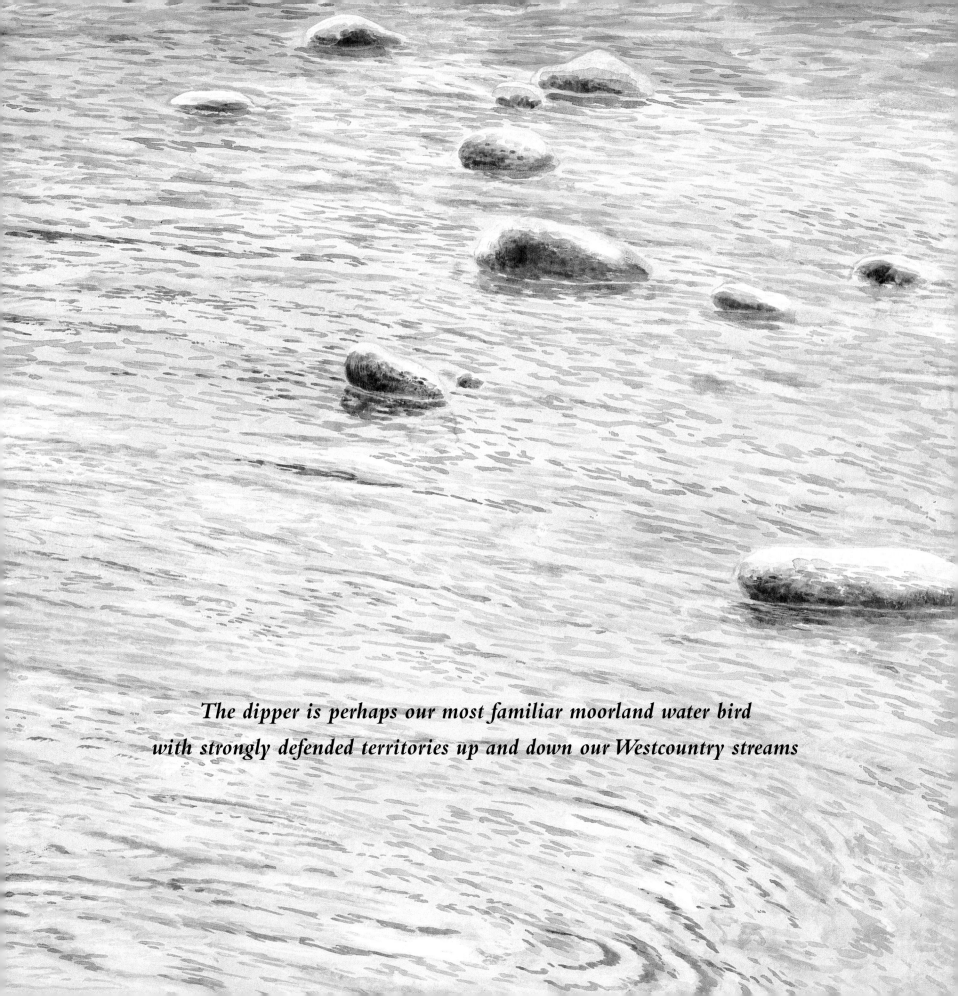

*The dipper is perhaps our most familiar moorland water bird
with strongly defended territories up and down our Westcountry streams*

Springtime composite

Silver-washed fritillary

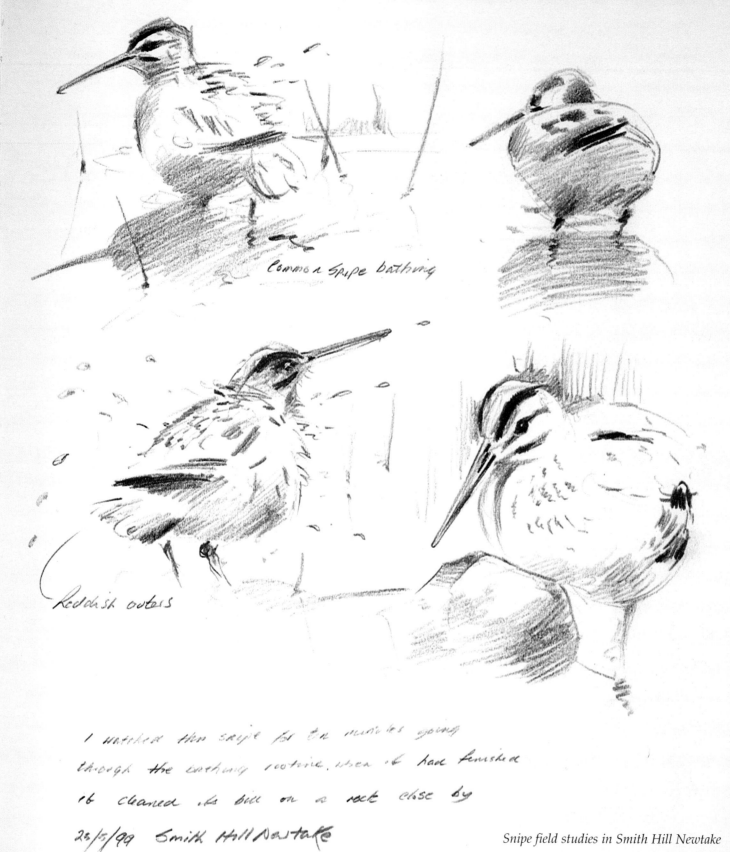

Common Snipe bathing

Reddish outers

I watched this snipe for ten minutes going
through the bathing routine, when it had finished
it cleaned its bill on a rock close by
23/5/99 Smith Hill Newtake

Snipe field studies in Smith Hill Newtake

Working with the River Wardens

Thirty years ago concern about the environment was very much a matter for the pioneer. I have mentioned earlier Ewan Clarkson's role as an environmental reporter for the *Western Morning News*. Such a position was unusual then, although that was not so long ago. These days we all like to think that we can make things better for our countryside and the creatures, insects and plants that live there, even if for some, it means taking the law into their own hands. I remember on one such occasion Brian Letts did just that. The woods and fields around Steps Bridge are a haven for our wonderful wild daffodils, not the great gangling four-engined variety that stands snake-headed in millions of suburban gardens, but small compact and prolific, at least wherever the bulbs can remain undisturbed and the leaf mold is loose and supportive.

One day Brian was walking upstream from the bridge when a woman came towards him carrying a full armful of blooms, many with their bulbs dangling hopelessly at the end of the stem. Incensed, Brian said 'I do hope you realise that they are wild flowers you've just picked, and the ones with the bulbs on won't grow again next year.'

The woman glanced at the flowers and said '...doesn't matter, these are only for pots in the house, so I don't have to pick the proper ones from the garden, cost me a lot of money you knows.' Recognising her ignorance, Brian carried on his way quietly seething. Later that day Brian could be found knocking on the door of Peter Collier, the letterpress printer who worked with those wonderful old presses just three or four doors up from the Three Ravens.

'Hello, Peter,' said Brian. 'I need to ask you a favour.'

The next morning found Brian heading towards Steps Bridge much earlier than usual, parking his car in the normal spot beside the bridge. From the back seat he took a small oblong package, along with a hammer and three or four nails. He then headed towards the footpath and, arriving at the gate, neatly tacked on to it a notice. Twirling the hammer over and over in his hand like a bandleader's baton, Brian stood back to admire his handiwork. At about twenty yards the notice could clearly

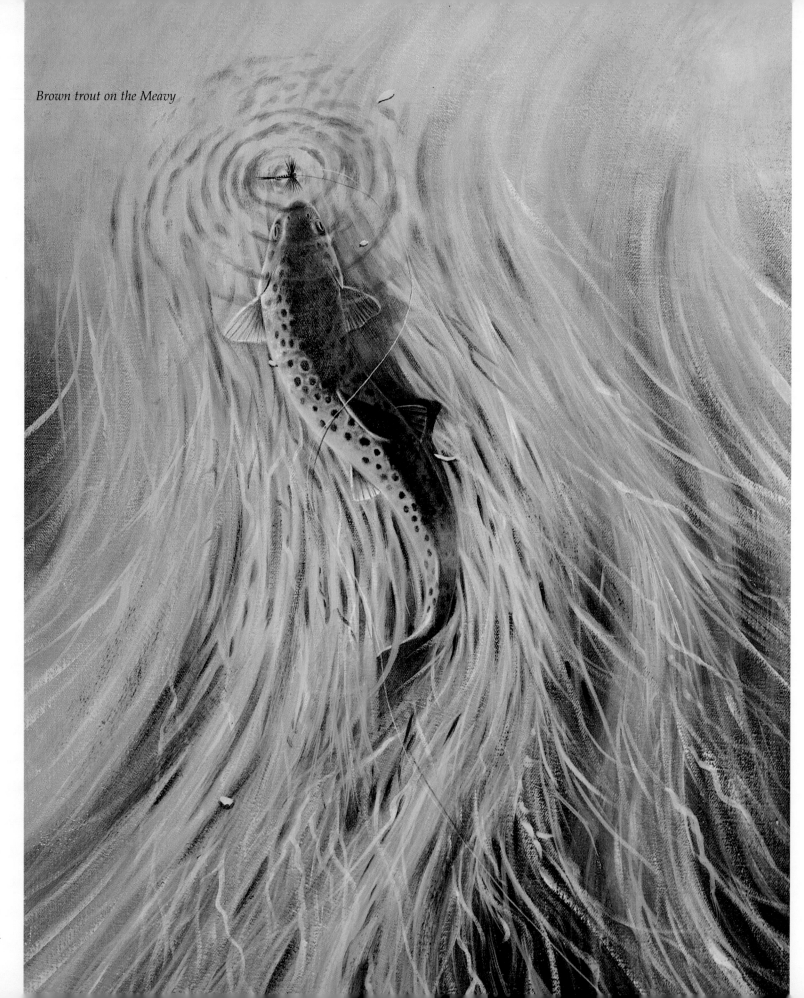

Brown trout on the Meavy

44

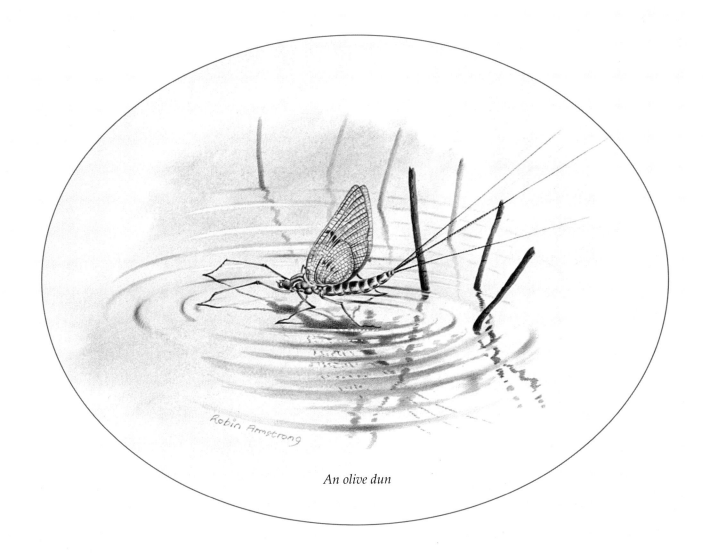

An olive dun

be seen and, narrowing his eyes, he read out loud 'THE FLOWERS IN THIS WOOD ARE CONTAMINATED WITH PSEUDONARCISSUS, PLEASE AVOID CONTACT WITH THE SKIN' – smiling quietly, he got out his notebook, logged the time and date, and carried on with his patrol!

When incidents like this occur, it makes one realise just how proud some of us are of our natural heritage. Even in our rural haven on and around Dartmoor, the natural environment is under constant threat, mostly from man himself. I can vividly recall one occasion which threatened the entire eco-structure of the Teign. It was whilst I was working as a river warden, and although my 'patch' included the rivers Tavy, Walkham and Plym, the severity of the case meant that wardens were drafted in from all other areas to deal with the situation.

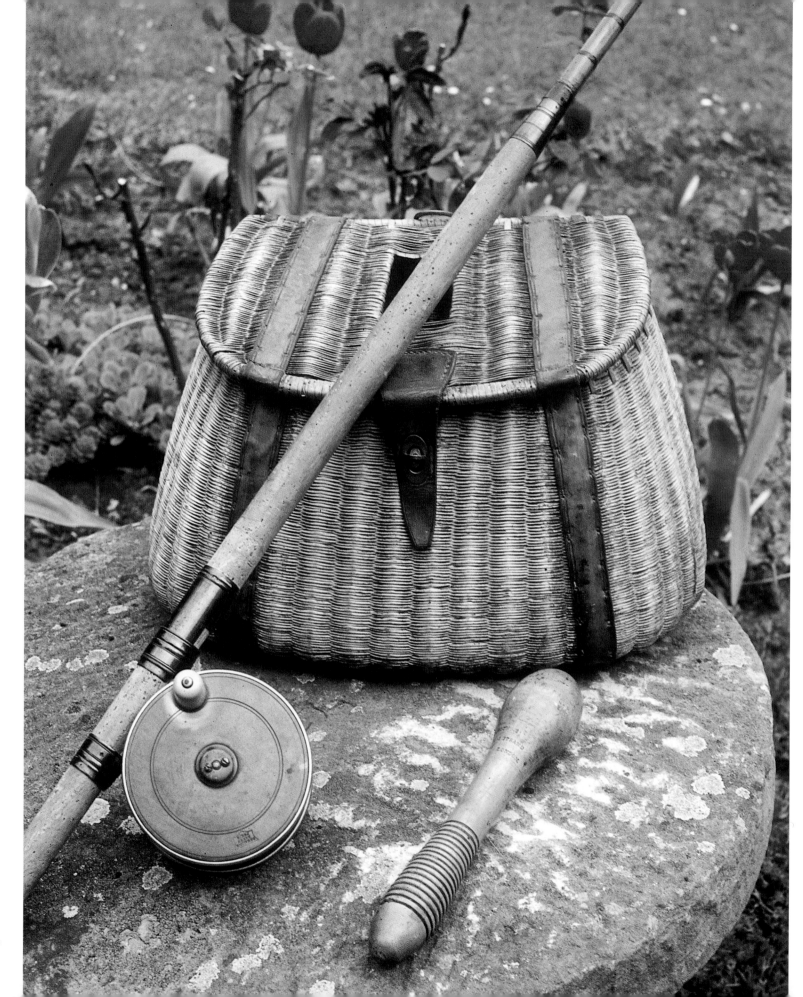

Brown trout

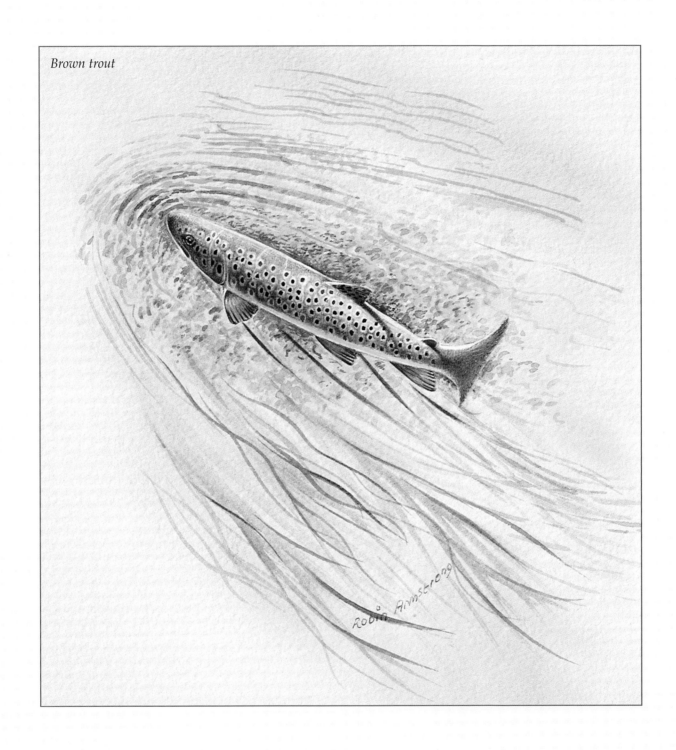

Opposite: *Some ancient salmon fishing tackle*

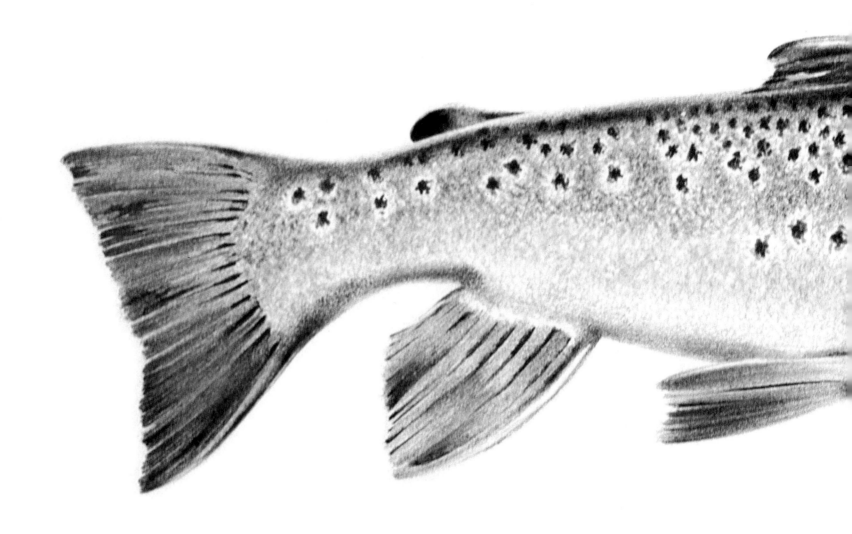

For two years in succession, coinciding exactly with the annual leave of the local warden, Robin Peardon, the river had been poisoned with builder's lime in a stretch above Steps Bridge; the deeply cut banks at this point harboured many salmon and sea-trout. These fish would hide amongst the numerous roots and rocks along stretch of river from Steps to Fingle Gorge. Not only did the lime kill all these fish, but everything else in its path until the toxins dissipated. Invertebrates as well as fry suffered as a result of this particularly cruel and senseless method of poaching which even those locals who were known to take a few fish illegally found abhorrent. This was a townies method, one which resulted in getting what they wanted, with no thought as to the long-term damage they left behind. Robin Peardon was a true countryman and knew his patch well; he'd come close to catching the culprits on at least one occasion by returning early from his holiday. But this was a job

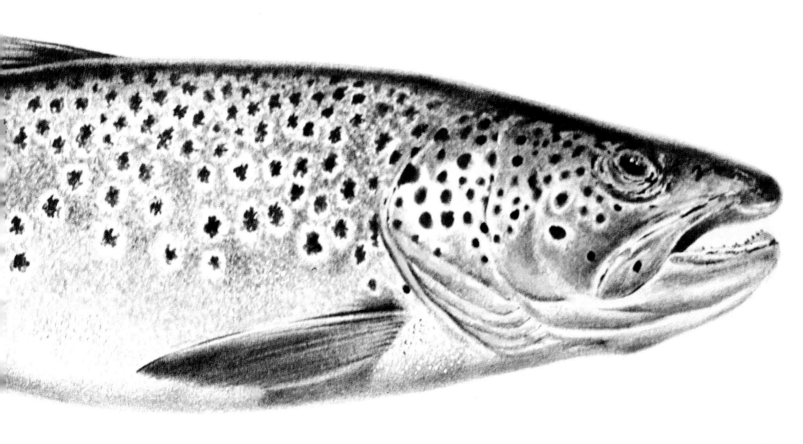

Dartmoor cannibal

that required inside information and, that being the case, a trap needed to be set up. Robin's annual holiday was drawing closer, and by now word had been spread amongst the locals as to the dates that he would be away.

A team had been gathered by Malcolm Chudleigh and Brian Letts, both Fisheries Officers, to deploy wardens in teams of two at strategic points along the river, the strict brief being that we were to stay in touch by radio and, more importantly, to stay put so as not to warn the would-be offenders. The observations were to start on the day that Robin left and continue until either something happened, or until he returned. This was to be a night operation and by its very nature would be potentially frustrating for the wardens involved; it required patience and resolve.

It was into the third week before anything did happen, and then by luck more than good judgement we got our men! One pair of wardens had been positioned beside a small footbridge over a stream leading to the main river when, at first light, one of the wardens broke cover to investigate a noise he could hear from upstream. As he did so he was confronted by two men, both wearing waders and carrying black binliners containing salmon and sea-trout. The warden immediately radioed control and, although both men ran off, they had been recognised and were subsequently traced, interviewed and charged – the judge took a dim view of what they had done and they were very heavily fined.

A Move to Powdermills

Our time at Laployd Barton was about to run out. The farm needed a full-time worker and I had been getting more and more involved in my art. Finding a farmworker was relatively easy. Bruce Clarkson, Ewan and Jenny's son, was looking for a job since he'd graduated from agricultural college and it would be an ideal place to start work. The trouble for Pat and I was that there was only one tied cottage on the farm and we lived in it with our new baby daughter.

Making way for Bruce, we decided our next move would be to the high moor. In the hope of finding a vacant property I went to see the Duchy Reeve in Princetown to ask if any of their properties would be coming up for rent. Sadly they had a full tenant list at that time but did suggest that I had a word with one or two of their tenant farmers, to see if there was any chance of renting an empty building.

Les Russell rented Powdermills, the newtake, the farmhouse and the farm buildings that went with it, from the Duchy of Cornwall estate. Les was a colourful character who didn't suffer fools gladly but was nonetheless very fair, provided that people were direct and honest with him. It transpired that he did have a vacant house – the farmhouse at Powdermills. He wasn't sure how much rent he wanted, but looking me up and down said 'whatever it is, I don't suppose you'll pay it.'

Male blackbird

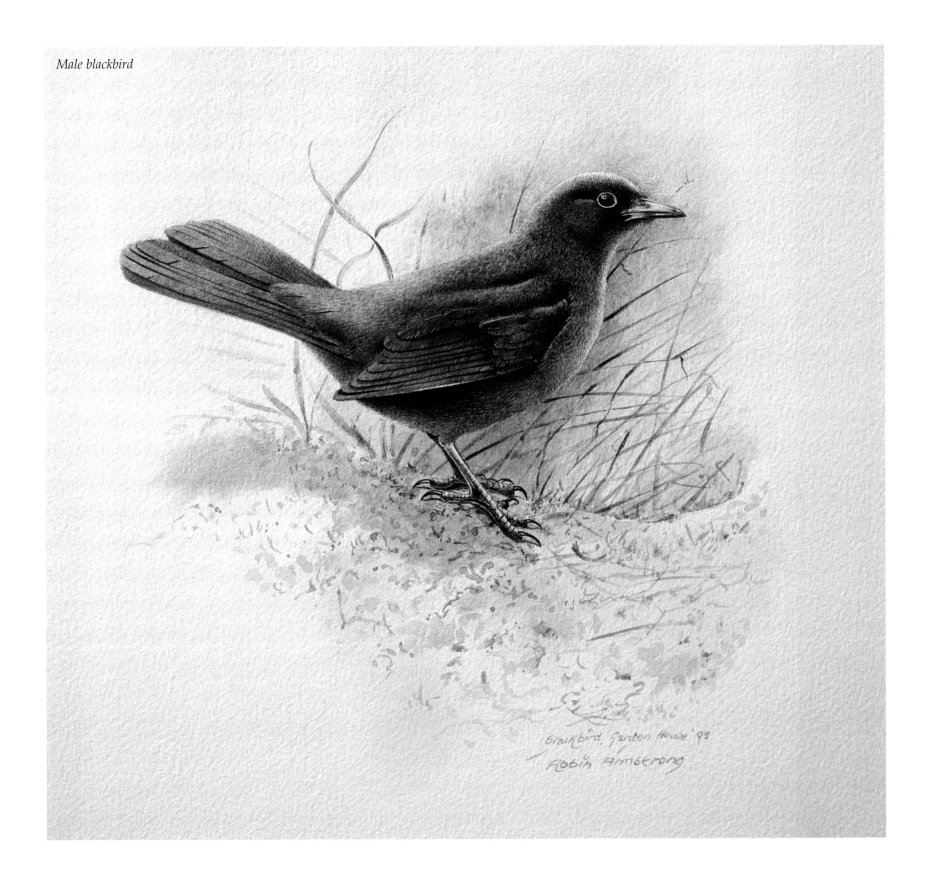

Blackbird, Garden House '95
Robin Armstrong

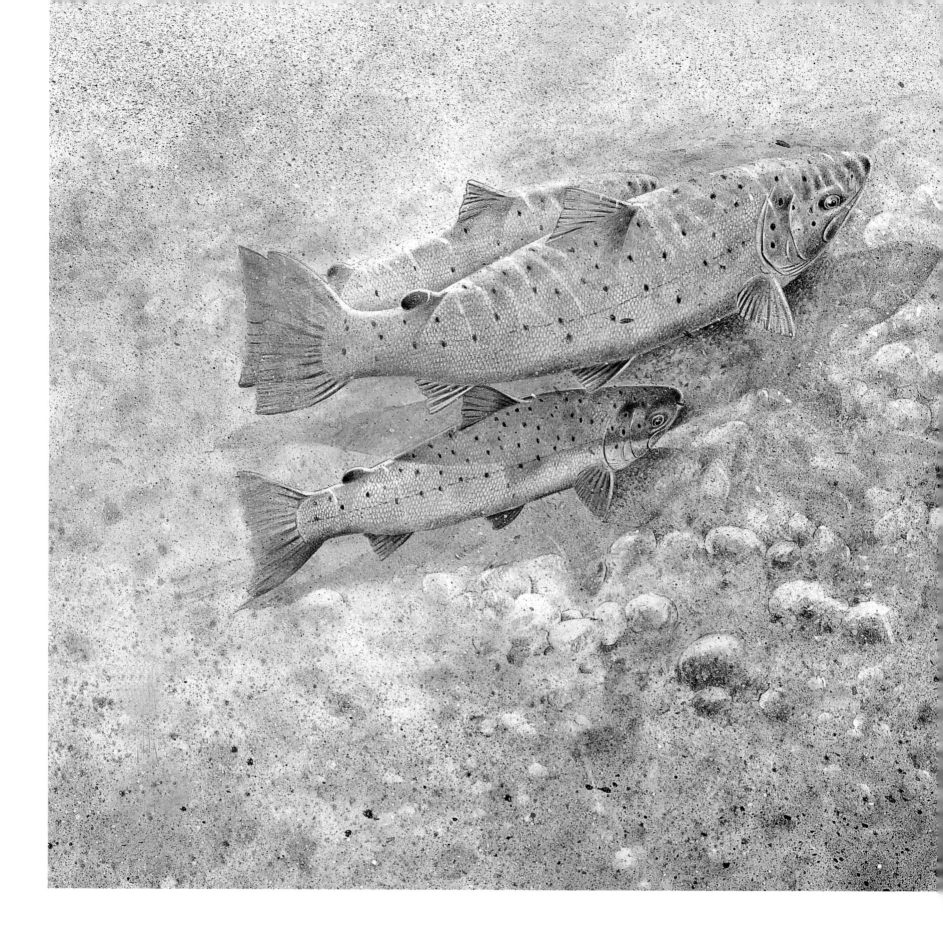

© Robin Armstrong

I had earlier that day been to a friend's funeral and my only suit was a light blue pin-stripe with flared trousers and a waisted jacket. Add to this my shoulder-length hair, gaucho moustache and platform shoes, and Les must have thought he'd been confronted by an alien. In any event we settled for four pounds a week.

The early days at Powdermills were heady, but although the summertime was hot, the living was far from easy. It's always been a precarious job being an artist. Sometimes it's good and sometimes it's bad, and unless you are either very lucky or have a superb business brain it tends to be the latter. Nonetheless painting and drawing has always been much more of a compulsion than anything else, and so I continued to paint the subjects that I enjoyed studying around the Dartmoor rivers.

Sea trout off the tide

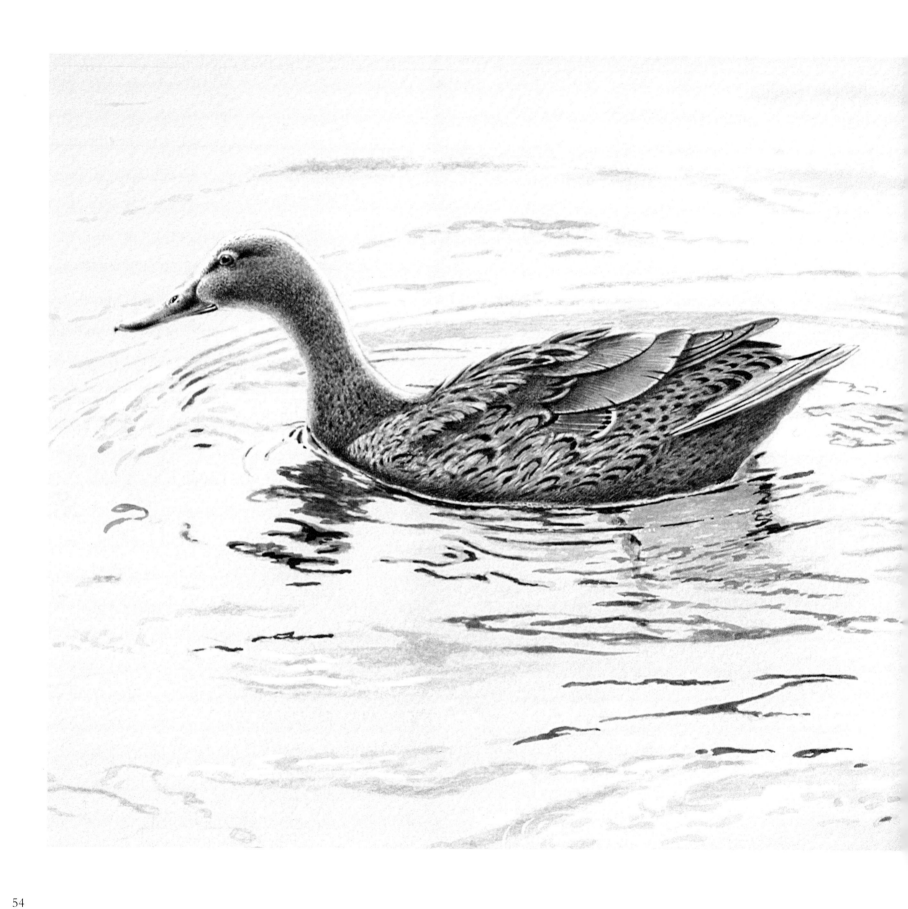

Mallards are without doubt my favourite ducks. Common and successful as they are I never tire of hearing their gentle quacking and squabbling as they go about their business outside the studio at Lopwell.

Last year we had a female sitting on fourteen eggs just a few yards from the studio door, despite all the comings and goings of the public, she managed to hatch all fourteen. Sadly however, many perished soon after, mostly due to predation by crows. Undaunted, she reared another brood in a nest not twenty feet away from the first. This time she was successful in rearing all nine of her second brood.

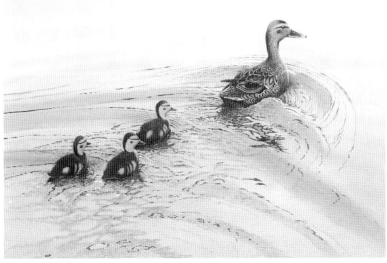

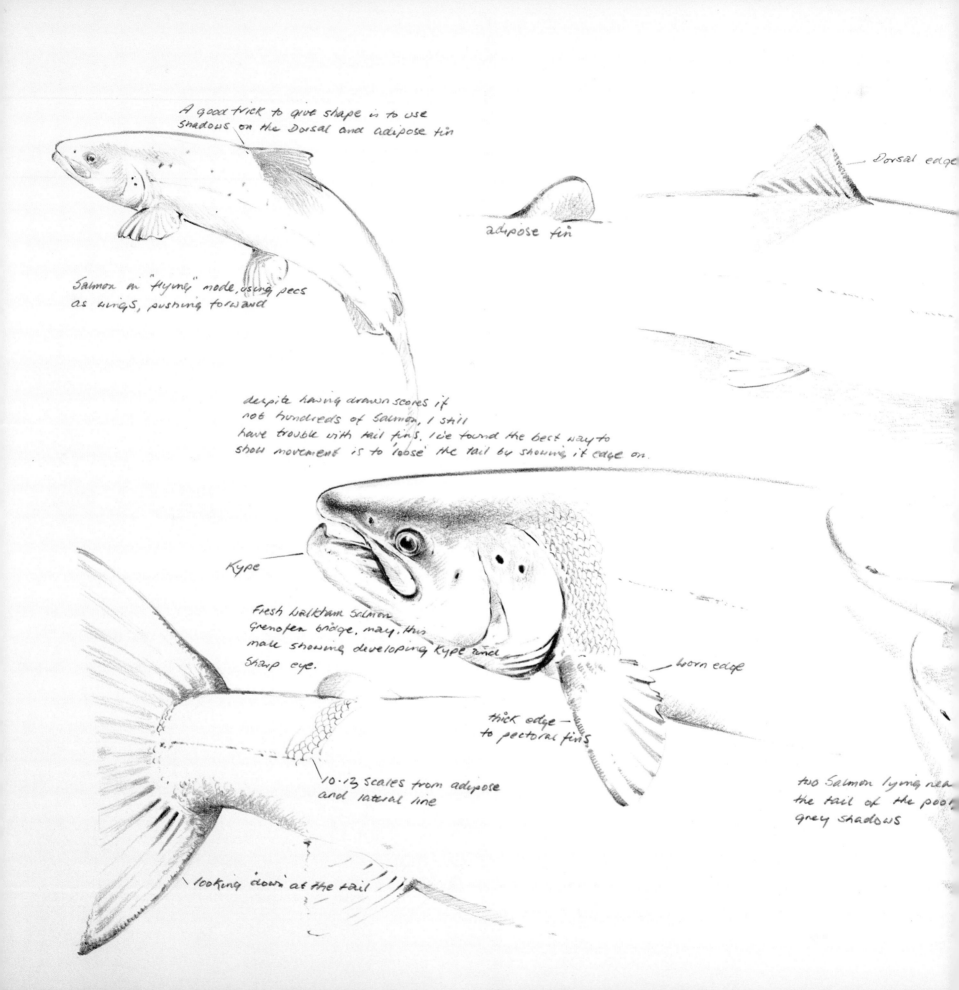

A good trick to give shape is to use shadows on the Dorsal and adipose fin

Dorsal edge

adipose fin

Salmon in "flying" mode, using pecs as wings, pushing forward

despite having drawn scores if not hundreds of salmon, I still have trouble with tail fins. I've found the best way to show movement is to 'loose' the tail by showing it edge on.

Kype

Fresh Waltham salmon Grenofen bridge, may. this male showing developing kype and sharp eye.

worn edge

thick edge to pectoral fins

10-12 scales from adipose and lateral line

looking 'down' at the tail

two salmon lying near the tail of the pool grey shadows

thick

Good Spawning gravel
at the tail of Grenofen
pool

Close up of eye

We had very little furniture in those days and what little we did have was hand-me-downs from my parents or from friends. I did have one or two generous patrons and a good gallery in Moretonhampstead run by a man called Terry Tilson Chown. Terry did well for me and produced my first ever print. It was printed by a firm called Cotswold Collotype using a very traditional and expensive method of reproduction; the result was superb and well worth the effort. The painting itself remains as clear in my mind as though I had finished it yesterday, the subject being an otter, sitting with its head raised and peering at two damselflies, with a foxglove in the background. The foreground was a stony spit on the Cherrybrook, with all the stones carefully worked in minute detail. I painted a broken beer bottle that was part buried in the sand with some of the label remaining.

Salmon studies

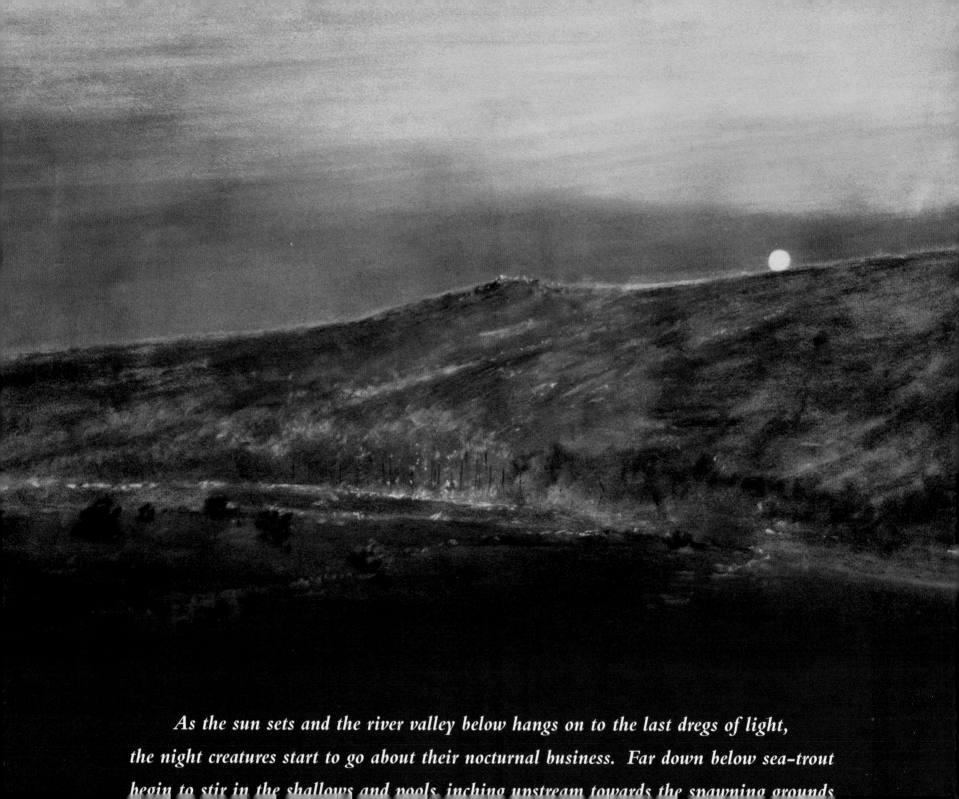

*As the sun sets and the river valley below hangs on to the last dregs of light,
the night creatures start to go about their nocturnal business. Far down below sea-trout
begin to stir in the shallows and pools, inching upstream towards the spawning grounds.*

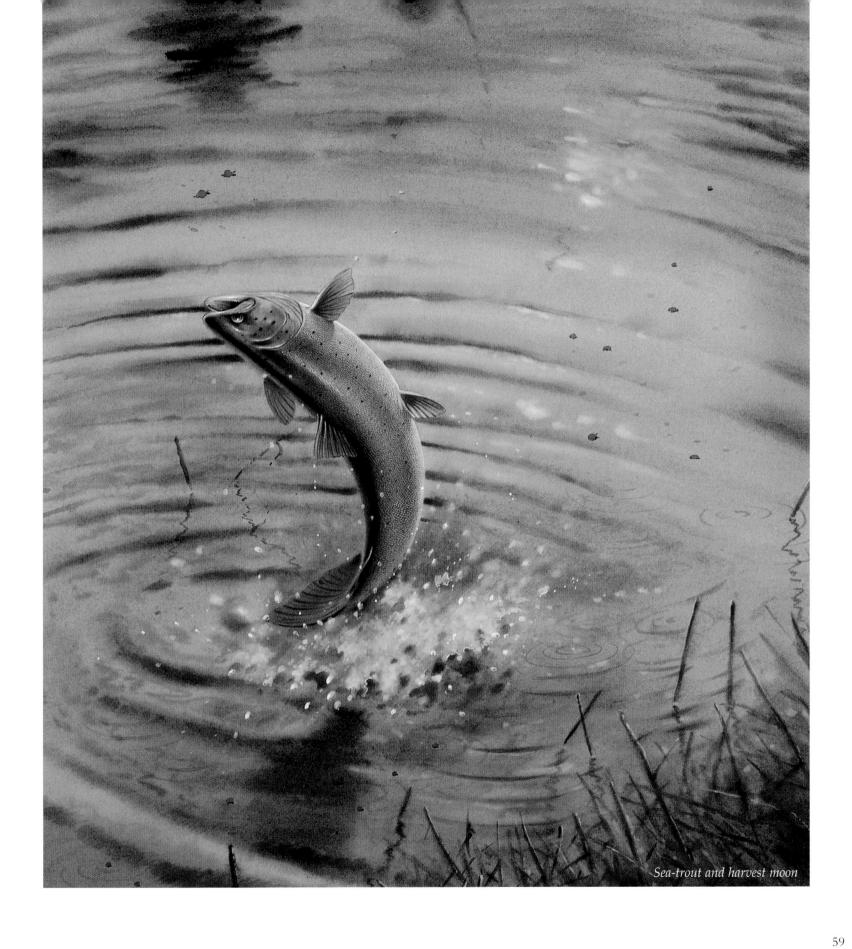

Sea-trout and harvest moon

As the little stream wanders out of the forest and into the daylight, life begins to stir

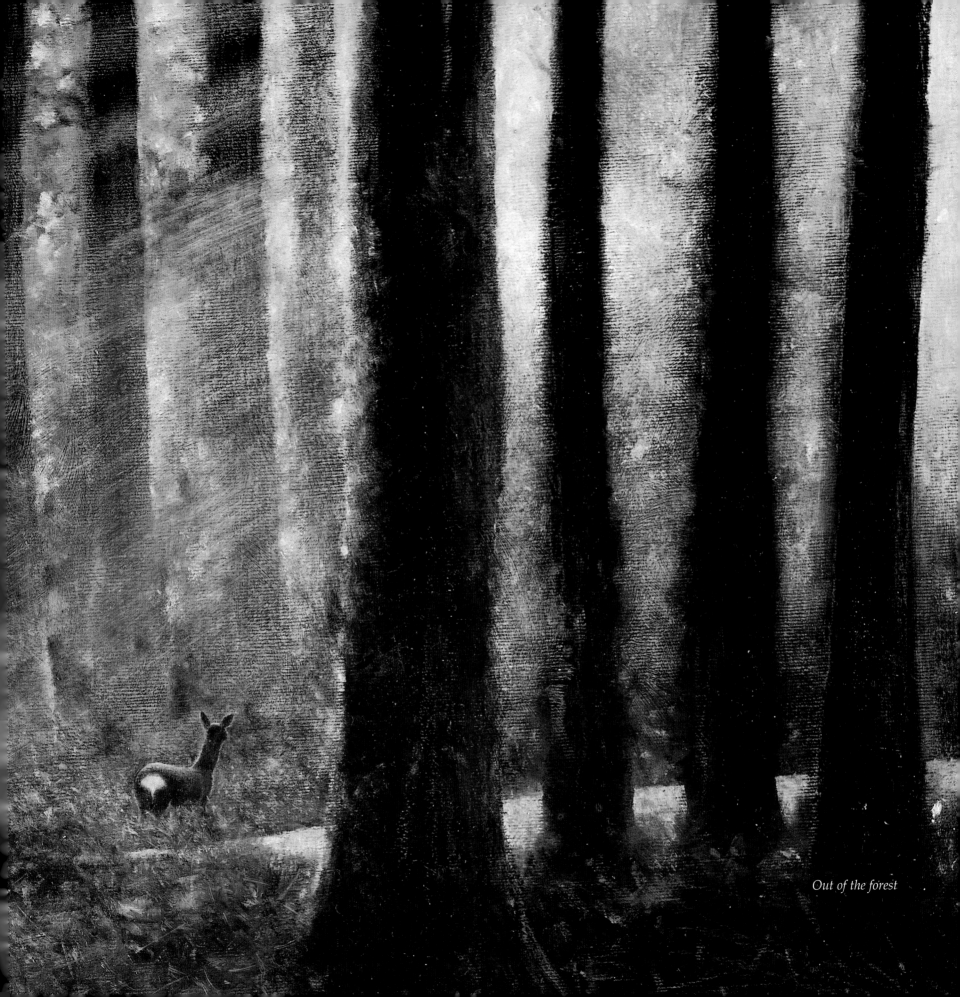

Out of the forest

At first glance, one could be forgiven for concluding that the artist was making a visual statement about litter pollution, and indeed I have done so on many occasions, as have others (I recently saw a photorealistic painting of two tiger cubs bathing, with a cocoa-cola bottle floating between them!). But this time I was making a statement of grief. My father had died a few months before I did the painting, finally succumbing to a long-term and bravely-suffered heart condition. His life had been full, with four children for whom he had worked very hard, but somehow I always got the feeling that he was a frustrated countryman (a feeling, perhaps, passed on to his son!). He loved the hills of his native Northumberland, so as a small tribute I painted parts of a Newcastle Brown beer bottle label and, as a thankyou to mother nature, included a carefully depicted foxglove, from which digitalis is derived, a drug which kept him with us for as long as it did!

Our life on the moor at Powdermills, provided the weather was good, was enviable, apart from the lack of money. Although by no means a commune, there were quite a few artists, sculptors and writers living alongside those who farmed the moor. We would help with the hay at Beardown, listen to music and create our own visions. We weren't dropouts, merely individuals who had decided that the rat-race was not for them. Having now honed my rabbiting skills to perfection I could contribute considerably towards the food supplies. I'd sold my shotgun, but with a couple of ferrets, my whippet Blue and my lurcher Bridie, few rabbits got far from the ditches and hedgerows from which they were flushed.

Blue was a wonderful dog. I acquired him as an eight-week-old pup from a prison officer in Princetown. Although he was a pedigree, he would not have made a show dog because he grew too tall for the UK breed standard and because he had a funny little kink in his tail. Neither of these faults mattered to me. In fact his increased size meant that he was better able to deal with the terrain on the moor as he was 23 inches at the shoulder, which is about 2 inches over the standard.

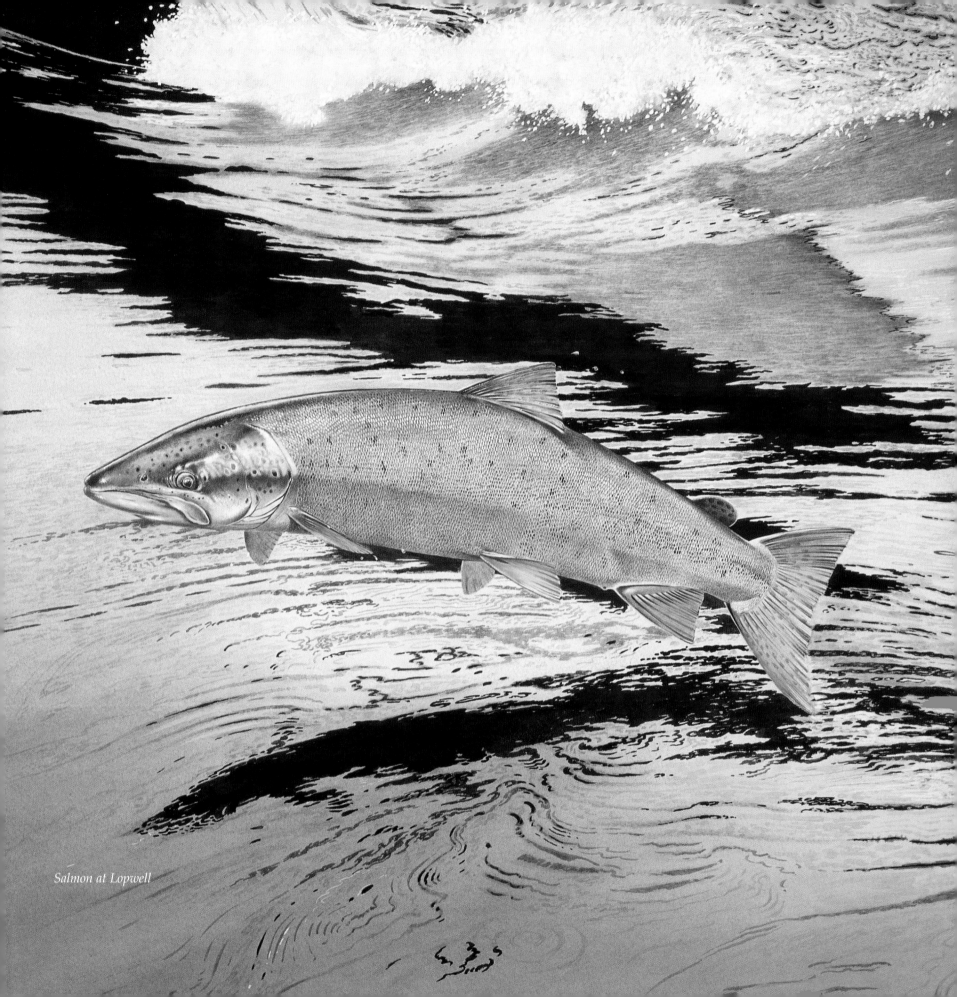

Salmon at Lopwell

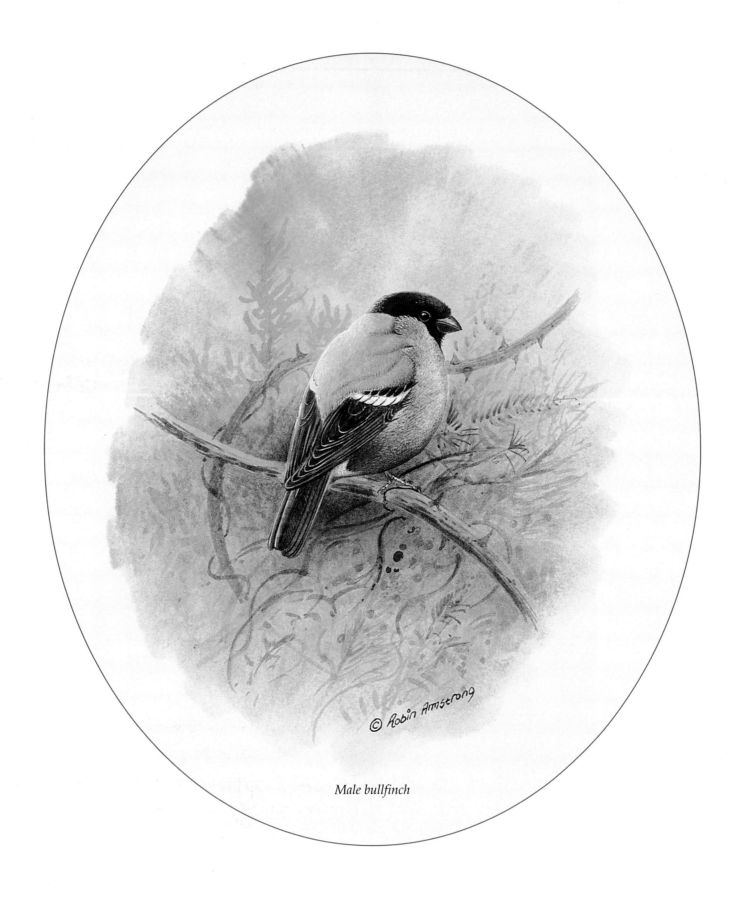

Male bullfinch

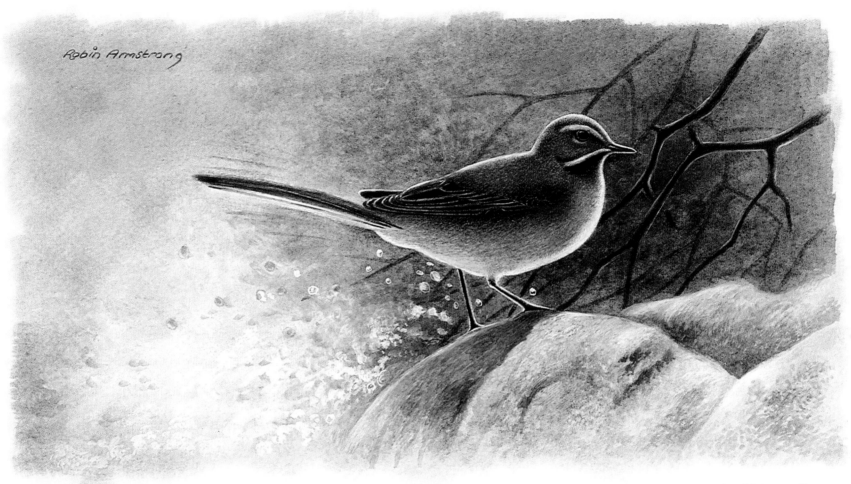

But when he was muscled up and groomed he shone like a star. As his name suggests he was a uniform blue-grey with just a hint of white on his chest and paws. Blue was my constant companion and lived until he was fourteen, well into my time as a river warden.

Bridie was a different kettle of fish; we had rescued her from a dirty back yard in Plymouth where she had been tied up for 24 hours a day. She must have driven the neighbours mad because when we got her, her voice box had been surgically removed and the only noise she could muster sounded like the cough of an old man with laryngitis. Bridie was, however, a superb hunter, she was first-cross greyhound-deerhound and about 26 inches at the shoulder; this made the going easy for her on the open moor. She was unstoppable once up to speed, but Blue could easily lick her over short distances, making him a better dog for hedgerow rabbitting. Bridie's coat was long and wiry like a deer-

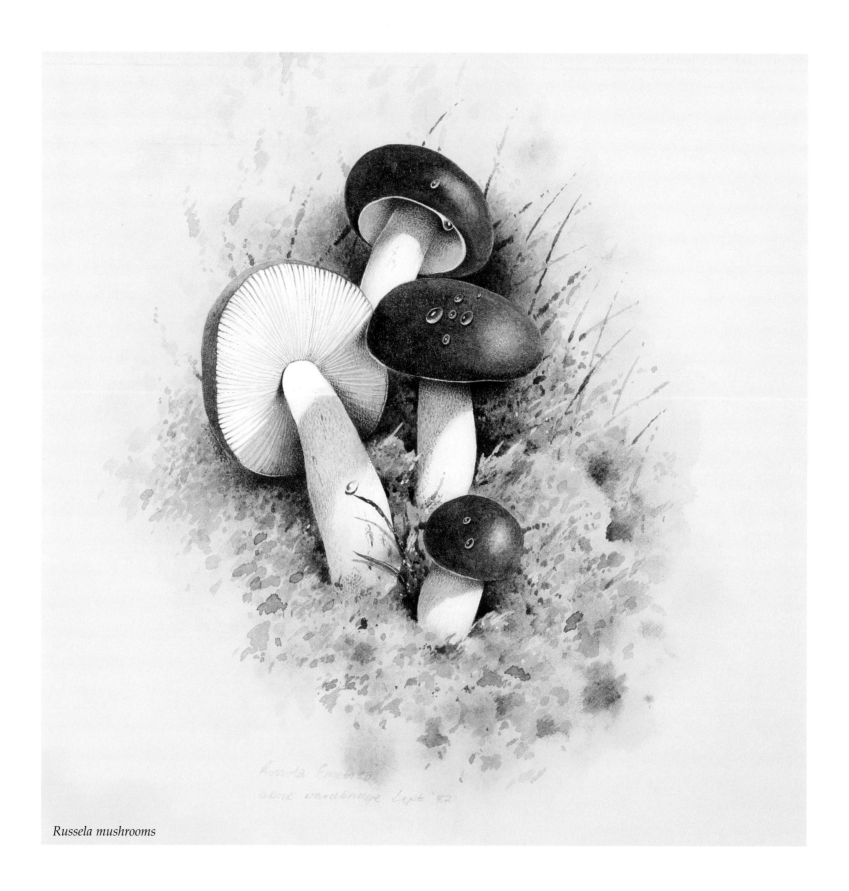

Russela mushrooms

hound and her character was larger than life – she could steal a leg of lamb without you noticing even if you were standing beside it! While her table-manners were appalling, at the same time her charm would shine through those big doleful eyes. I remember on one occasion when Chris Chapman, the photographer, was living alongside us at Powdermills, Bridie had sustained an injury to one of her paws and so Chris and I took her to see Bob Piggott, the vet in Moretonhampstead. Bob put his hand on her leg and she coughed; it's surprising how intimidating that little sound could be, and so taking no chances he muzzled her with a loose bandage and asked his veterinary nurse to look after the front end whilst he did the examination at the back. The nurse and I steadied her in front, and Chris took photographs with his old brass Pentax. The resultant picture became one of Chris's seminal photographs, and Bridie's portrait, along with that of the veterinary nurse, can be seen in the wonderful book *Wild Goose & Riddon* that was published in 2000.

Moorland Characters and Fishing

Some years before I had met and struck up a friendship with Taff Price, the famous fly-tyer. In the early days at the flat Taff would often come down and stay at the White Horse pub in Moretonhampstead. It was while I was living in the flat there that I illustrated his first book, *Lures, For Course, Game and Sea Fish*, and he had constantly to chase me to get the work finished, because line drawing has never been my strongest discipline, but finish it I finally did. When we moved to Powdermills, Taff would come and stay with us because there was plenty of room. One of his passions was the pioneering of macro-photography, capturing images of the thousands of different aquatic creatures that the angler uses to create artificial flies in order to fool the fish. I remember that at one stage the dining room was converted into a full photographic studio, with an aquarium, strobe lights, the lot.

The main pursuit of course was fishing. We'd fish the Dart, the Cherrybrook, the Teign and the Exe. I'd introduced Taff to an old wag, Phil Seppings, and they hit it off immediately, a friendship that lasted until old Phil died in the late 1980s. We would go off, the three of us, to a stretch of water and subdivide it into three, meeting at a given point for lunch. Just like a scene from the 'Last of the Summer Wine', we would amuse and rib each other over the silliest things. Because I was the youngest I would often bear the brunt of these antics, but I did enjoy it! Taff introduced me to several people who became friends, and at least one who didn't!

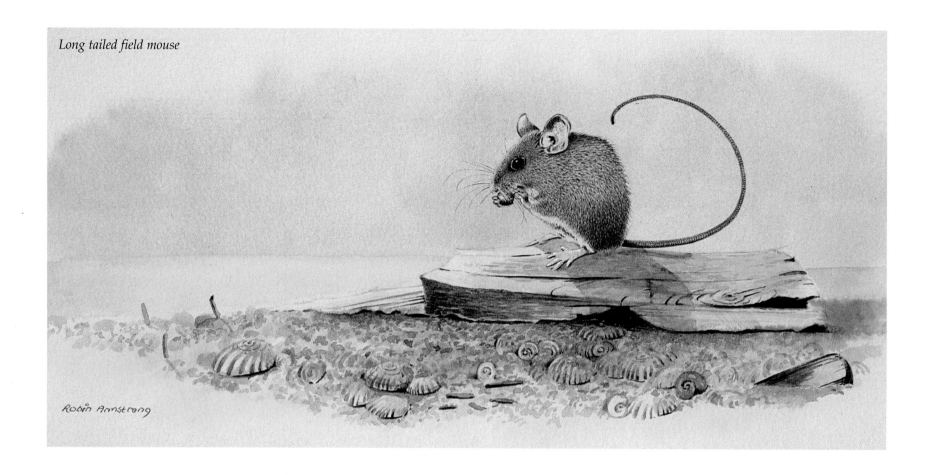

Robin Armstrong

Ivan had been the best man at Taff's wedding. He was not a fisherman, but nonetheless quite fancied a few days on Dartmoor whilst their respective wives went off on a holiday to the sun. They arrived on the Friday intending to stay until the middle of the following week. Ivan seemed a pleasant enough chap, although I did think that he looked a bit 'towni-fied' for the kind of capers that we were likely to get up to at Powdermills. On the Saturday, after a few pints at the Warren House Inn, they decided that they wanted to go rabbitting. I didn't think that this was a great idea, the dogs had been fed and the ferrets hadn't. Finally I agreed to give it a go, so the three of us headed off, along with the dogs and ferrets, towards the Cherrybrook Hotel, where John and Susan Reynolds, who ran the hotel, used to let me ferret the hedges around the property. I had two ferrets, one was Nipper, a lithe and pretty little pink-eyed bitch, and the other one was a big black dog fitch called Otis. I say black, but he was black around the face just like a polecat, and part-coloured elsewhere. Otis was mean and several times had clamped on to Bridie's nose when she pushed her luck too far. Handling him was like playing Russian roulette; if I got it right I could distract him with my left hand and then smoothly grab his neck from behind with my right, if I got it wrong, then ouch! He would connect with those razor sharp canines like greased lightning.

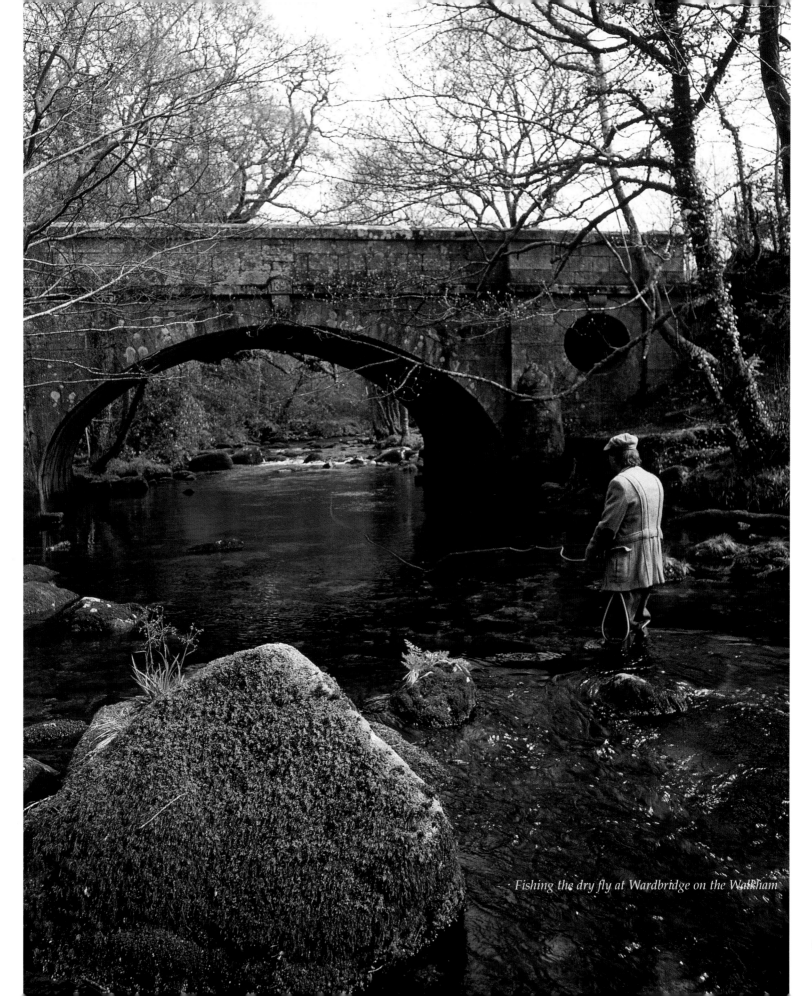

Fishing the dry fly at Wardbridge on the Walkham

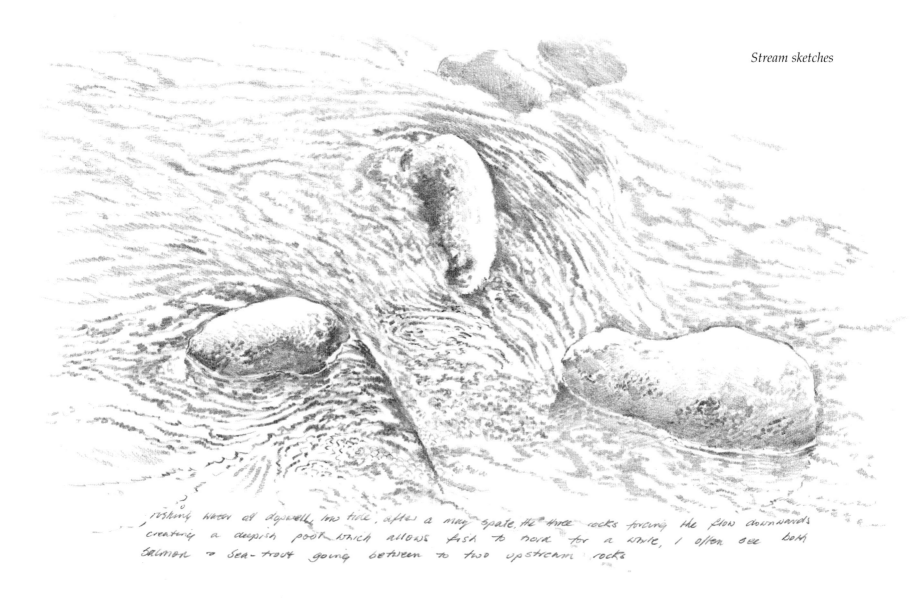

rushing water at dogswell, low tide, after a may spate, the three rocks forcing the flow downwards creating a deepish pool which allows fish to hold for a while, I often see both salmon + sea-trout going between to two upstream rocks

When we arrived at the top field gate, I tied up the dogs so as not to disturb the area and alert the rabbits. Putting down the ferret box I told Taff and Ivan to stay by the gate while I did a little recce to find out if the burrows were in recent use. There are several ways of doing this, but the easiest is to look for fresh droppings. It wasn't long before I found the evidence I was looking for and so I suggested, as neither Taff or Ivan looked in any way keen to handle the ferrets, that they each take a dog and wait for me to shout when I'd seen a rabbit bolt. One side of the field had a 200 yard run before the next hedge burrow, and the other side was open moorland. I knew that neither of my dogs would have any difficulty with this set up. I took Nipper from her box and popped her into a little bolt holt five yards inside the gate. She was a quick mover and it wasn't long before I heard the double thump as a rabbit banged its back foot to warn the rest of the warren of impending danger.

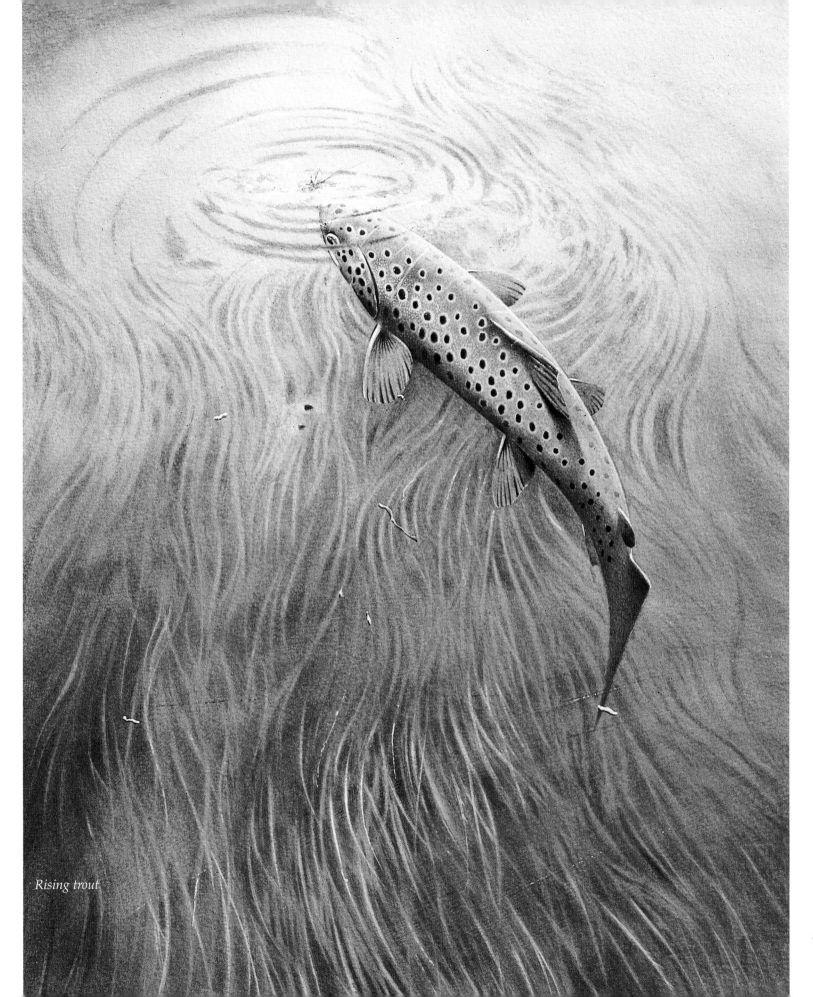

Rising trout

Kestrel

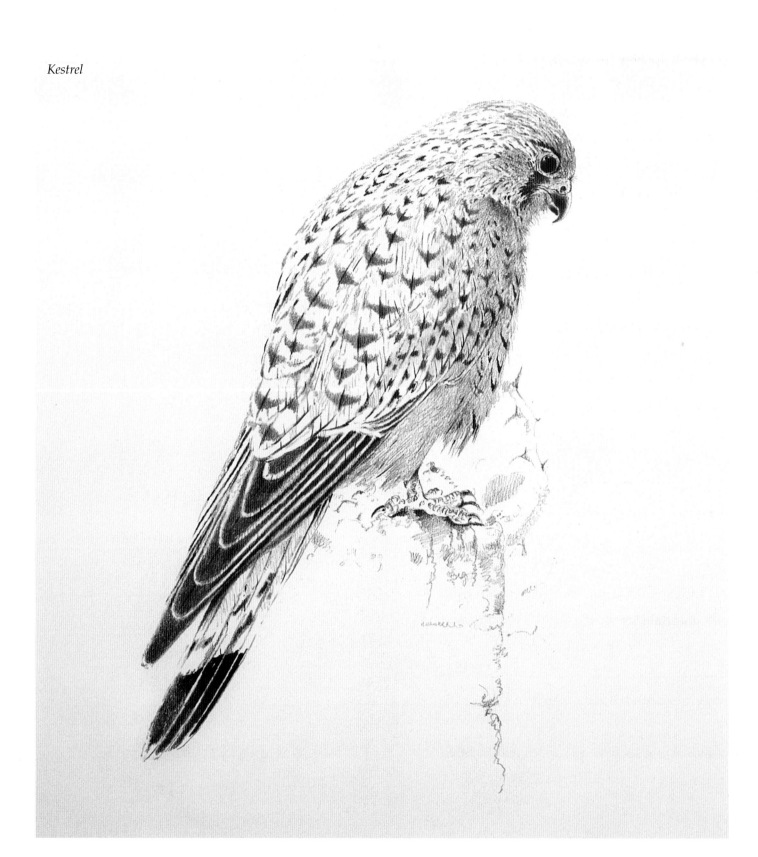

The first rabbit to show torpedoed from a little bolt at the top of the hedge, landing in full stride and shooting off towards the downside hedge. Taff had Blue and I yelled at him to let him go, he fumbled with the quick-release collar and away he went. I looked over my shoulder to make sure that Ivan had Bridie in check and to my horror saw that he had unleashed her too. I knew my dogs well enough to know that if they were both on to the same rabbit a collision was almost certain, and that this usually ended up with one or other of them, or even both, sustaining an injury, and I couldn't afford this to happen. Blue was almost on the rabbit when Bridie arrived on the scene; she stooped to beat him to the punch and they collided almost head on sending them both cart-wheeling out of control, leaving the rabbit almost casually to escape into the first available burrow.

Fortunately both dogs were unhurt and none the worse for the experience but I did point out to Ivan, and in no uncertain terms, that he'd been stupid to release the dog without my say so and that it could have ended in tears. It was then that I discovered that friend Ivan was of hot-blooded Italian descent. He made several gestures towards me and the dog, barking several phrases which sounded considerably uncomplimentary! I gathered the dogs in and re-leashed them, this time giving Bridie to Taff. As I turned to hand Blue over to Ivan, I saw him standing

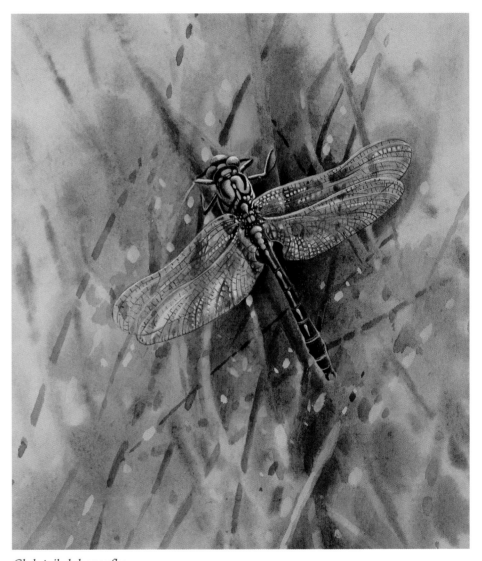

Club-tailed dragonfly

73

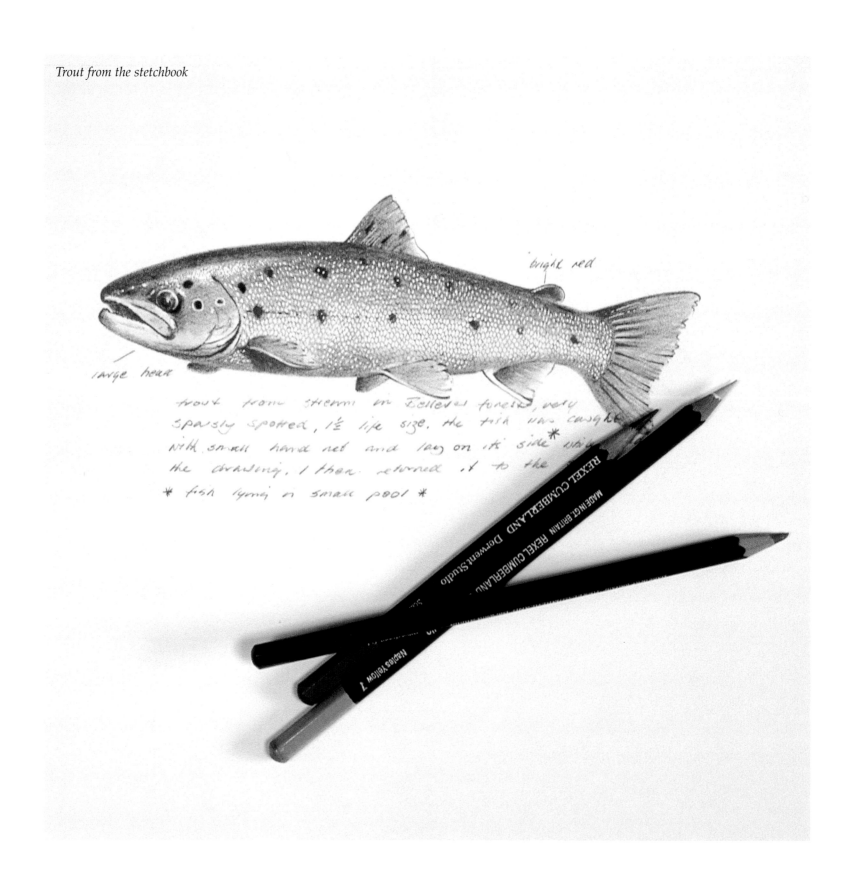

'bright red

large head

trout from stream in Tolleval forest, very sparsly spotted, 1½ life size. the fish was caught with small hand net and lay on its side whi* the drawing, I then returned it to the

* fish lying in small pool *

on top of the hedge with a mushroom in his hand shouting 'Porcini Porcini'. Taff said 'Oh dear, I should have warned you, he'll be rooting around all afternoon for those things now that he's found one; they are a great delicacy in Italy you know.'

I didn't know and I didn't really care. What I did know was that Ivan's antics would certainly have sent every rabbit in the neighborhood burrowing as deeply as they could go. By this time Nipper had finished in the top hedge and was dallying around by the ferret box, so I picked her up and put her back into her half of the double-compartmented box. I had decided a move to the next field, a better option than wasting our time on the disturbed burrows. We walked over to the next field and again I gave Taff and Ivan a dog each, and this time I got Otis from the box and took him to a bolt hole halfway down the hedge. I knew he was agitated because he was making that chittering sound that ferrets do, so I was quite glad when I released him and saw him go below. Almost immediately a big buck rabbit came storming from the hole that Otis had entered and tore off on to the open moor. I shouted for Ivan to let Blue go and nothing happened, Ivan was grubbing around in the hedgerow for *Boletus edulis* and Blue was tied to the gatepost. By this time the rabbit had disappeared into the first clitter of rocks and was home and dry, so I suggested to Taff that if things were going to continue like this then we would be wasting our time; he nodded in agreement. At this point another shout went up and Ivan lifted another mushroom in triumph above his head. As he did so Otis appeared from a hole just by his right foot and immediately clamped on to the toe of his trainer. With a blood-curdling scream Ivan took off toward Powdermills with the ferret hanging on for grim death. Ivan was shouting 'Call it off, call it off,' but sadly ferrets don't usually respond to words of command and, even if they did, I suspect that old Otis would have ignored it!

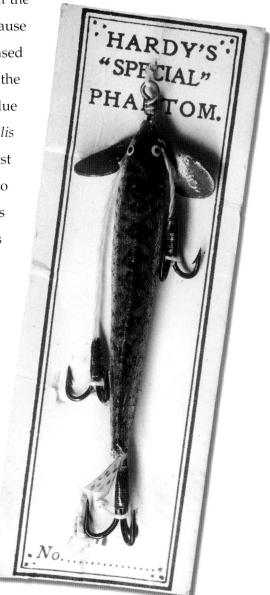

Ivan and Taff left the next day, calling into Moretonhampstead Cottage Hospital on the way to update Ivan's tetanus cover.

Our neighbours were Paul and Pippa Caton, an easy couple to get along with. Paul was a sculptor and had his studio next to the farmhouse in an old converted garage. Although we didn't live in each other's pockets, we saw each other daily, often sharing tea and coffee breaks and exchanging notes and musings about what was

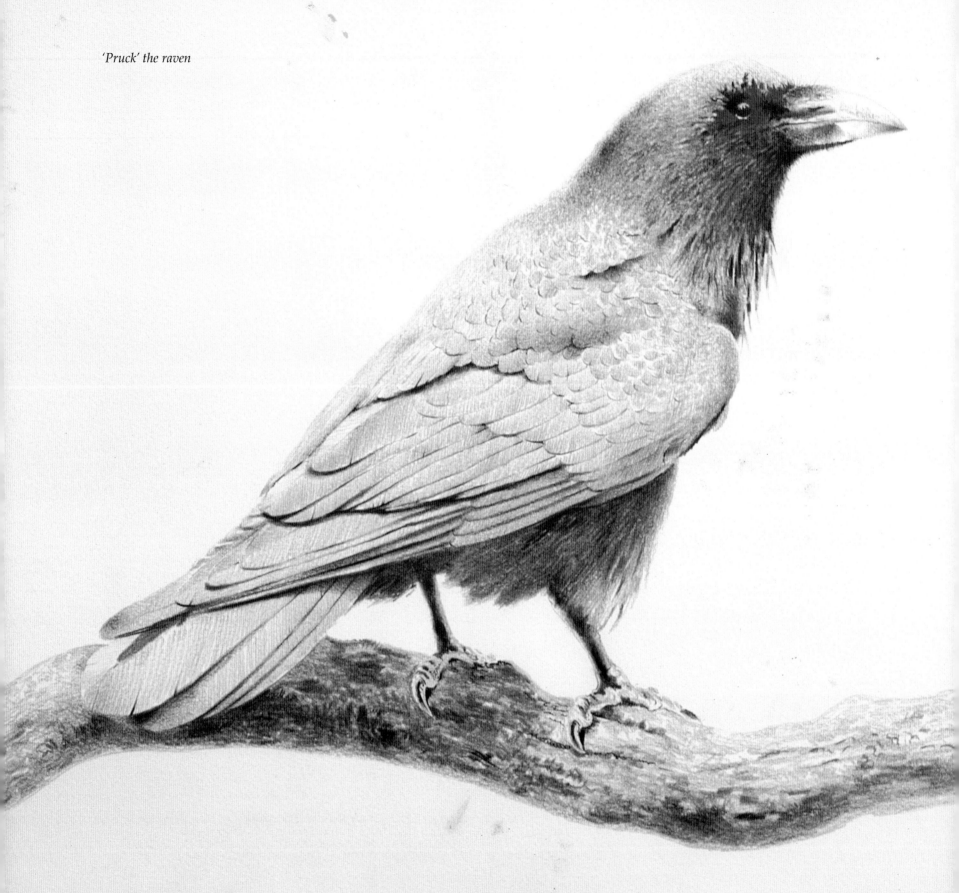

'Pruck' the raven

going on at the farm. We would often help out with the cattle, especially when they were being moved to and from the newtake, and we did quite a lot on the survival front together, including rabbitting and tending the night lines.

One afternoon in an early spring, Paul appeared at the back door and sitting in the palm of his right hand was quite the ugliest critter you could imagine. Telling the tale, Paul explained that he had been for a walk upriver and on his way back had come over the back field where, underneath a stand of Scots pine, he had found this creature.

My years as a birdwatcher had stood me in good stead and I knew it was a fledgling crow of some kind, in fact knowing that a pair of ravens had nested in one of the pine trees allowed me to conclude that it was indeed a raven chick. It must have fallen from the nest, perhaps during one of the frequent storms that raged at that time of year. There was almost no chance of returning it to the nest because, although Paul was a very accomplished climber, there were almost no outriding branches on the tree and the nest was eighty feet up!

'I'll rear it,' said Paul. 'It'll be company for me in the studio.' Reserving my opinion, I nodded.

'Pruck', as he was christened, was one little eating machine; nothing was refused! In the wild ravens will eat just about anything, relying mainly on carrion such as dead sheep or cattle, but they will also eat worms and other insects, plus the eggs or young of other birds. It wasn't long before little Pruck was not so little anymore; his feathery whisps were quickly replaced by spiky blue quills, and both his beak and feet seemed to grow out of all proportion to the rest of him. Within a few weeks he was fully fledged with a wingspan of five feet, a bill like an anvil, and a pair of artful beady black eyes. His gentle little 'pruck', from which he was named, had turned into a fearsome 'gronk'.

They say you can teach ravens how to do tricks, and this may well be true, but one thing you didn't have to teach him to do was to steal; nothing was sacred. He would nick anything that took his fancy, usually small brightly-coloured things like Tammy's toys or my fishing lures, and the spoils would be taken back to his cache in the corner of Paul's studio where he roosted. There he would sit menacingly on his perch on sunny days giving us an occasional guttural 'croak' as if to remind us that this was his home too.

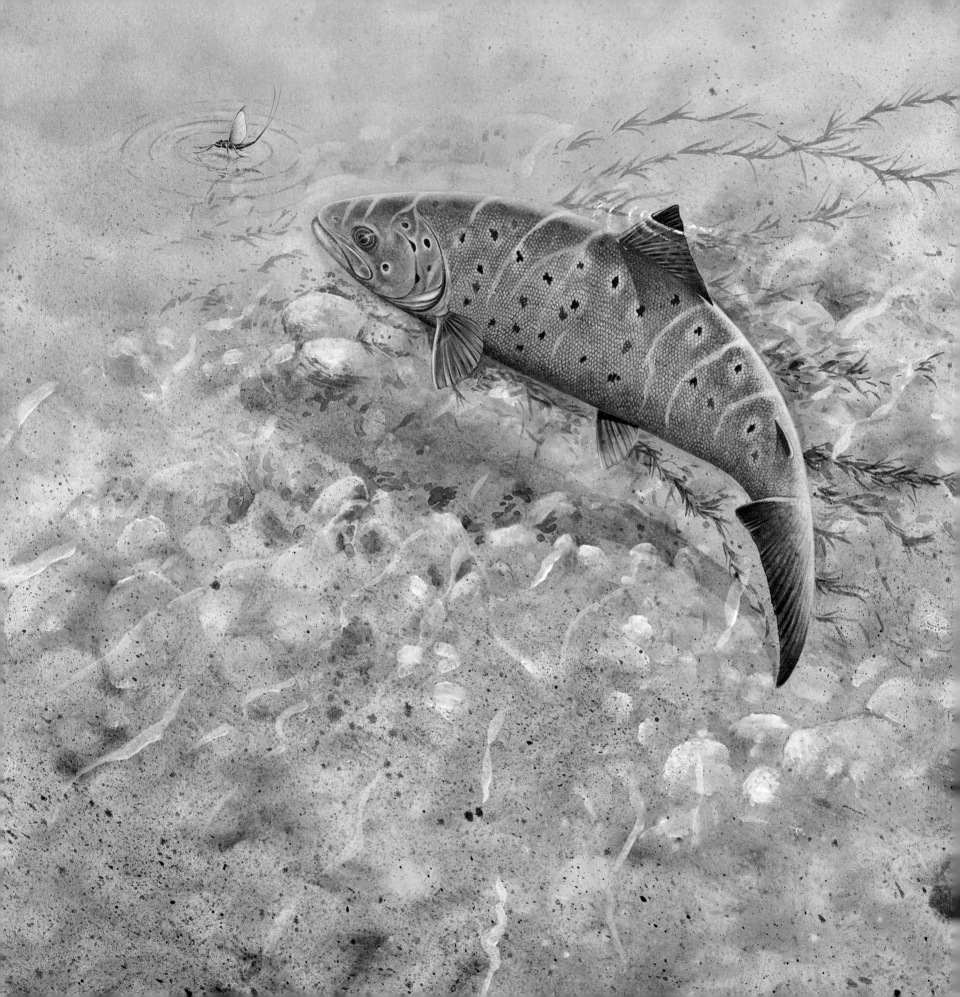

Country postmen and women were then a vital part of remote country culture. Long before the days of Consignia and job cuts, the postie would not only deliver mail but also often milk, eggs or sometimes just good wishes. Arthur Smith was our postie. Always happy and smiling was Arthur, even on the bleakest of winter days. That is, until Pruck became of age. All the time he was growing, Arthur would stand and watch in wonder at just how much food could disappear down that noisy little gullet – once he learned to fly however, Pruck suddenly became very territorial. He knew us all well and hardly ever bothered to acknowledge us, but for some reason known only to himself he didn't like Arthur.

It all started innocently enough, when it had been raining. The track down to the farm could be turned into a quagmire; on these occasions Arthur would leave his post-van at the main road and walk the couple of hundred yards or so to the houses. At first Pruck would give the impression that he was flying up to greet postie as he made his way down the track, and then the intimidation tactics were implemented. He started with low-level sorties and when Arthur was not looking he would land, usually on a gate post or whatever was to hand, and there he would fluff himself up and croak as loudly and for as long as he could. This went of for a while without much being said; one day however Pruck finally pushed his luck too far.

Cherrybrook brown trout

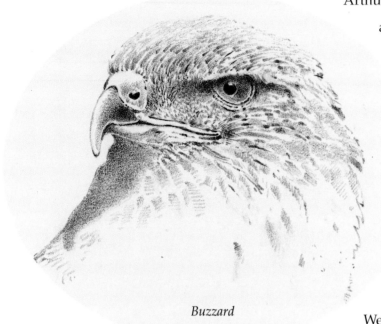

Buzzard

Arthur was walking down the track as usual and Pruck was already in the air manoeuvering himself into position for today's attack. As Arthur neared the house he swept up from behind and landed neatly on the poor man's head, delivering a single peck on the upper part of his forehead, before flying off croaking in victory.

I opened the door to see Arthur standing there looking shocked, a small stream of blood running from the neat hole in his forehead down his nose and dripping off the end. 'That's it,' said Arthur. 'I've had enough, either that bloody bird goes or you lot can collect your mail from the top gate.'

We invited him in and cleaned up his wound, promising that the raven would be found a new home. A few days and phone calls later saw Pruck on his way to new quarters at Bristol Zoo. I did go to see him once on my way north and I'm sure that beady eye recognised me! Ravens are reputed to live to a great age, so maybe he's still there today.

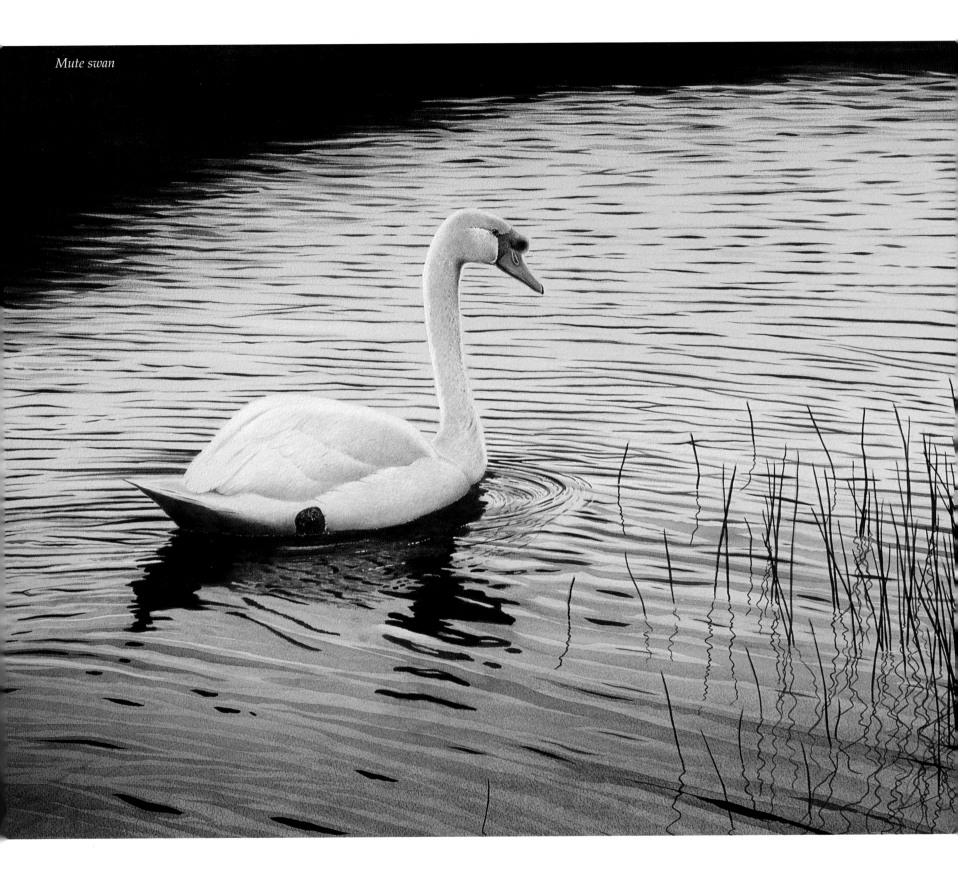

Mute swan

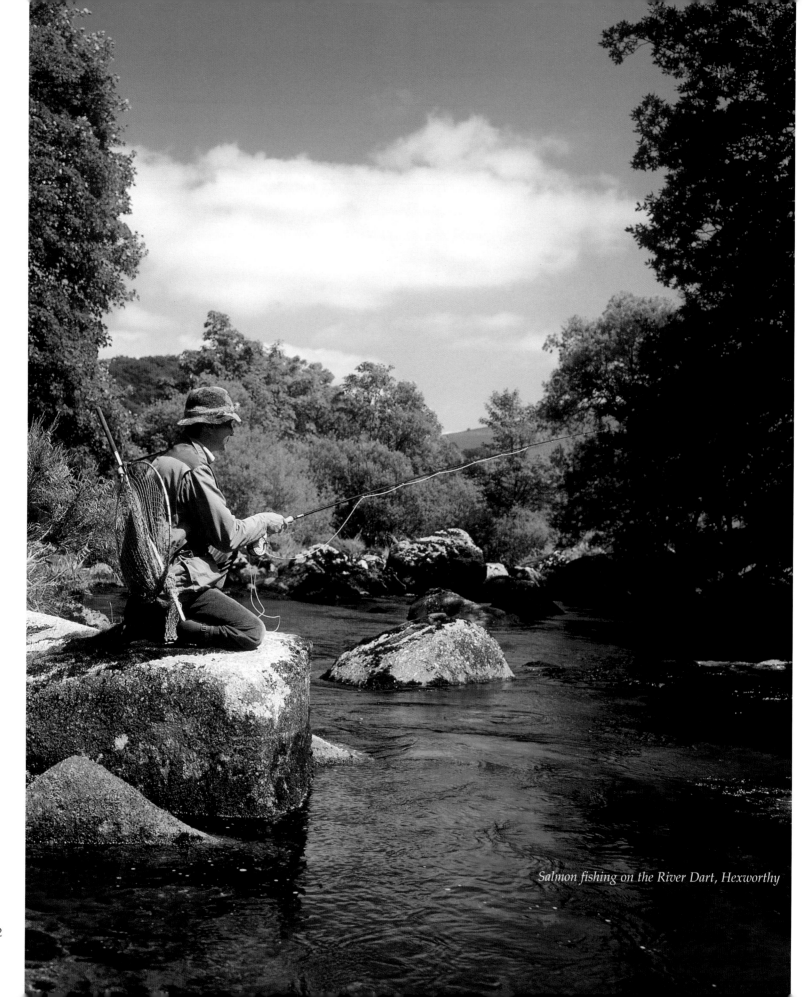

Salmon fishing on the River Dart, Hexworthy

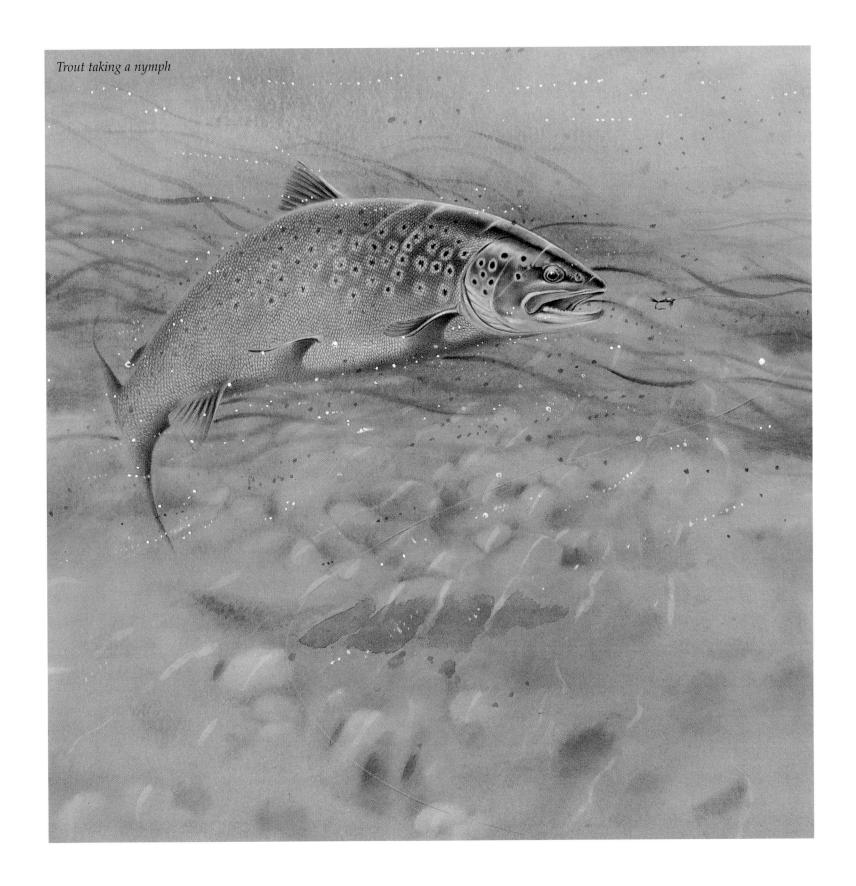

Trout taking a nymph

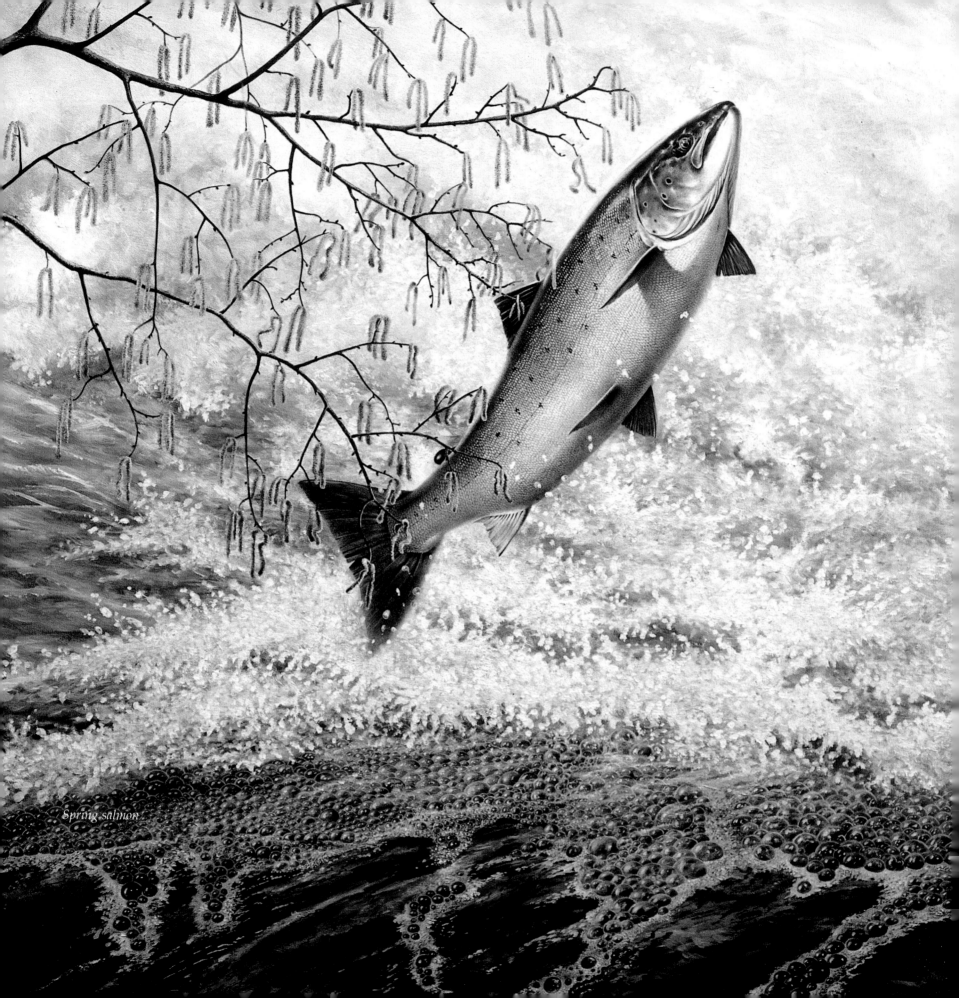

Spring salmon

Reading the River

I hinted earlier that my marriage to Pat was not to last, and it was the split that created the catalyst for us moving off the high moor; Pat had been missing her roots back in Bideford and I, if anything, was looking for an even more remote location to live.

I found Woodtown Cottage by way of an association with the art dealer Nick Skeaping, son of John, the famous equestrian painter and sculptor. Nick's partner Fanny had a sister who was moving out of the cottage imminently. I made contact with the landlord, Colonel Owen Collier, who put me in touch with his agent. Woodtown was much smaller than Powdermills, but it was tucked away on a wooded hillside, only yards from the River Walkham. As soon as I moved in it felt warm and cosy; the rent was reasonable and it was only a fifteen-minute drive to the market town of Tavistock.

Getting to know Colonel Collier was not all that easy at first; he was a relic directly from colonial days. Having spent time away in Africa building bridges he was steeped in army tradition and discipline but, as I was to discover later, he had a heart of gold beneath the façade, and as time went by we became good friends. His wife Frances would run the house like a dusty old hotel, and they would breakfast, lunch and dine, one each end of a huge dining table in the kitchen. Our only neighbours were an old couple who 'did' for the Colliers. The husband Charles worked part time in the garden and Louise, his wife, worked in the house. She was of Austrian stock and I nicknamed her 'Iron Girder'.

The Colliers were already in their eighties when I moved to Woodtown but were still very active. Owen Collier was very proud of the estate. He had installed his own water supply running off from a spring high up on a hillside opposite my cottage, and was almost paranoid about keeping the drop-off reservoirs clean and weed free. He walked the pipeline once every week come rain or shine, and would make notes about any areas that needed tending. The estate consisted of around 350 acres, most of which was either coppice or deciduous, with one clump of pines at the back of my cottage. You could stand in the garden and watch through the trees as the river glistened and tumbled on its way

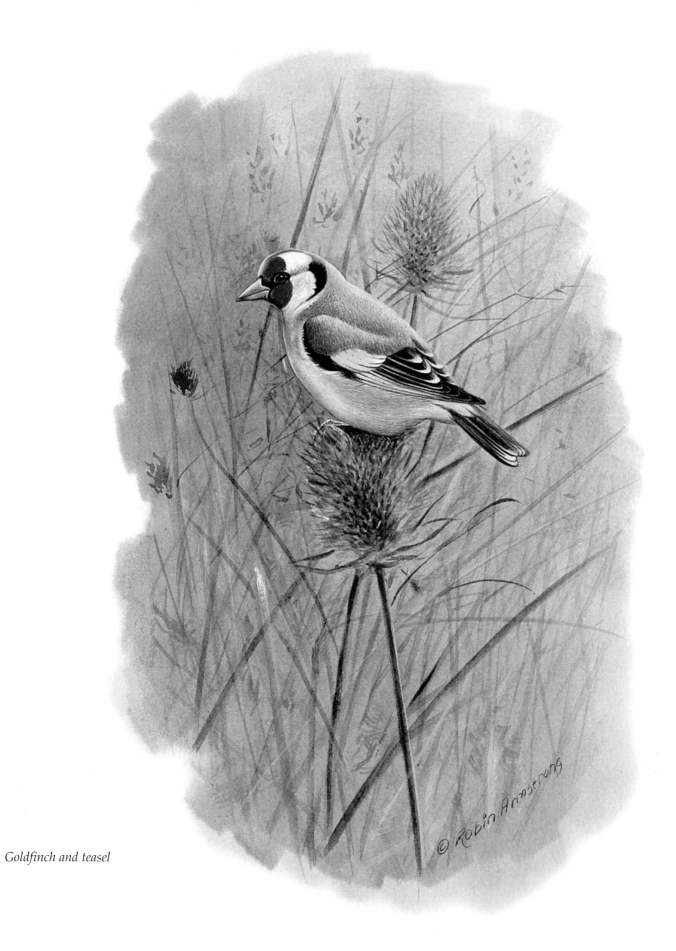

Goldfinch and teasel

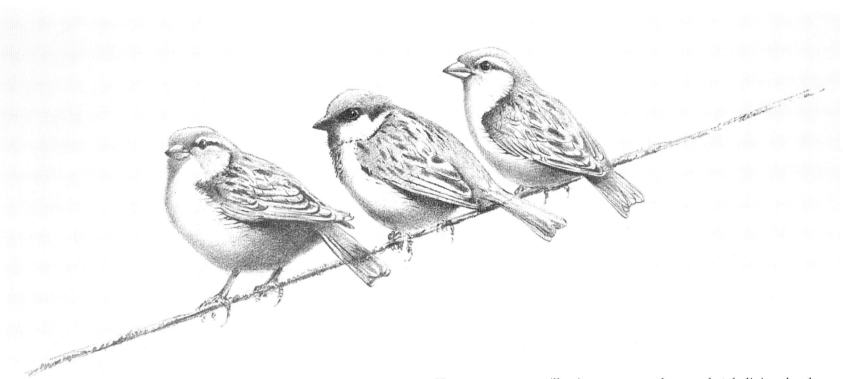

House sparrows are still quite common on the moor, but declining elsewhere

downstream; in all there was about a mile and a half of some of the best wild brownie fishing on Dartmoor, coupled with some of the best spawning grounds for salmon and sea-trout on the whole of the Tavy system. I was to get to know this stretch better than any other in my thirty or so years of studying Dartmoor rivers.

Almost as soon as I took up the tenancy of Woodtown Cottage, I wrote to Colonel Collier asking him for permission to fish. Everything had to be above board as far as he was concerned; he knew the river wardens well and so my days of trying the odd night line in order to catch a trout for the pot were over. It wasn't long before I too became acquainted with the wardens, and through that became one myself, firstly as an honorary warden and finally in 1977 a full timer. I have written elsewhere of my experiences as a poacher-catcher and so I won't dwell on it here, save to say that some of those experiences are inevitably linked with the subject of this book, so I make no excuses for including these.

Learning to 'read' rivers is a basic skill aspired to by all who would seek to fish, and also for that matter by anyone interested in wildlife in general. To know the pools and riffles, the undercut banks and where the tributaries join, arms us both as angler and wildlife watcher with much information about the likely places to find a good trout, or where you would

expect to find a dipper's nest for example; and I can tell you right away that the latter can sometimes be found in the most extraordinary and precarious places. One such example was at Wardbridge a few years ago. On the upstream side of the bridge stands an old crooked oak, with one branch that hangs down to about three feet off the water at its normal level. From somewhere high up in the tree, probably during a storm, part of a branch had become unshipped and had fallen down towards the river. Just before hitting the water it had become lodged in the last few fingers of the overhanging branch. At almost any time you would imagine that gravity would ensure that the fallen branch would continue its journey the couple of feet or so to the river. But no, it just stayed there gently bouncing up and down like a kid on a bungee line!

Part of the branch was covered in thick moss and lichen, dribbling off at one end, and it was here of all places that Mr and Mrs Dipper decided to build a nest and raise their brood. So certain was I that the clutch was doomed that I even considered poking the branch off with a stick before nest building had been completed so as not to waste the birds' time by allowing them to lay their eggs, only for them to perish prematurely. I decided in the end, and not for the first time, to leave nature well alone, and you can probably guess the outcome – the dippers not only successfully reared a first brood of four, but raised a second of three!

I told the Colonel about the dipper's nest which he would pass on his daily march around the estate. I knew it would interest him because we had once discussed getting old and he had said, 'things to see and things to think about,' had kept him

young, adding 'That's why the British are so good at building bridges.' He often called into the studio on his way home, stopping for a few moments to report on the dipper's progress. Having made his report he would always leave with the words, 'Must move on or she'll be sending out a search party; can't afford to lose the manpower back at base camp!'

Every week the Colonel would drive his old Morris 1100 into Tavistock for supplies. He had an account at Crebers and would get most of what he wanted, principally gin, from this timeless emporium. Frances loved the fact they had a huge pantry at the big house and it was often stacked right to the gunnels with every sort of gin you could imagine. Other calls in town were to the ironmongers for various clips and connections to repair and maintain his precious water supply, or to Sweets, the Gentleman's Outfitters, for something personal

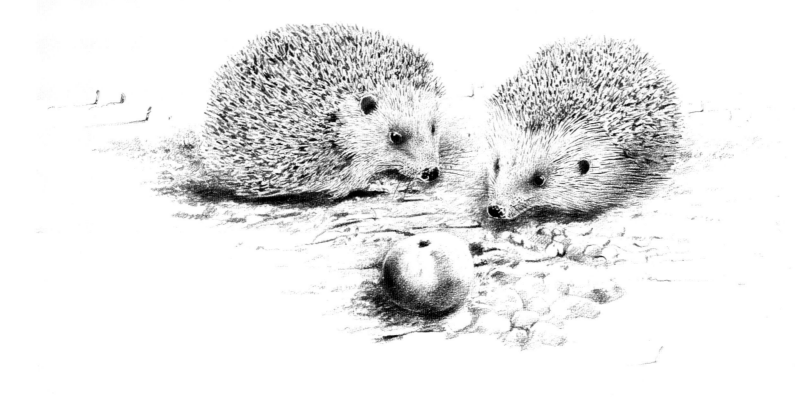

(he once told me that he hadn't brought a new pair of underpants since 1950). 'Get good'uns in the first place,' he would say, 'and they'll last forever.'

On occasions the road conditions would be awful on the high-sided narrow little lanes leading down to Woodtown. Ice and snow being the main culprits, and this is when the Colonel's secret weapon would be called into play. He had one of the very first domestic ride-on mowers and, apart from using it for the purpose for which it was designed, he used it as regular transport whenever the need arose. He would hitch up his little trailer, collect Charles from the lodge, and with himself at the wheel and Charles sitting bolt upright in the trailer, they would head off towards Tavistock at about 5mph.

The Collier family had been wine importers for many years and in addition several of them had been well-known Dartmoor artists. The big house contained many pictures that had been handed down through the years. Arthur Bevan Collier was perhaps the best known of them all, painting often little-known river and moorland scenes along the Walkham

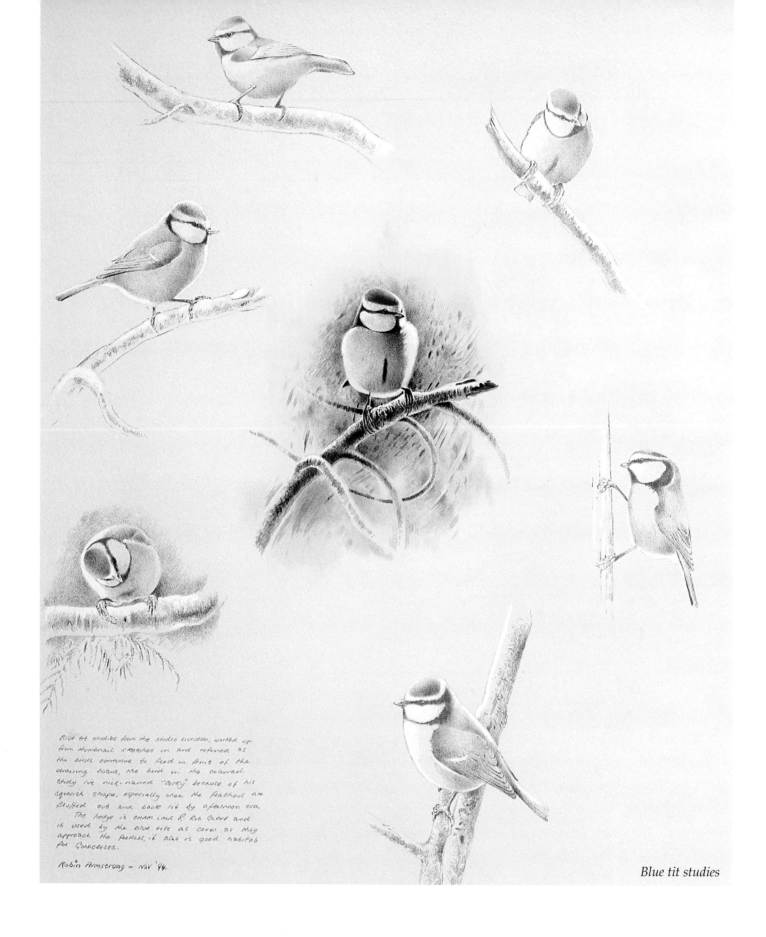

Blue tit studies from the studio window, worked up
from thumbnail sketches in and refined as
the birds continue to feed in front of the
drawing board. The bird in the coloured
study I've nick-named "Corky" because of his
squarish shape, especially when the feathers are
fluffed out and backlit by afternoon sun.
 The hedge is CHAMLAUS R. Rob Grave and
is used by the blue tits as cover as they
approach the feeders. It also is good habitat
for Goldcrests.

Robin Armstrong – Nov '94.

Blue tit studies

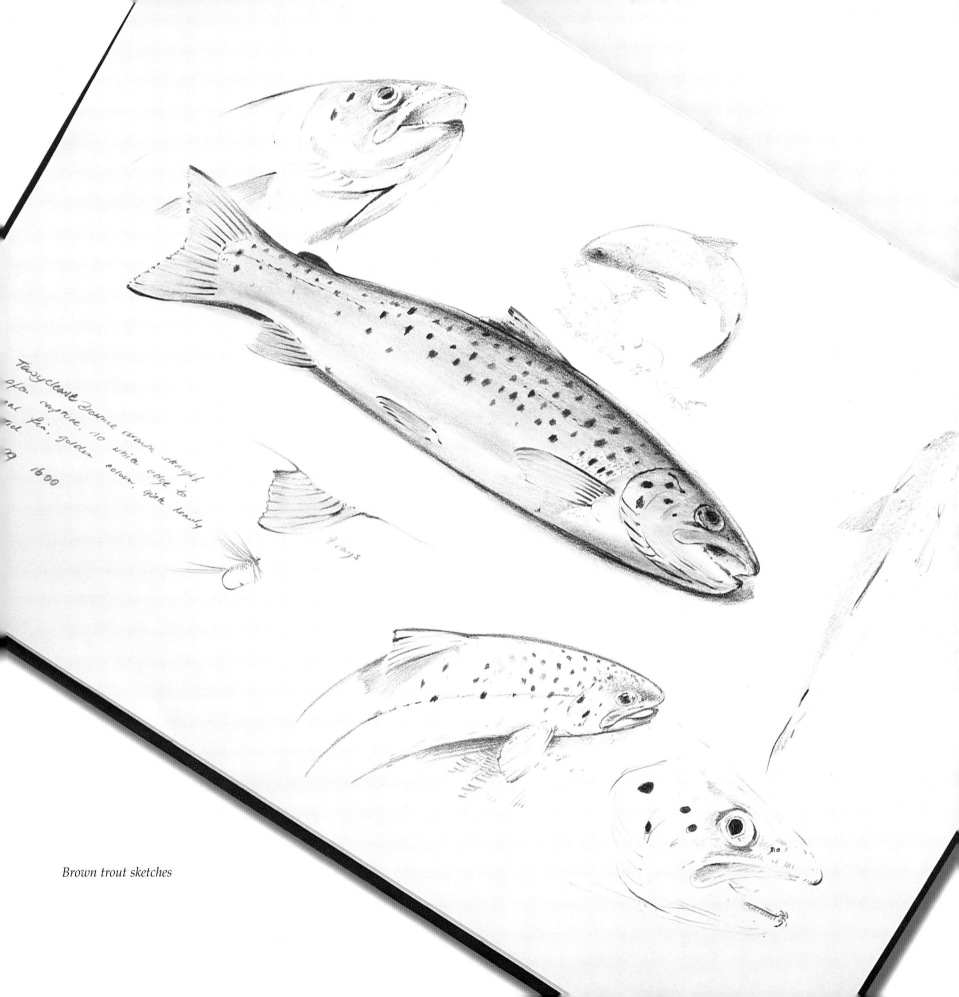

Brown trout sketches

Moorhen on nest

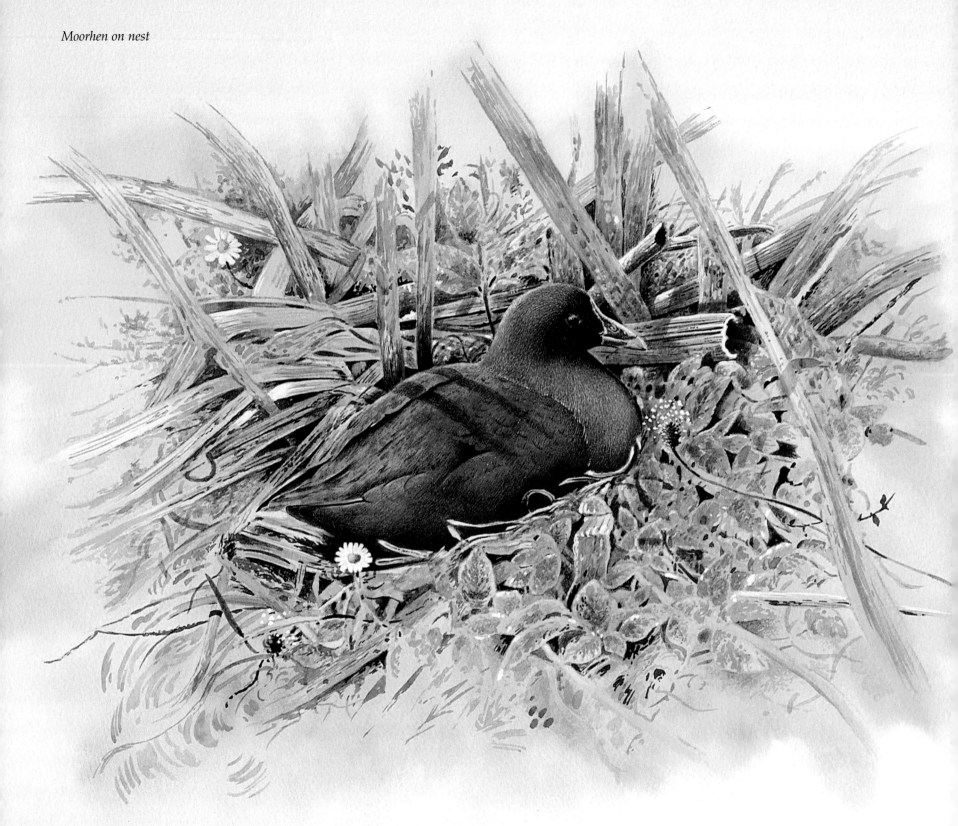

Moorhen sitting, Slapton
Robin Armstrong '95

Valley. The family passion was to continue in Nick Collier, who had recently given up his job running the art department at Kelly College to take up painting full-time.

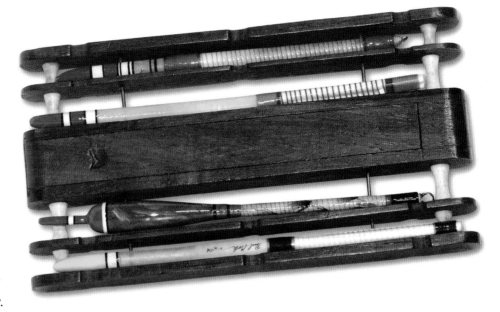

Mention home brew and I'm sure that most of us would conjure up visions and tastes varying from yeasty to plain yuk! Owen Collier's however was completely in a league of its own. His methods were kept very much to himself, although he did admit to me once that he used quite a lot of sugar. The result was a pale honey-coloured liquid which when poured from the ceramic suction-capped bottles in which it was stored, exploded into the glass like an avalanche, sending out bubbles and spume in all directions. You had to wait at least two minutes for it to settle unless you wanted an agitated mouthwash as well as a drink! The alcohol content was unknown, but more than two glasses would probably have felled an elephant!

Down the rhododendron path towards the Weir Pool, the Colonel had installed a wooden seat overlooking the river, and this was often used by the river bailiffs to keep observations on the pools below, concealed as it was behind the thick mantle of evergreens. The lads from Walkhampton and Horrabridge would favour Woodtown Weir because it was quiet and remote, and only a short hike overland from the village. One day during the height of summer, Bill Sprent, the head bailiff had arrived at the house having received a tip-off that the lads could be expected that afternoon to poach the pool. Bill had a few words with the Colonel before heading off to the seat and settling down to wait. Before he left the Colonel said 'I may come down in an hour or so and join you, two pairs of eyes are probably better than one.'

An hour or so went by and nothing had happened when Bill heard the Colonel shuffling down the path towards the seat. When he arrived he sat down beside Bill and placed a shopping basket containing some sandwiches and beer. 'Thought I'd join you for lunch,' said the Colonel. 'Things are a bit stormy up at the old house at the moment. Seem to be in the doghouse for some reason.'

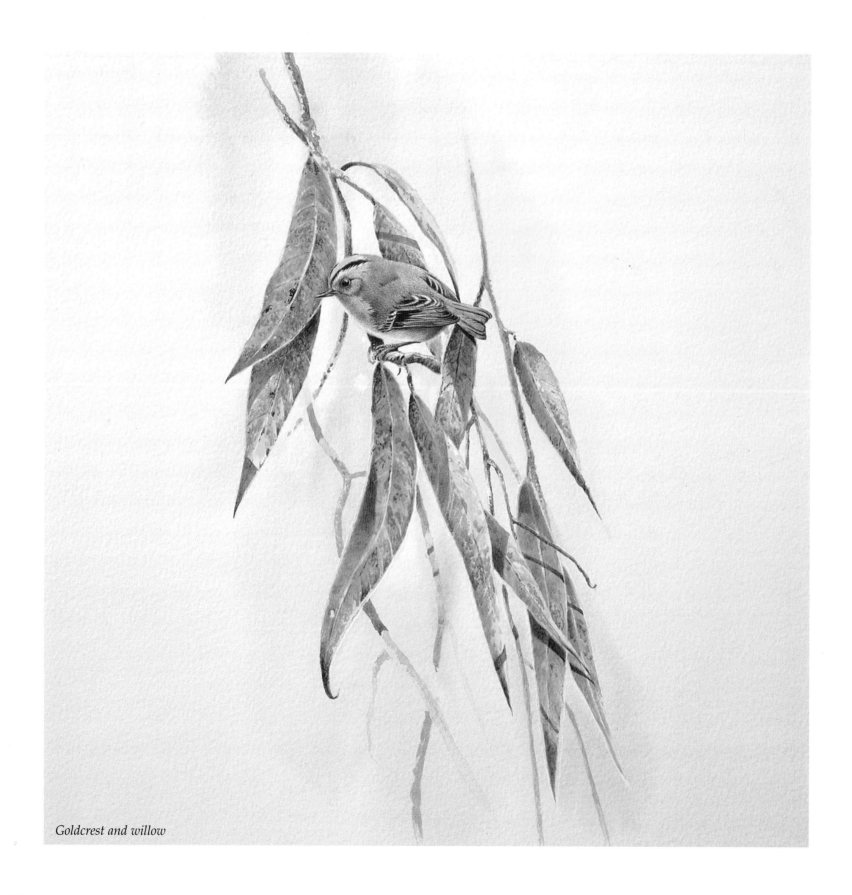

Goldcrest and willow

The two men sat and mused, talking about this and that, and all-in-all generally chewed the cud. They finished the picnic, and the beer that came with it, and all of a sudden the world seemed a much better place, the hazy sunshine slanting through the trees and the river gently gurgling in the valley below.

The next thing Bill remembered was being woken by a tawny owl in the tree beside the seat. There was no sign of the Colonel, he'd gone, basket and all. It was freezing cold and a mist was coming off the river. He fumbled his way back to the yard, dug around for his car keys and finally managed to open the driver's door; turning on the inside light he looked at his watch, it was 3.45am! Bill's notebook entry for that day read: 'Patrols and observations at Woodtown Weir, hot day occasional fish movement – nothing seen.' At least he was telling the truth!

Musings on Wild Trout

Looking into the water below from a bridge has always been a favorite pastime for me; watching little Dartmoor trout dashing and darting about their business comes top of the list. I can't resist humming Schubert's Trout Quintet to myself (very badly) whilst watching them compete for any morsel that comes their way in the fast-flowing water. Unlike their chalkstream brethren these little acid-stream brownies have to be very quick off the mark in order to tell the difference between an insect being carried downstream by the current and a piece of leaf or twig. It's fascinating to watch as they dash up from their lie, often called a 'station', to suck in some small object, only to eject it straight away having decided that it wasn't food. I remember once standing on Wardbridge with the angler and writer John Bailey, who'd been staying for a few days. We watched as a large bumble bee got itself into difficulties and became water logged, it thrashed about haplessly on the surface all the while being carried closer to the lie of a small trout lying beside one of the bridge parapets. Tensing itself with anticipation, the fish darted up and grabbed the bee, only to reject it immediately. This same act was carried out four or five times in lightning succession before the little fish decided that this relatively large object was real food. It engulfed the bee in one last effort and was back on station within a split second.

Terrestrial food does form a large part of a wild trout's diet. In these fast-moving acid-fed streams there is certainly less natural water-bred

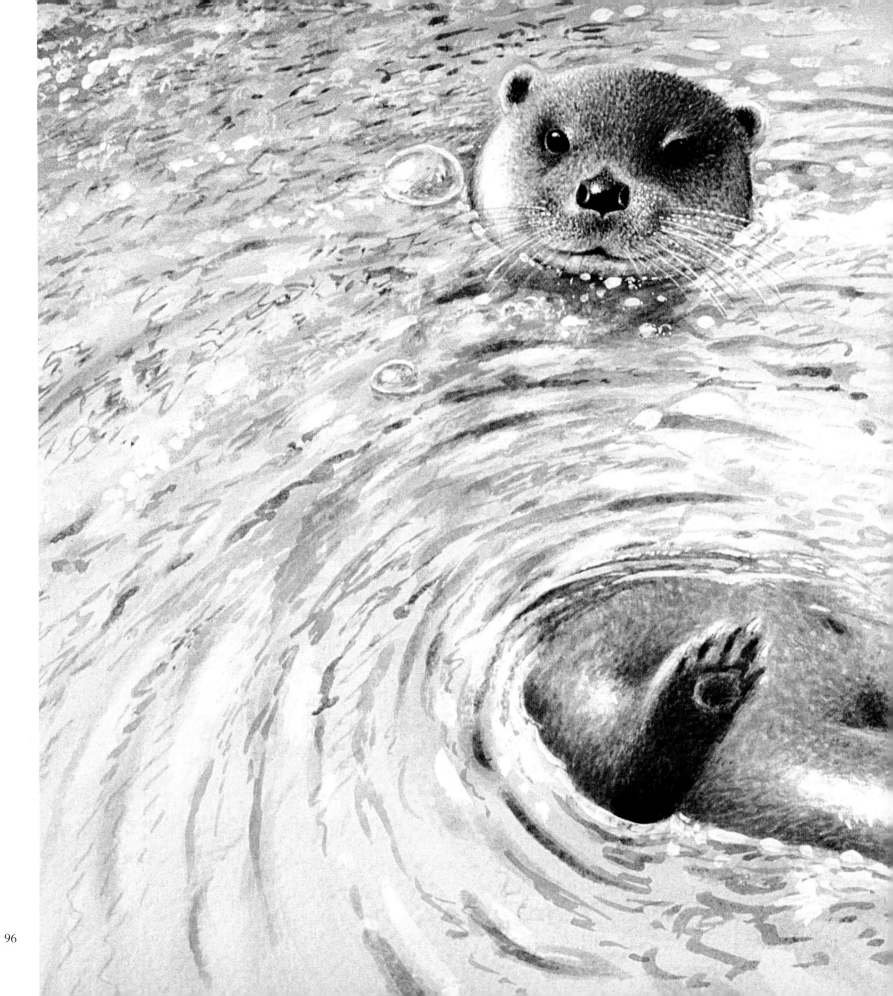

If left undisturbed, otters will thrive in the food-rich waters of our Westcountry rivers. Relying mainly on eels, they are perhaps the most charming example of our natural fauna.

Watching an otter at play is without a doubt one of the most rewarding experiences there is. Impish and lithe they will often play and spar with inanimate objects such as sticks or stones, rolling over and over in the stream, catching and retrieving the object of their attention with remarkable dexterity.

Frolicking otter

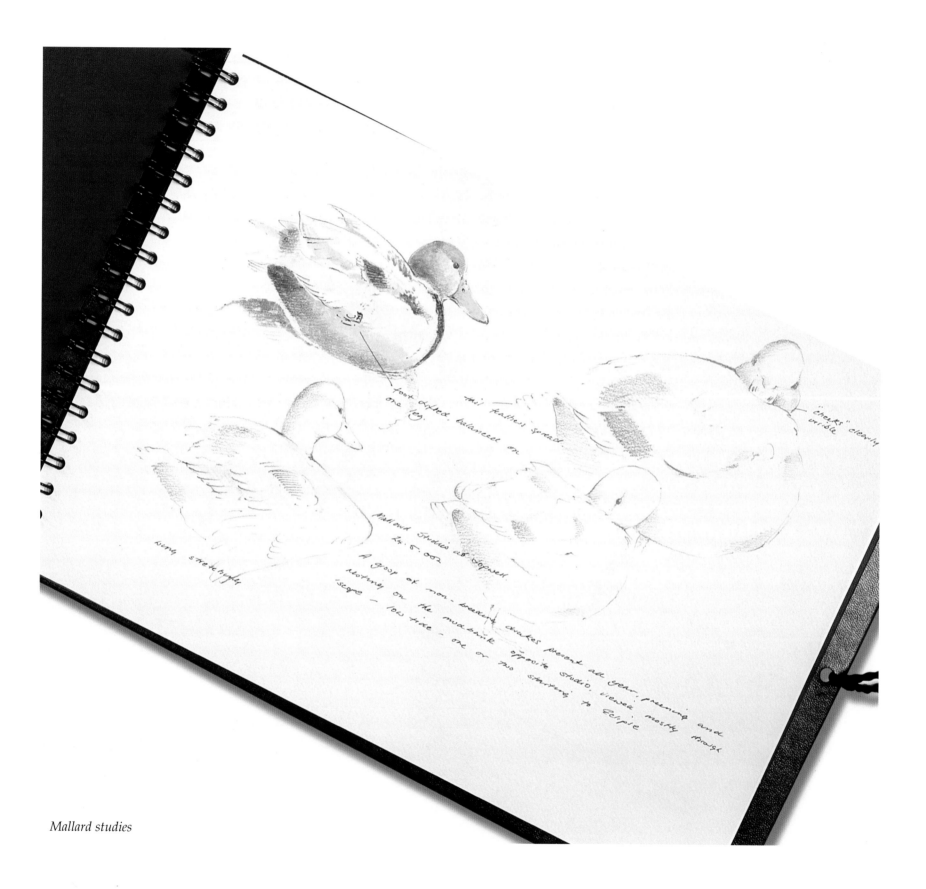

Mallard studies

food than in the rich chalkstreams of the middle counties. Freestone rivers provide the trout with clean oxygenated water at the cost of bulk feeding opportunities!

Pollution, unless committed by man in the way I described earlier, is often less damaging too, the fast water carrying the polluting agent or agents downstream; hopefully dissipating them quickly and efficiently.

Lack of weed in our moorland streams, compared to that of the chalkstreams, also means that food is less plentiful; nitrates encourage weed growth and so whenever weed appears unnaturally in clear acid water there has to be a suspicion that someone close by has been using nitrogen on the land.

There are certain places in the river where more food is available than at others, and it is at these places that the trout tend to be bigger. Survival of the fittest is the name of the game, as it is with everything else, and if a good feeding spot is vacated either by its occupant being taken by a predator (including man) or simply dying, then it takes very little time before that spot becomes the home of another hopeful brownie. Darker spots in the river are occupied usually by darker fish, and lighter places by light coloured ones. Natural camouflage in wild trout is yet another of nature's wonders.

Once trout reach a certain age and size, they tend to become cannibalistic, taking not just their own kind but bullheads, loaches and minnows (where present). An old cannibal trout can wreak havoc amongst fry populations and so in the long term can be bad for the overall health of the species.

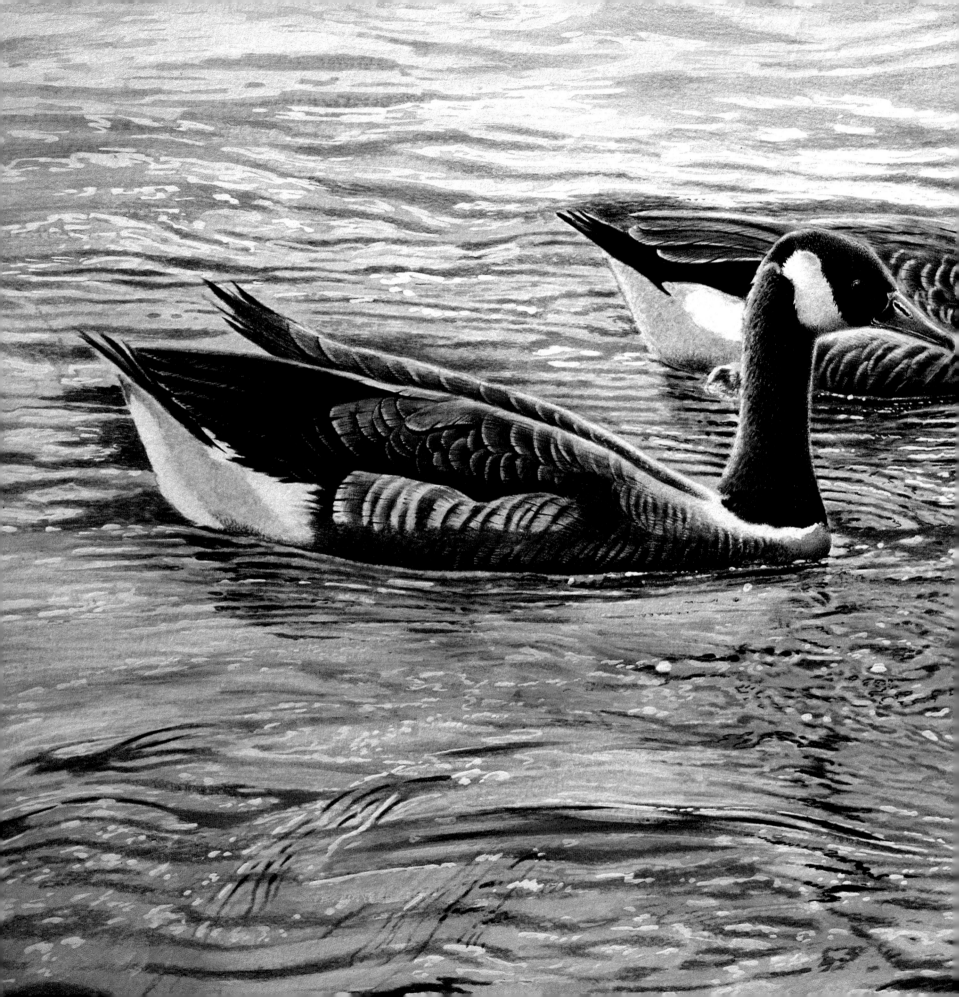

Canada geese

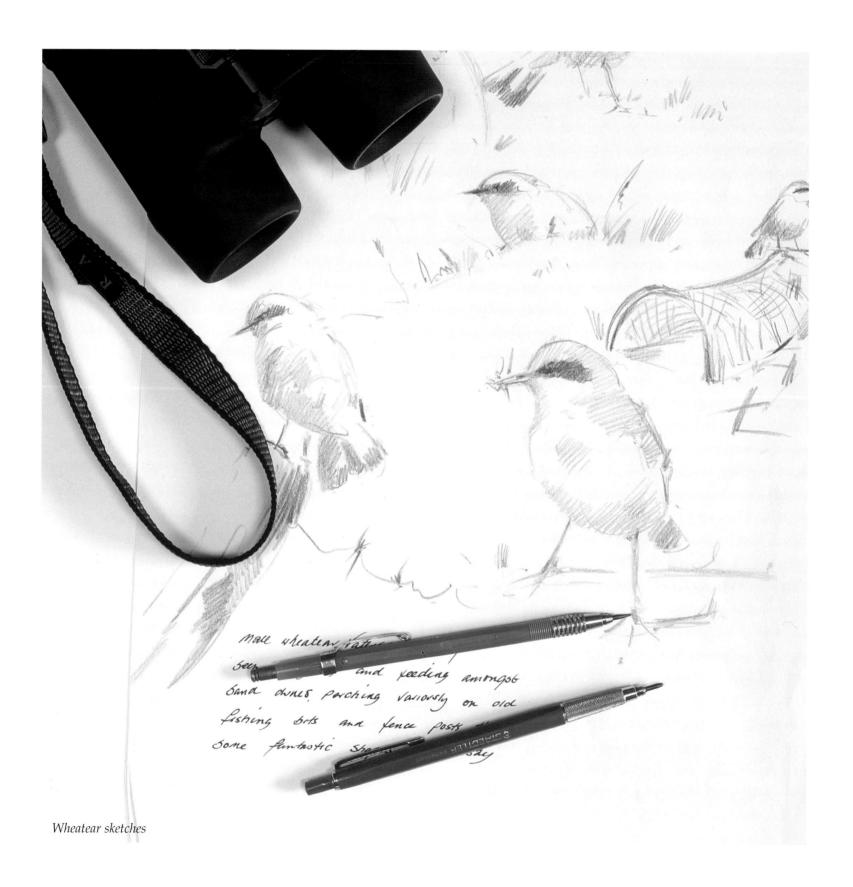

Wheatear sketches

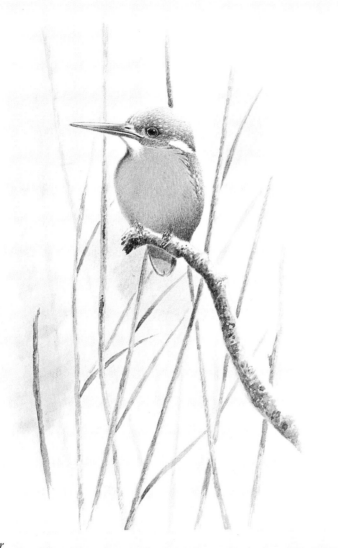

Kingfisher

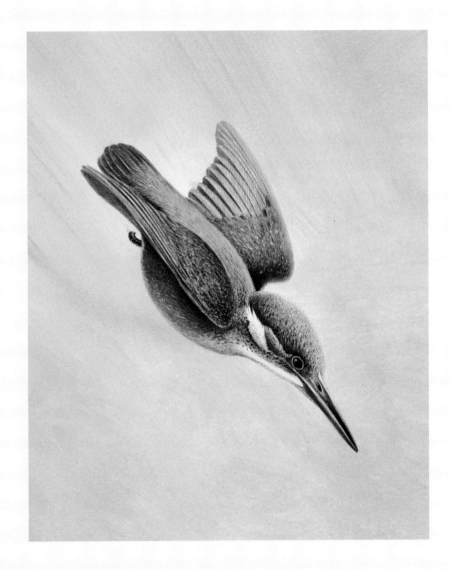

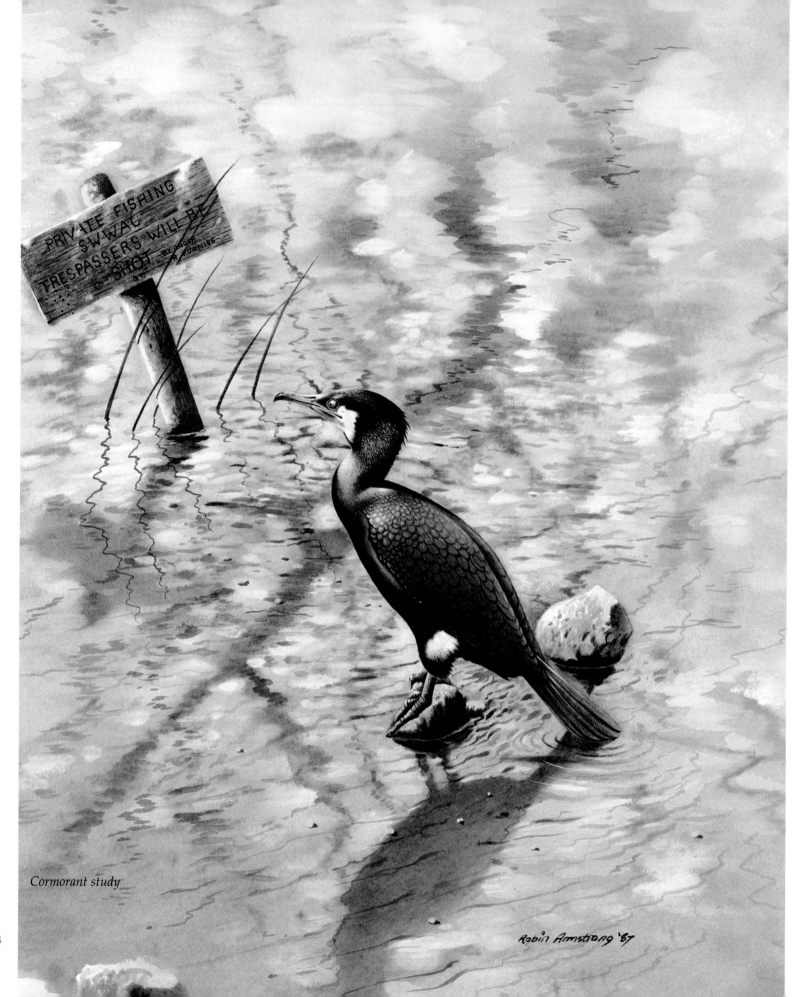

Cormorant study

104

Robin Armstrong '87

Seasons on the Rivers

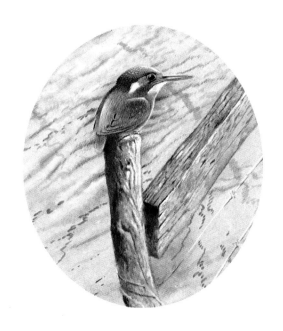

When proud-pied April, dress'd in all his trim,
Hath put a spirit of youth in everything.

William Shakespeare

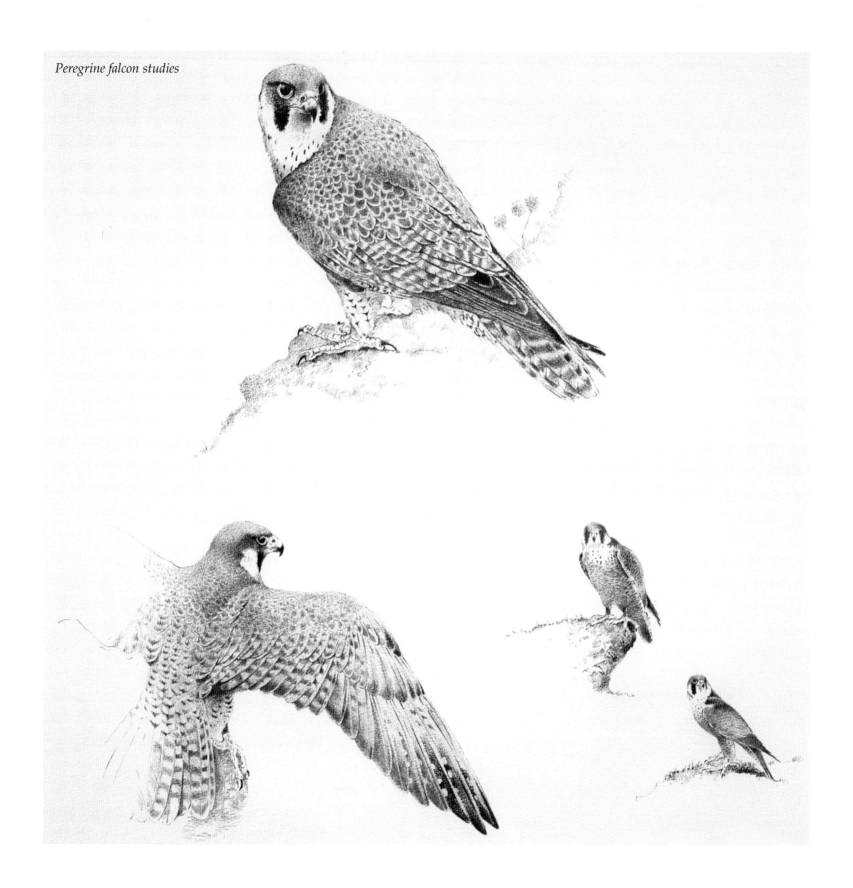

Peregrine falcon studies

Most of the twenty-one principal rivers on Dartmoor rise within a short distance of each other, some on the north moor and some on the south. The River Tavy rises just south of Cranmere pool at around 1800 feet above sea level and is soon joined by the Rattlebrook and the Amicombe Brook. The drop-off in height at this point is quite dramatic, and by the time it reaches Tavy Cleave is even more so, with huge clitters of rock funneling the river through the towering peaks of the gorge. This is a hauntingly romantic place, with the eerie sound of silence that is typical of the high moor, save only for the gentle rippling of the river far below and the occasional outburst from its sparse wildlife. I once heard a ring ousel 'shout' from within the Cleave during November and was amazed at not only hearing one so late in the year, but at the huge distance that the sound seemed to travel.

I can't imagine that the river here was always so insignificant quite simply because of the sheer size of the gorge. However it pays to err on the side of caution when dealing with spate rivers; for the most part precipitation will run off fairly quickly, as the words of the Tavistock poet, William Browne record.

Here digs a Cave at some high Mountains foot:
There undermines an Oake, teares up his root:
Thence rushing to some Country-farme at hand,
Breaks o'er the Yeoman's mounds, sweeps from his land
His harvest hope of Wheat, of Rye or Pease:
And makes that channel which was Shepherds lease.

Occasionally even Dartmoor finds it hard to deal with severe storms and Robert Burnard wrote of one such deluge in the early hours of 17 July 1890, over the watersheds of the Tavy, Walkham and Cowsic, resulting in such rapid and heavy flooding of these rivers that the oldest inhabitants 'could not remember its equal'.

Although the thunderstorm was general over the whole of Dartmoor, and all the rivers rose to an unusual height, the heaviest fall of rain occurred on the Northern moor between 8.00am and 9.00am. The Tors visible from Tavistock, right up to great Mis Tor, bore a remarkable appearance; for

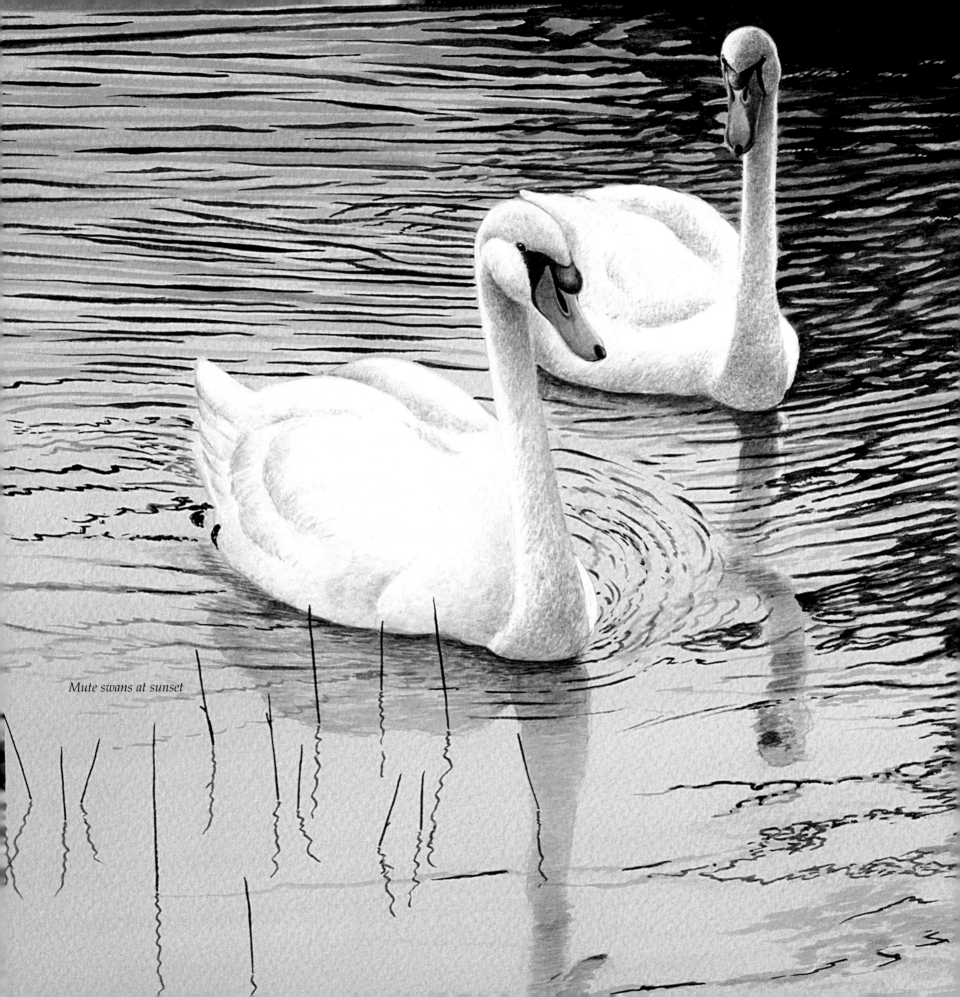

Mute swans at sunset

numerous streams were rushing impetuously down their slopes, swamping fields, deluging the roads, and swelling each tiny rivulet into a mighty torrent. By half past eight a terrific roar was heard, and the folk of Tavistock knew that a big river was coming down. The Tavy presented a sight not easily forgotten. It came in immense volumes, increasing in strength and height until the Guildhall square was flooded. The Abbey bridge was threatened with destruction. All the low-lying cottages were flooded, and a prisoner was rescued from a cell in the police station. Although the bridge stood, the weir which supplies the canal was washed away.

At Mary Tavy, apart from the havoc and destruction wrought by the storm which broke over the upper reaches of the Tavy basin, the sight was supremely grand. From the heights of Stannon the water flowed in roaring cataracts so broad as to appear like one vast sheet of foam, down into Tavy Cleave, where, seething, boiling and dashing along, it swept away clams, banks and bridges, including the picturesque old structure at Harford.

The Walkham also rose in violent flood, carrying away a portion of the Merrivale bridge and destroying the quaint seventeenth-century Ward bridge in the valley below.

That was all of one hundred years ago, but the power of the river can still be awe inspiring, as I have witnessed on at least two occasions; reminders that we should respect these wild waters.

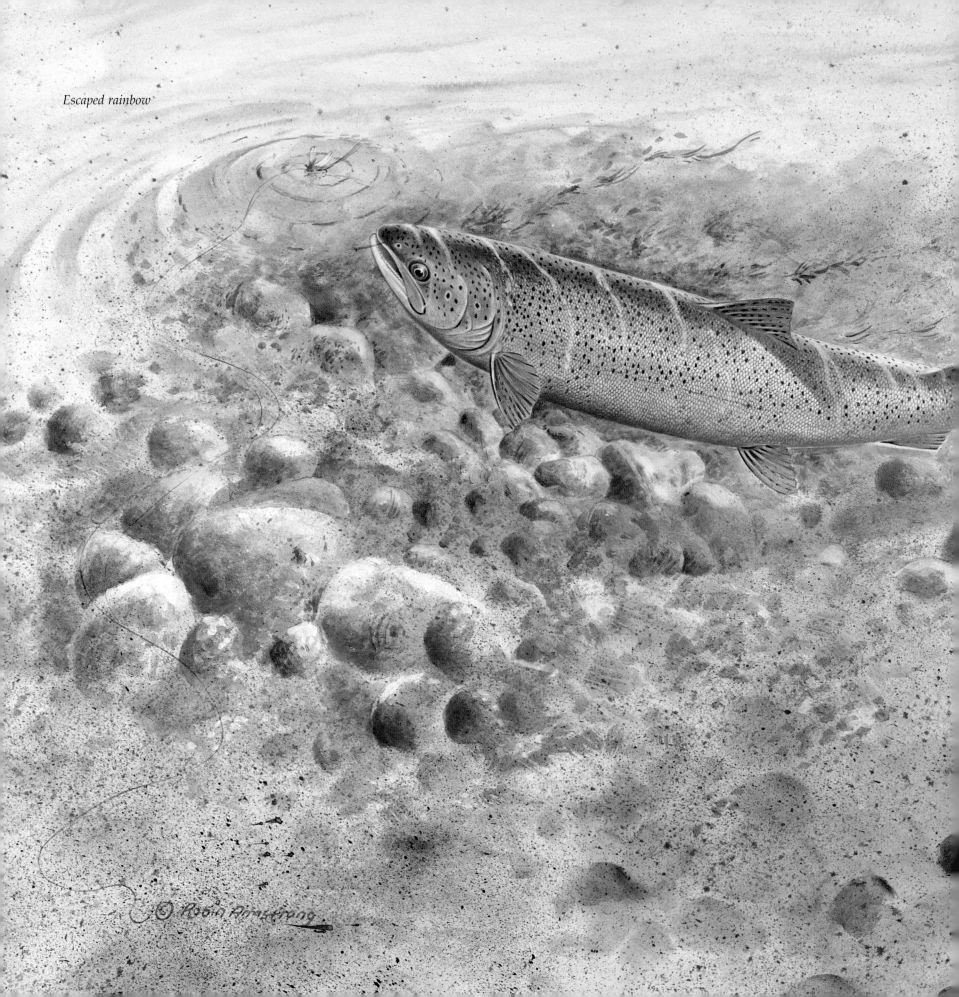

Escaped rainbow

Farmed rainbow trout are often accidentally released into the river system beside which the fish farm operates. When this occurs the escaped fish will often revert to their ancestral state becoming firm of flesh and sharp in appearance. If they survive for long enough they will migrate back to sea and much like sea trout, flourish in the coastal waters, taking advantage of the rich feeding.

Those that do return are different creatures indeed. Like bars of silver they hardly resemble the tired land-locked little fish of a year ago. In this state they become a real angler's prize, hard fighting and simply the best to eat.

A letter from Raymond Ching

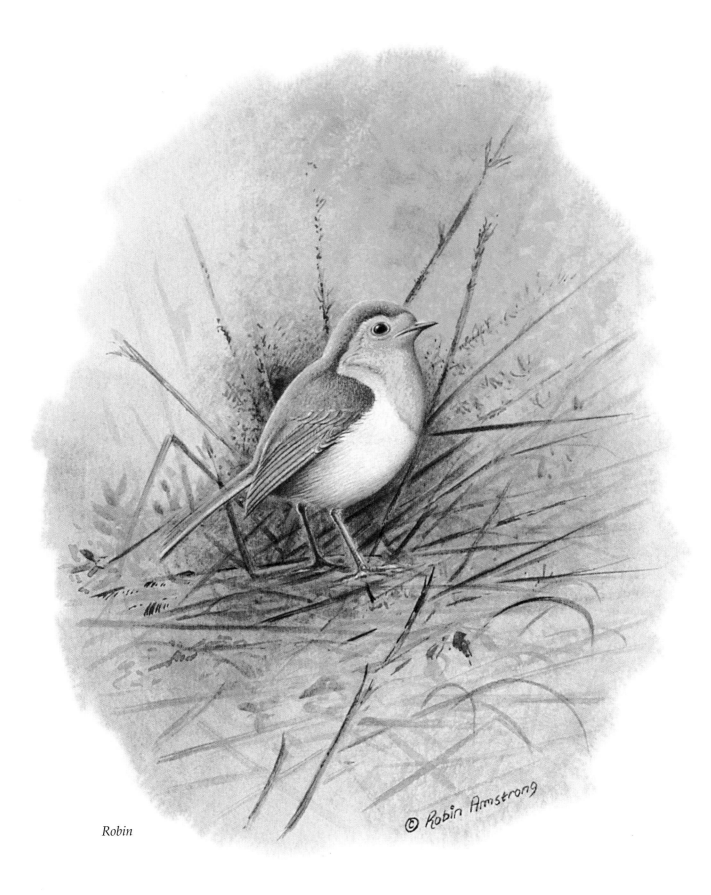

Robin

© Robin Armstrong

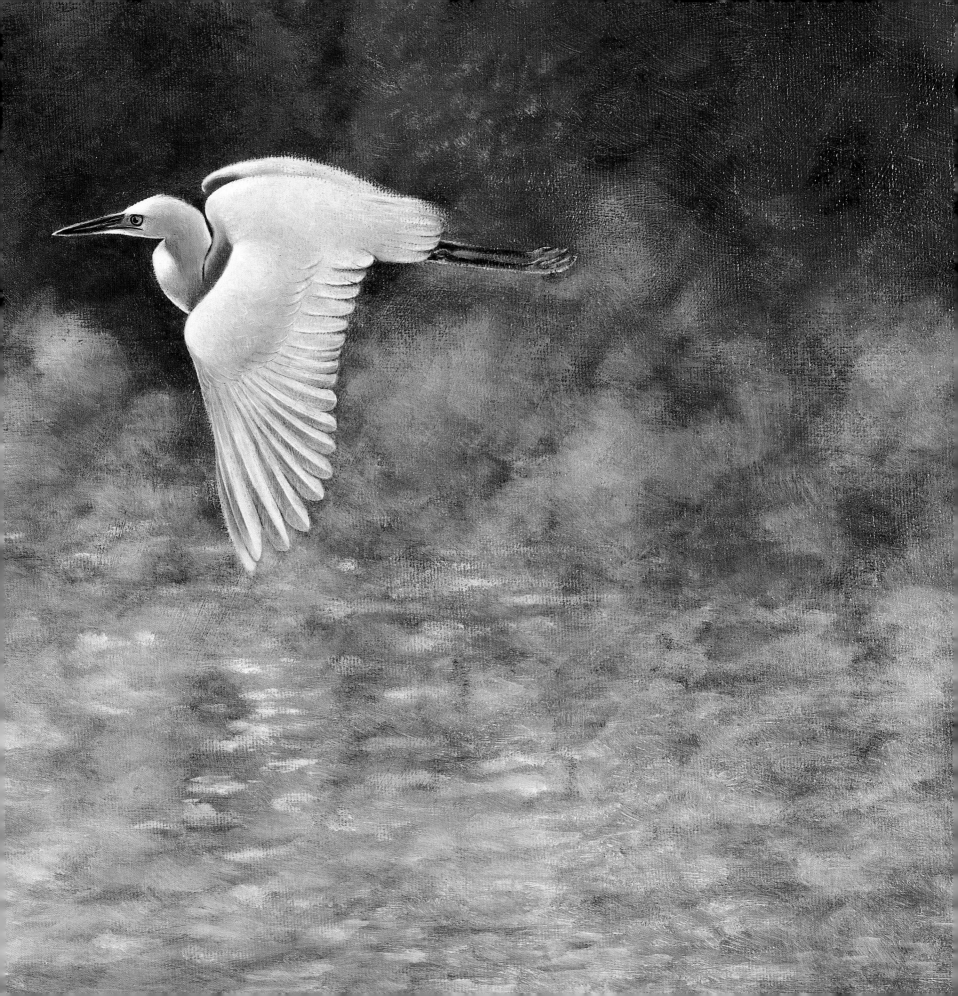

During my years as a river warden, my colleagues and I were periodically drafted in to help the fisheries biologists with parr and brown trout census surveys. The best time of year to conduct these studies was in the summer months when river flows were at their lowest. The process is simple: stop-net a section of river or stream so that no fish could escape and then electrofish the stretch, stunning the fish temporarily and removing them by hand net. They were then measured, identified, and in some cases scale samples were taken to determine age, growth-rate and so on. These days were physically quite exhausting, involving a team of three carrying all the gear needed, which included mobile generators, stop nets, stakes and measuring boards, sometimes a mile or so either up- or downstream, depending on the access available.

One such survey was on a section of the Tavy just below Hill Bridge at Creason Wood and involved a tiring hike from the available parking space at the bridge itself.

The day started well enough, with a clear blue sky and warm sunshine. It was the 15 July, a memorable day if only because it is my birthday! We met at Hill Bridge and gathered the gear together for the hike downstream. I remember, as birthday boy, getting some stick from the others about passing the age of no return. The section was easy enough to survey, and the results were very promising, we had almost completed our third sweep when I glanced up and looked towards Hill Bridge. The sky was as black as coal, not above us but away up towards the Cleave. We heard a distant rumble of thunder and saw the occasional flash of lightning. We could see that the storm was coming our way and so decided to pack up and get the gear back to the Land Rover at Hill Bridge. As we loaded the kit into the vehicle the first drops appeared, followed by a steady patter of refreshing summer rain.

Having packed away the gear and ritually cleaned the usual mud and debris from our personal equipment, the final job was to clean off our chest-waders by getting into the river and washing them down. As I blundered in and began the job I heard what sounded at first like a radio crackling between wavelengths, but within a few minutes the noise became at first a grumble and then a roar. We all looked up and there, coming from the upstream direction and heading down on us fast, was a wall of charging white foamy water, the like of which I had never seen before. We all moved like lightning and jumped into the Land Rover. The surge hit the bridge with tremendous force, and we could see rocks and logs jammed under the parapets. For a few moments we

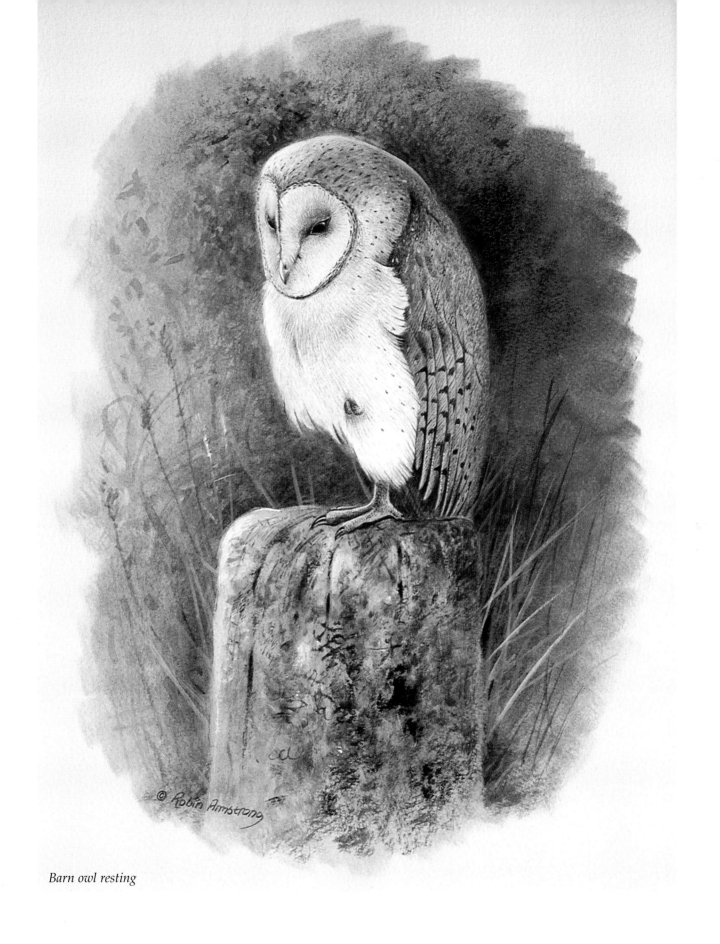

Barn owl resting

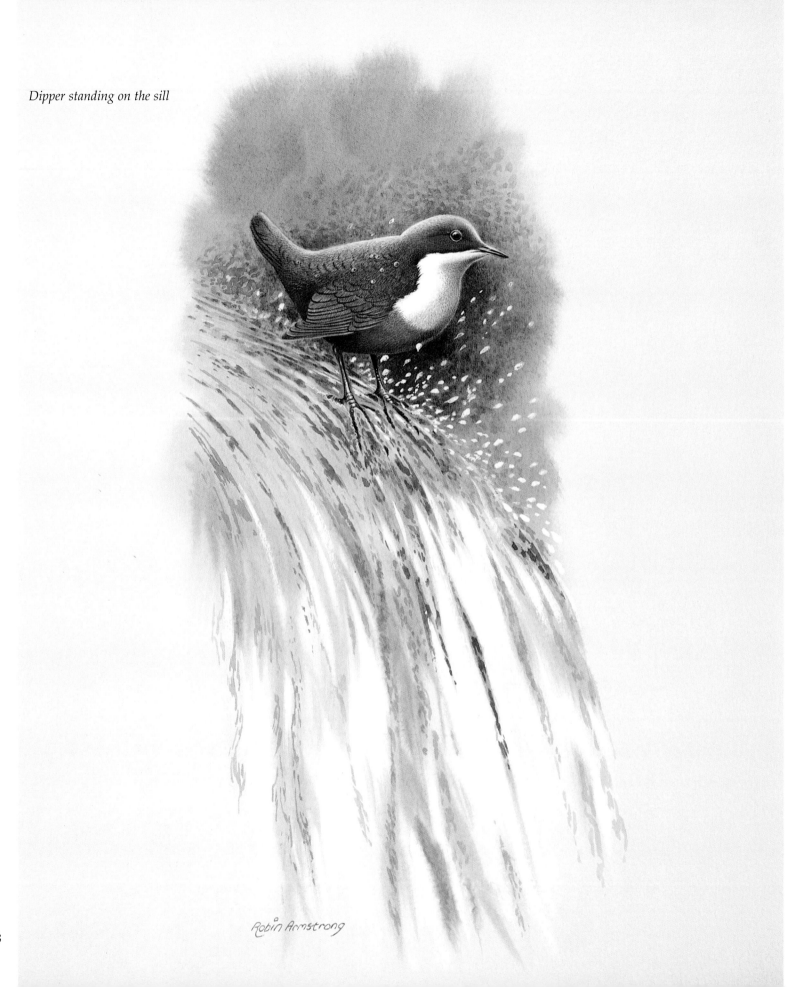

Dipper standing on the sill

Robin Armstrong

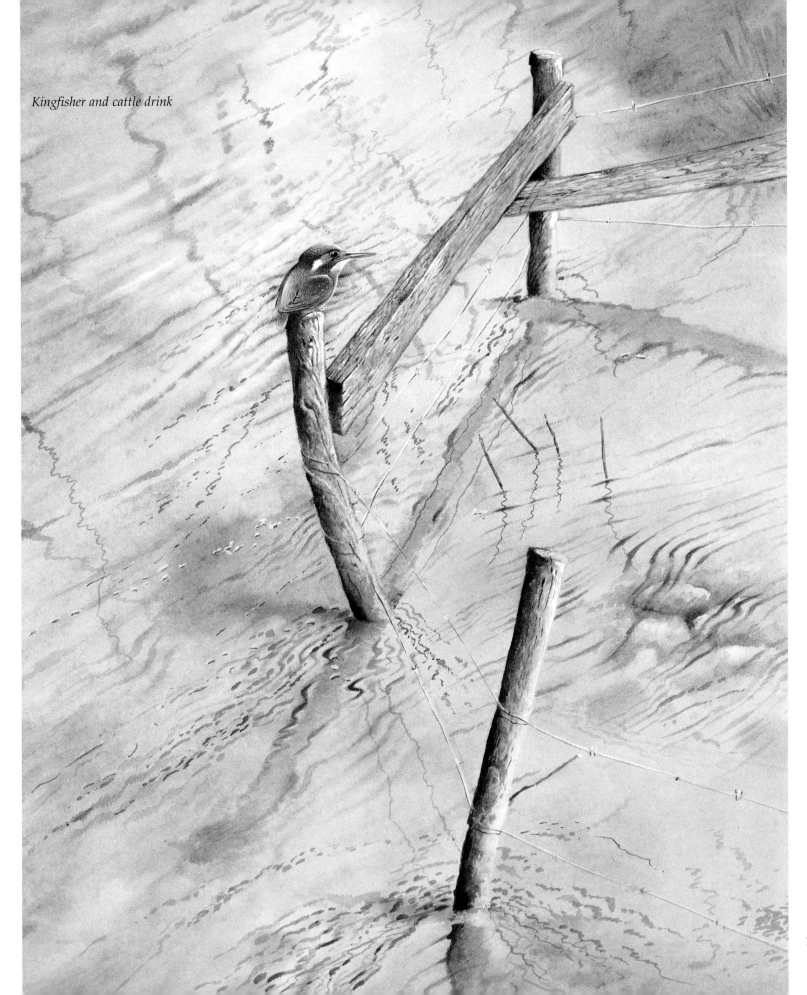

Kingfisher and cattle drink

119

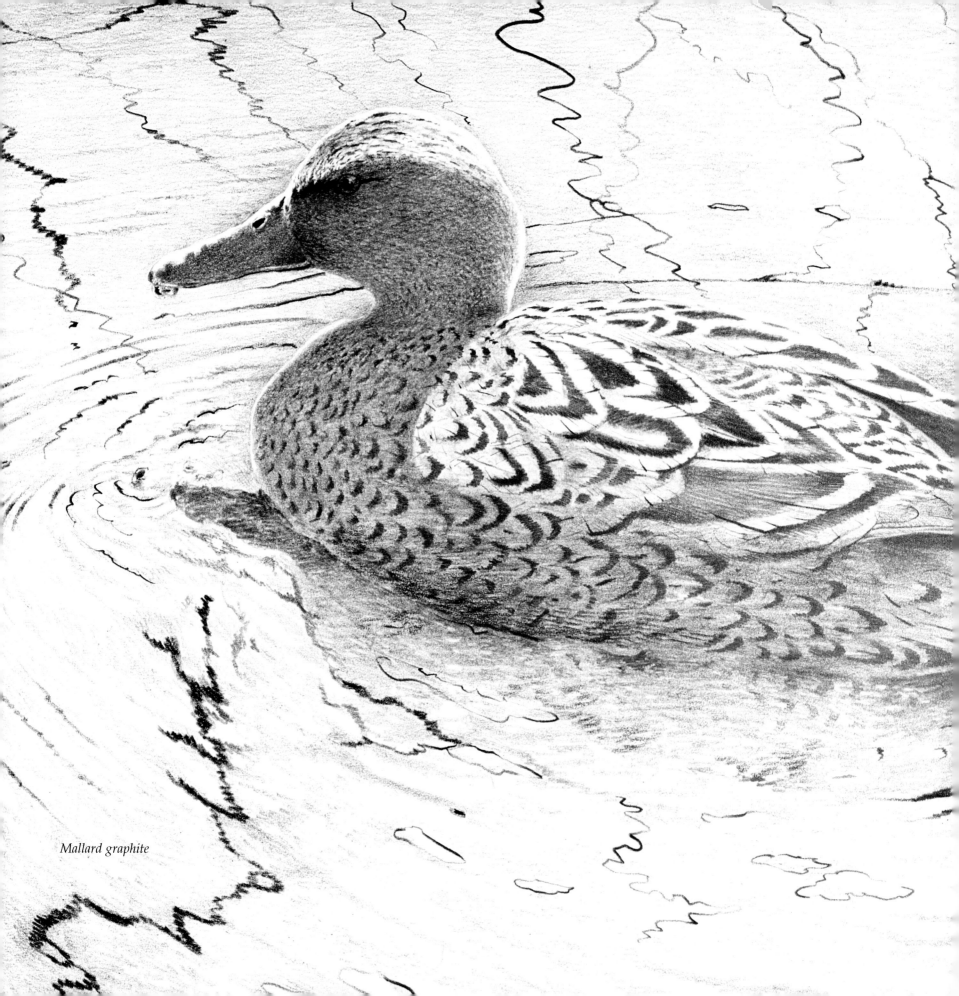

Mallard graphite

all looked at each other in amazement and made comments about how lucky we were to have got out of the river in time to avoid the deluge. Suddenly I realised that, no more than a few miles downstream, there was Harford Bridge Caravan Park with all of its summer visitors bathing in the river and basking on its banks! I have never driven so fast in my life, risking a head-on collision on the narrow road between Hill Bridge and Harford.

We arrived at the caravan park and squealed to a halt, shouting at people to get out and away from the river. Most probably thought we were mad, but Major Plumtree, who owned the land, was more than grateful for our interruption. When the surge did arrive it was no more than an inch or so of muddy water, but as history reminds us, it could have all been very different!

Springtime Pleasures

After the wild winds and white frosts of the early months on Dartmoor, April often comes to the river as a gentle relief. Nature begins to stretch and shake off winter's torpor, and the year's salmon hatch emerges from the gravels. Primroses fill the banks, trees sprout new leaf and hibernating mammals poke cautious noses into the promising air.

Chiffchaffs and willow warblers, 'true harbingers of Spring', have already broken into loud voice and, as an artist, I am presented with a surfeit of subjects. But of all

the many opportunities, the heron patiently waiting in the shallows, remains a favorite subject. Many die in bad winters when their pools freeze and food becomes hard to get, so it's good to see survivors, even though I know that some fishermen regard them with a jaundiced eye.

At this time of year, I always look forward to those early trips to the high moor to fish for brownies. Having spawned in much the same way as salmon, many of these trout (with any luck) will have stayed on in the upper reaches to feed on the insect life and the fry of their larger cousins. So whenever I get the chance, I arm myself with my favorite little cane brook rod, lovingly crafted by my close friend and fishing companion, Paul Cook. A handful of dry flies, half stone or treacle parkin perhaps, are all that's needed to find out what the higher reaches of such rivers as the Cowsic have to offer. The brownies which live in these remote streams are not giants, but they make for very exciting fishing. Some can reach ¾lb or more; all are a delight to the angler's anticipatory eye, and when hooked they cartwheel out of the water like tiny acrobats, full of tumbling life; they are almost too beautiful to take, but they also taste good, freshly caught and cooked simply, *a la meuniere*, they make a feast fit for a king.

Another spring-time pleasure is to witness the annual migration of the salmon and sea-trout smolts, young fish which have grown to a size when they need to leave their native Dartmoor and venture forth from river to sea. Every year they congregate in the higher reaches and begin to migrate downstream and, as they go, performing a kind of ritual known as 'dimpling', constantly rising up to buss the surface of the water, not in the deliberate way of feeding trout, but as part of some elemental game, played as they retreat from pool to pool. Once you have seen these primitive corybantics, you won't forget them. From then on, you will always be able to tell smolts from trout.

Working in the 'field'

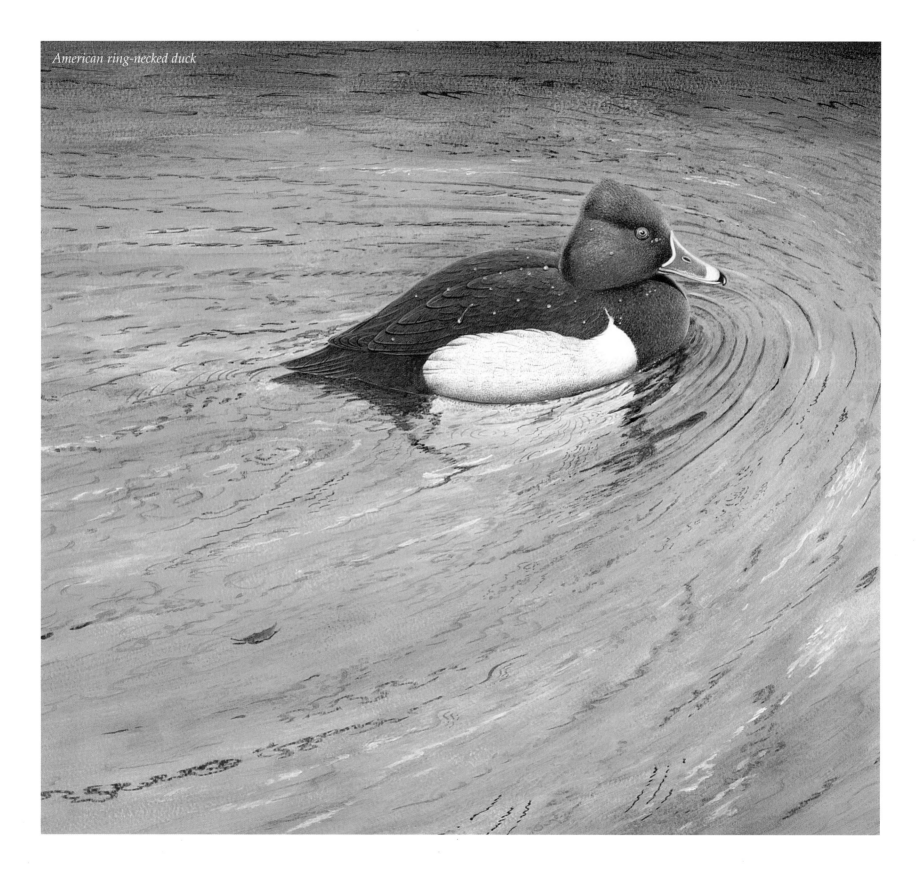

American ring-necked duck

Salmon on the Redds – River Tavy

No warmth, no cheerfulness, no healthful ease
No fruits, no flowers, no leaves, no birds, November.

Thomas Hood

Despite my twelve years as a full time river warden and several before that as a part timer, I still occasionally have difficulty in identifying salmon redds, the riverbed nest dug by the female in which she lays her eggs. In a side stream, where cattle may have disturbed the gravel, I certainly wouldn't bank on recognizing them well enough to stake my life-savings on my identification. Even though I know what to look for, I am never one hundred per cent sure that I shall read the river well enough to find them.

Sea-trout usually start to spawn in the early part of November, and salmon towards the end, this of course is entirely dependent on conditions. If the weather is running true to its usual form, with gales to start and frosts to follow, then the conditions ought to be right. But too many gales, and too strong, can bring disaster, as happens from time to time when storms and floods wash out the spawning beds at the top of the river. In one such case on the river Tavy, the effects of nature's ill-wind was made worse by man's folly in 'improving' the drainage of the fields adjoining the river without thought to the consequences. The velocity of the floodwater was increased and the damage done to the spawning beds was exacerbated. As often happens, the gains in one direction were offset by losses in another; the left hand of agriculture had acted without regard to its effects on the right hand of fish stocks. The capacity of the river to absorb changes to the environment was taken, as it often is, for granted.

I have already said that finding salmon and sea-trout redds is not easy. What one needs to look for, short of actually witnessing the salmon spawn, are areas of gravel which have been disturbed and shunted back upon themselves. Where there are small piles of stones different in color from the surrounding ones, it is here, in the depressions formed out of the gravel, that the female, accompanied by the excited male, lays her eggs – anything up to ten thousand of them. The apparent profligacy is deceptive, since many will simply get washed away or fail to get fertilized, and barely one per cent will grow into mature fish. Often, to compensate for milt which has drifted away, a 'bystanding' sexually mature male parr will be in attendance at the redd, hovering closer to the concentration of eggs than the larger male could hope to do, thus forming the third element of an essential fishy triangle designed to ensure the survival of the species.

Male salmon

Tufted-duck sketch

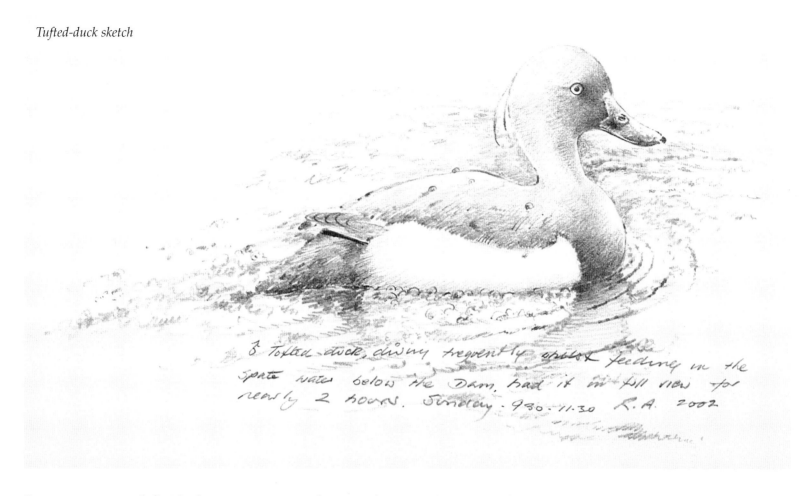

♂ Tufted-duck, diving frequently whilst feeding in the spate water below the Dam, had it in full view for nearly 2 hours. Sunday - 9.30 - 11.30. R.A. 2002

Sea-trout start and finish their spawning, at least in the West Country, rather earlier than salmon and, since they are generally smaller fish, they choose gravels of smaller size for their own redds. I have often seen sea-trout spawning at pool tails amongst tiny gravel not much bigger than course sand.

Once the spawning is over, and assuming they haven't perished after their labours (and many do), the females will head straight back to sea, leaving the cock-fish to stay on to defend the redd against marauding fish and egg-stealing birds. Indeed, most river dwellers will take advantage of this prolific gift of protein given the chance. The cocks will have gone through extreme physical changes, now sporting huge kypes (hooked jaws), and presenting themselves in a variety of shades which at once delight and frustrate any artist trying to capture them in paint.

All of this conception and procreation cannot be taken for granted. The pressures on rivers and spawning grounds, from nets to pollutants, are great, and there is no automatic guarantee that salmon and trout will continue to spawn in the future

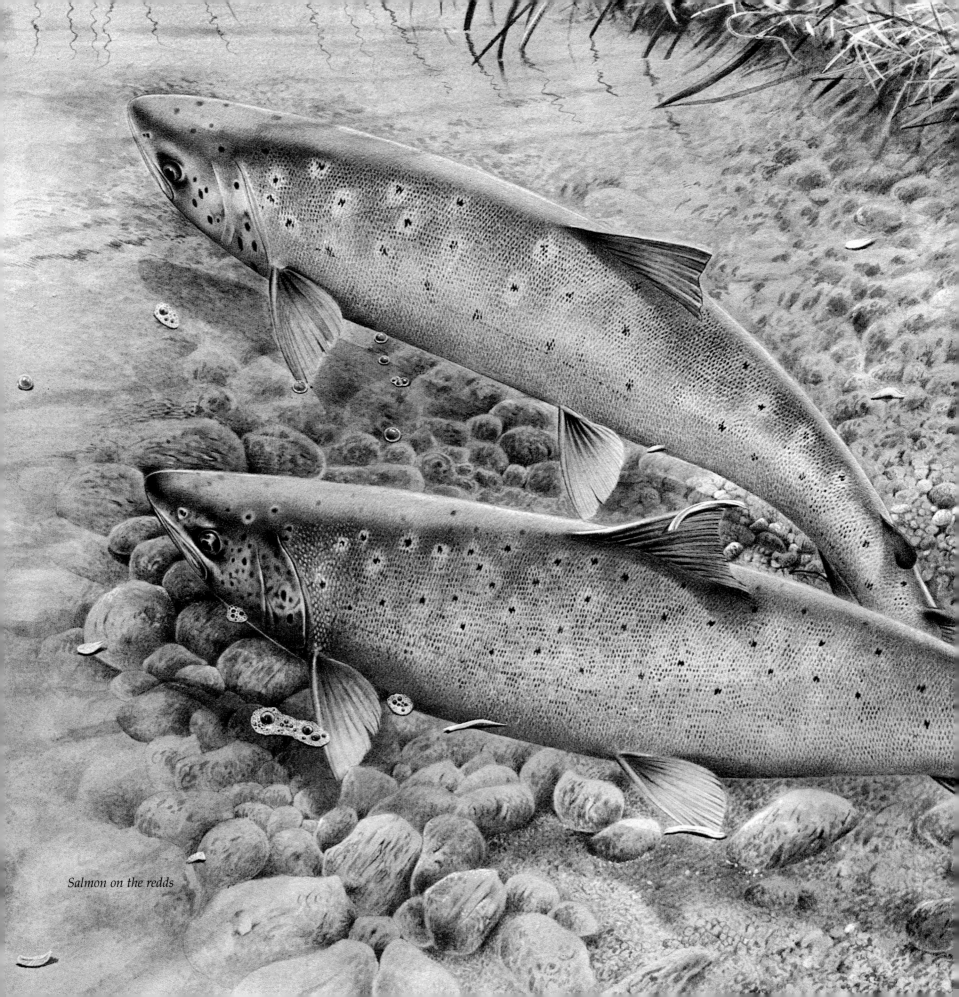

Salmon on the redds

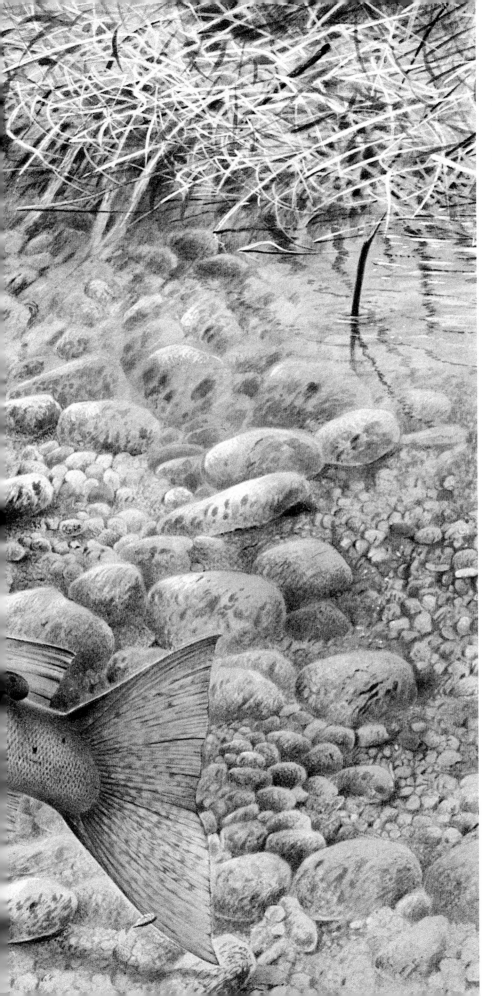

as they have done in the past. Even if governments were to be persuaded to bring some order and control into commercial fishing in the oceans, excessive exploitation of the stocks in our rivers could jeopardize their future.

The high moor also provides a splendid and unique habitat for many species of bird, from ring ousels to red grouse, the latter being surviving stock from earlier attempts to establish a population for shooting. For whatever reason, be it politics or population, the project didn't get off the ground, but even today the odd covey survives on the 'top'.

Ring ousels are birds of deeply gorged outcrops where the rivers tumble relentlessly down, and are always exciting to watch, often drawing the viewer's attention by emitting a loud and often echoing alarm call.

In winter, large flocks of golden plover gather on the moor to brave the elements, before moving off to their northern breeding grounds in the spring. A very few however remain to breed on the moor; nest sites are closely guarded and those that do breed are not like the northern race with very black breasts and golden spangled back feathers, but generally looking rather washed out, more like winter plumage in fact.

Other waders that hang on to a tenuous breeding ground on Dartmoor are dunlin with around 12–15 pairs, the common sandpiper (sadly now not so

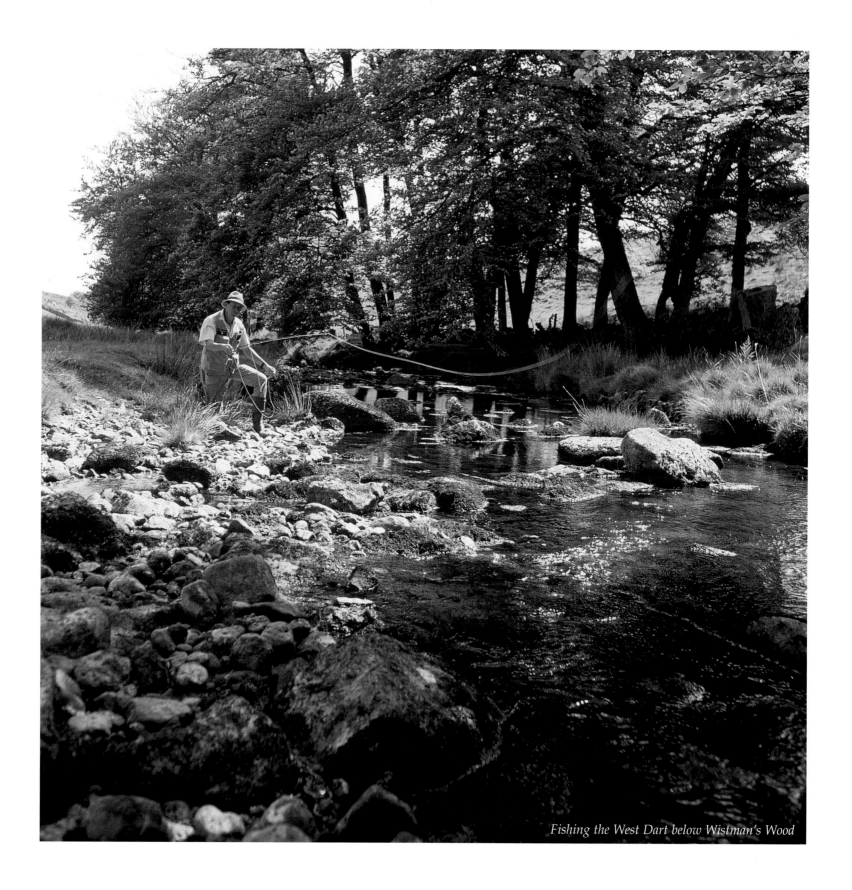

Fishing the West Dart below Wistman's Wood

common), and the beautiful lapwing which has declined all over the country, almost certainly as a direct result of changes in farming methods.

Curlews still nest on the moor but in much reduced numbers. I can remember eagerly looking forward to seeing and hearing the curlews arrive whilst living at Powdermills, that lovely bubbling courtship song would carry for miles over the boggy grasses of Smith Hill, and Muddilake Newtakes as well as Powdermills itself. I once found a curlew's nest very close to the nest of a snipe, perhaps the most successful of our breeding waders, both nests were quite close to a very distinctive bend in the Cherrybrook and the site was therefore quite easy to view through binoculars from the farmyard, we left them in peace to successfully incubate and rear both broods.

As Dartmoor rivers go, the little Cherrybrook could not be more typical, rising as it does a little north of Brown's House and then running almost in a straight line through the peat bogs and cotton grass of Hollowcombe Bottom, before becoming a proper stream by the time it gets to Powdermills. The gravel beds at this point will have revealed last year's spawning by salmon and sea-trout and the young alevins will be lying amongst the stones, slowly growing to face two years' of freshwater survival before migrating down to the ocean to feed on the rich pickings of sand-eel and krill, entering the sea at seven or eight inches, the sea-trout will return in a year or so as fully adult fish and make the hazardous journey upstream to the same spawning beds. Depending on how long they spend at sea, the salmon will return after one year at between 4–7lbs and after two years at sea could weigh anything up to 15lbs plus.

The brown trout population begins to stir at this time of year, with insect life becoming more active as the days become longer and warmer. It is also at this time that the wild trout come into their own, providing, without question, my favorite form of angling. I have been very fortunate in my fishing career and have been lucky enough to have had the opportunity to fish for exotic species all over the world. I've landed 200lb sharks from a Namibian beach, battled with giant Nile perch in Lake Nasser, and caught king salmon in British Columbia, but the joy of angling would be much reduced if I could not get my annual 'fix' fishing for the wild brownies on Dartmoor.

A Perfect Day on the Cherrybrook

Picture this: it is mid May and the past week has seen some changeable weather. The river itself has fined down nicely after a small flood; today the temperature has risen slightly and there is the merest puff of a southerly breeze. I've stopped

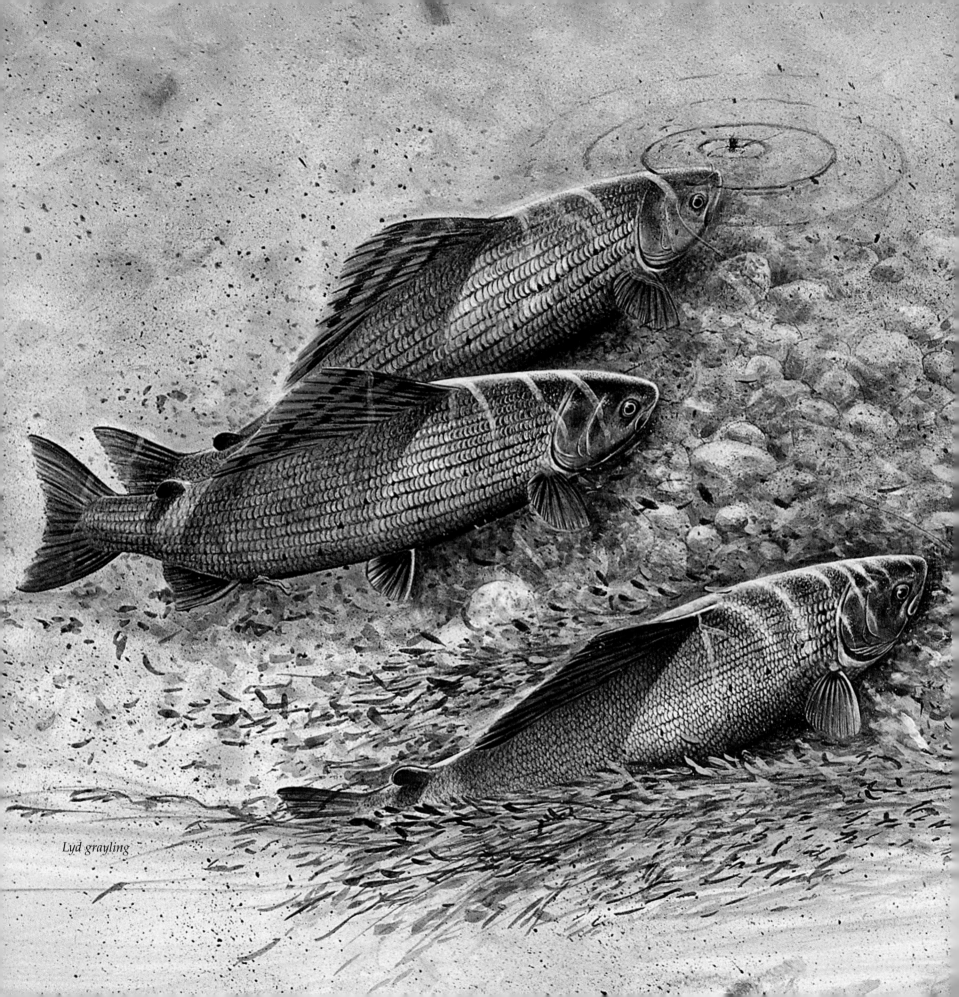

Lyd grayling

Robin Armstrong

at Two Bridges to check the West Dart and get my Duchy permit. The Dart looks fine, with very little colour and just a few centimeters above normal flow; the short drive to the Hairy Hands Bridge over the Cherrybrook takes but a few minutes and I park my car on the edge of Bellever forest, the place where many years ago the very last of Dartmoor's blackcock used to gather for the 'lek', when the males would fight it out for the right to mate the apparently disinterested females, known as greyhens.

Having gathered my gear together (and there is very little of it!), a 7ft split-cane rod made lovingly by my friend Paul Cook, fashioned from Chinese tonkin and glued together in strips to provide maximum strength and precise tapers. The reel could be any model really but in order to compliment the beauty of Paul's rod I'm using a recently reproduced Bougle made by Hardy Brothers of Alnwick. The original pattern of this reel was made in the 1930s to the specification of a Monsieur Bougle, based roughly on the design of the already existing 'Hardy Perfect', but the new model was made in lightweight aluminum with raised pillars and a rolling line guide. Original models can change hands for upwards of £1000 and are much sought-after by collectors. My reel is just as fishable and matches the little cane rod perfectly; add to this either a silk line (I still have a recipe for dressing them), or one of the new synthetic lines, a small box of flies and a small creel. My creel was made by Malcolm Greenhalgh's brother who, in his business as basket-weaver and part-time vicar, could fashion a mean creel and bless it at the same time!

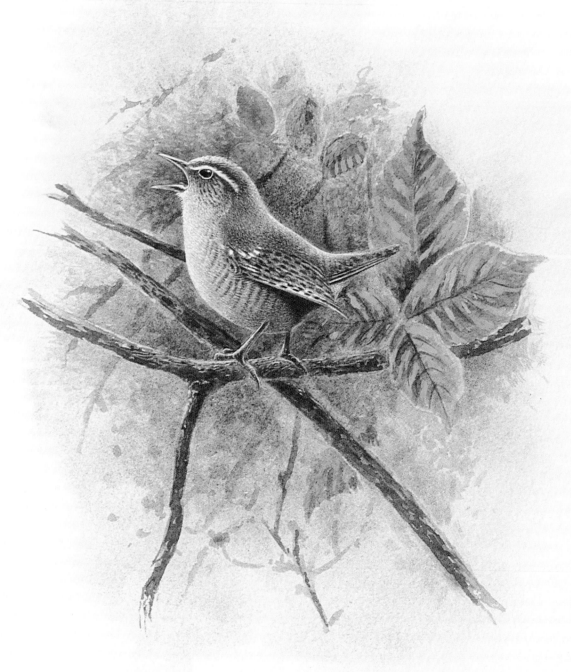

Singing wren

Robin Armstrong

Once on the river it's much more a question of looking and waiting than casting blindly at every ripple. As to fly patterns, I think size is the most important thing, taking note at what, if anything, is coming off the water; a few olives perhaps, or less commonly a March brown or two, would be the most you could expect from these exposed moorland streams. Patterns to try might include pheasant tail or red spinner, and it has to be said that most of the food that moorland trout eat comes off the land and not from the water. So to choose a fly pattern that represents a terrestrial insect is probably far more likely to succeed than trying to 'match the hatch' as one would on a lowland river or chalkstream.

I once knew a man who fished the Cherrybook in a unique and dedicated way. By special arrangement with the farmer he had sought permission to place and then to conceal a small caravan in one of the tumbledown buildings on the old Powdermills site, opposite the Clapper Bridge. I first met him one evening in early May by the bridge itself; he was bemoaning the din created by the numerous jackdaws nesting in the old powder chimney. Having established his birth-place, not just by the gravelly accent but the sporting of a full highland kilt, including sporran and skean-dhu, I asked him how long he had been coming to Powdermills.

'Twenty years,' he replied. 'I come whenever I want to think or fish.'

I asked him where he stayed during the week: 'Away down in Bovey Tracey' he said, as if it was a continent away. He produced from his sporran a pack of Capstan Full-Strength ciga-rettes and offered me one and, when I declined, he took one himself and lit it with an old battered Zippo lighter, the flame nearly igniting his grey and nicotine-stained mous-tache. Returning the pack of cigarettes and the lighter to his sporran he then produced from the same place an ordinary matchbox, which amidst a great cloud of smoke he flicked open with the forefinger of his right hand, thrusting the box under my nose. 'This is all I ever use here.'

135

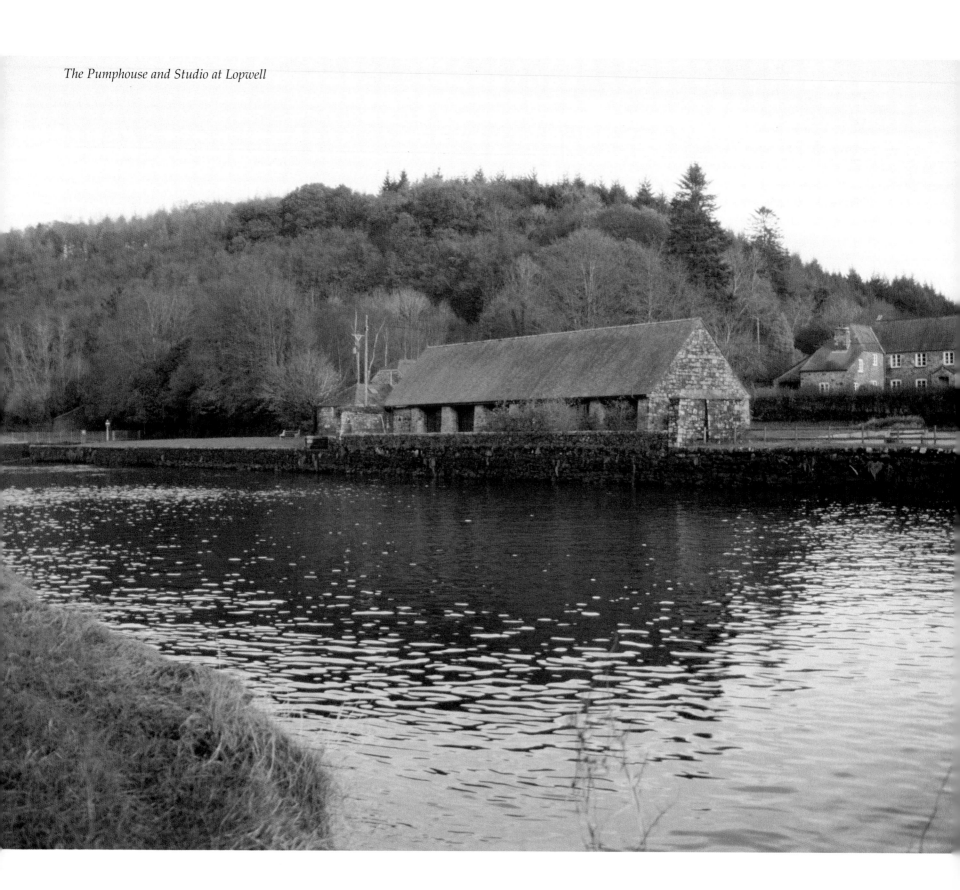

The Pumphouse and Studio at Lopwell

Inside the box was half a dozen smallish flies, with a peacock herl body, a ginger hackle and a little orange tag. 'Grayling flies they are,' he said, 'they represent some little beetle or other off the moor.'

'What's the pattern called?' I enquired.

'Treacle parkin,' he said expressing a great Highland roll on the 'r'. 'I've had fish wi' these when nothing else will work, apart from,' and he stopped...

'Apart from what?' I asked.

He looked me up and down and seemed to decide that the last thing I represented was any kind of authority. 'Apart from the garden fly,' he confided. 'We come some weekends when the wee brook has been in flood, then's the time to turn over a few rocks and collect the garden flies.' I smiled and this seemed to please him a little, even the jackdaws seemed to fade into the background. 'I fish even the garden fly with my fly rod,' he said, as if it made fishing the worm more acceptable than with any other type of rod!

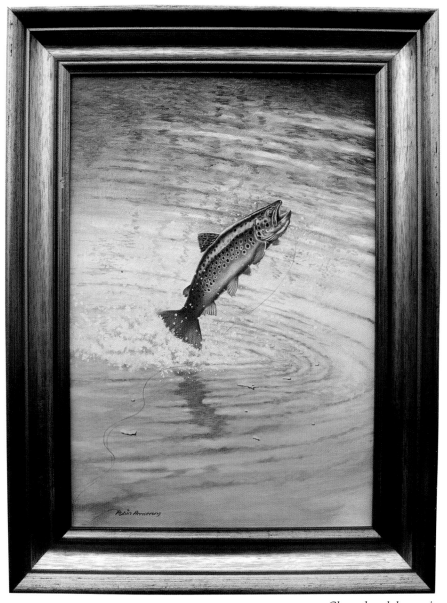

Cherrybrook brownie

We enjoyed many a conversation after this first meeting, and often enjoyed the fruits of each other's success with the wild trout.

Back to my perfect day: I will often go downstream into Smith Hill Newtake and fish a treacle parkin up into the throat of a likely looking pool, often with positive results; the fish are on the whole very small, a good one is 4 ounces, a taker is half a pound, and monster is 12 ounces. There are bigger fish in these streams but anything larger than a pound is certain to be a cannibal, with a great ugly head and jaws like a crocodile. One exception was a fish I caught in the

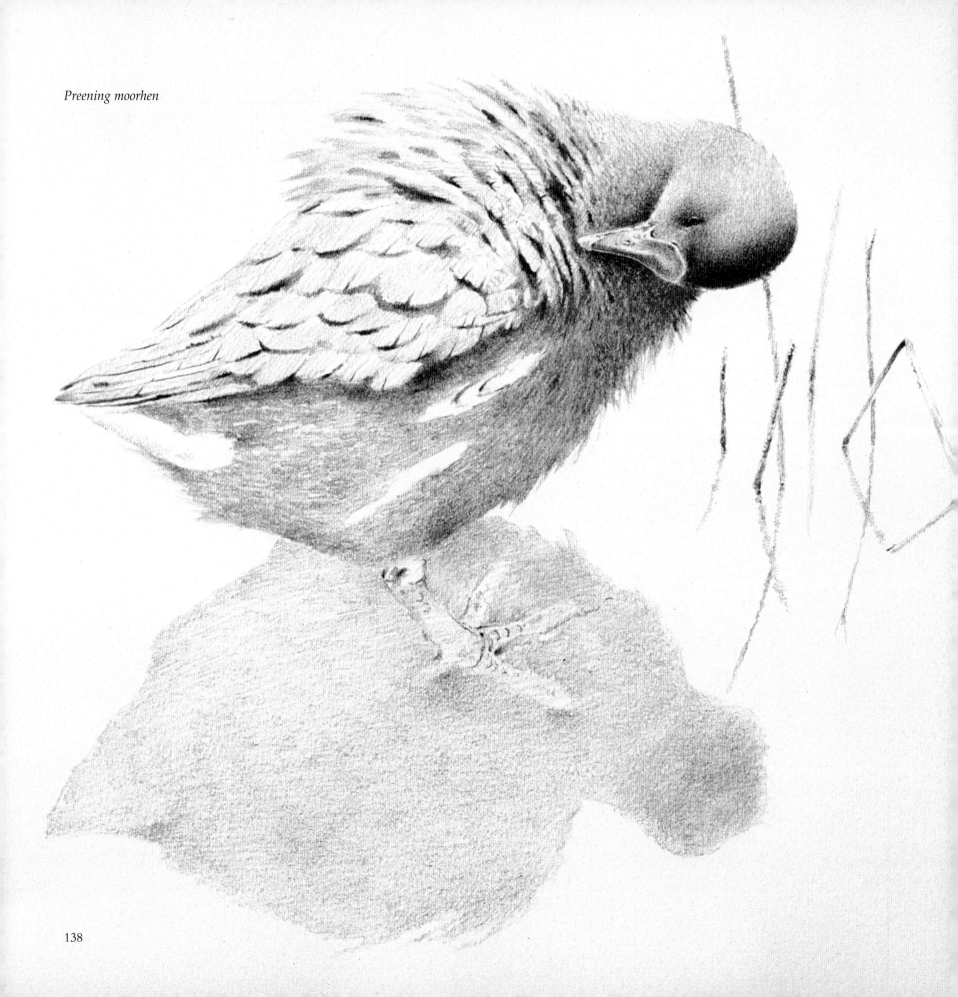

Preening moorhen

Walkham in a spate during April, it weighed 2¼lbs, was perfectly proportioned and to date remains my best-ever wild Dartmoor brownie.

If you've had the good sense to pop a bottle of white wine in your creel, and had the good fortune to land a couple of 'takers', pop them into the creel on a bed of fresh dock leaves (fern leaves will do if you can't find docks), and they will remain as fresh as daisies. When lunchtime beckons stop at some suitable place on a gravel bank, well away from the grasses and heather, build a small fire (surround it with rocks to doubly ensure that it doesn't spread), and into the square of foil that every trout angler carries in his or her creel, place the trout. Put the foil on the fire for about ten minutes and in the meantime pour yourself a well-earned glass of wine, remove the trout from the fire and put it aside to cool while you put the fire out. If you've had the extra glass you may lean back and nod off to the sound of the river tumbling its way over rocks and stones; the skylarks will be up on high – the only thing between yourself and heaven.

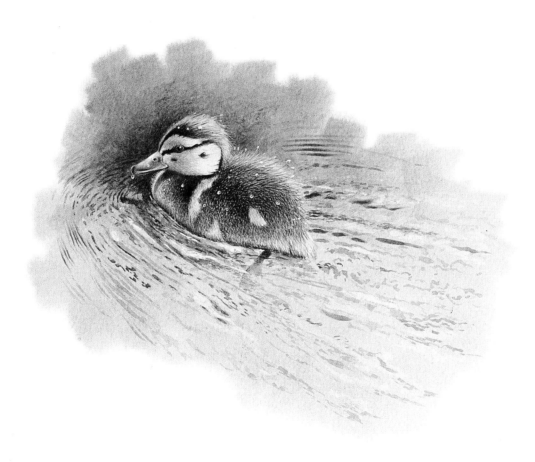

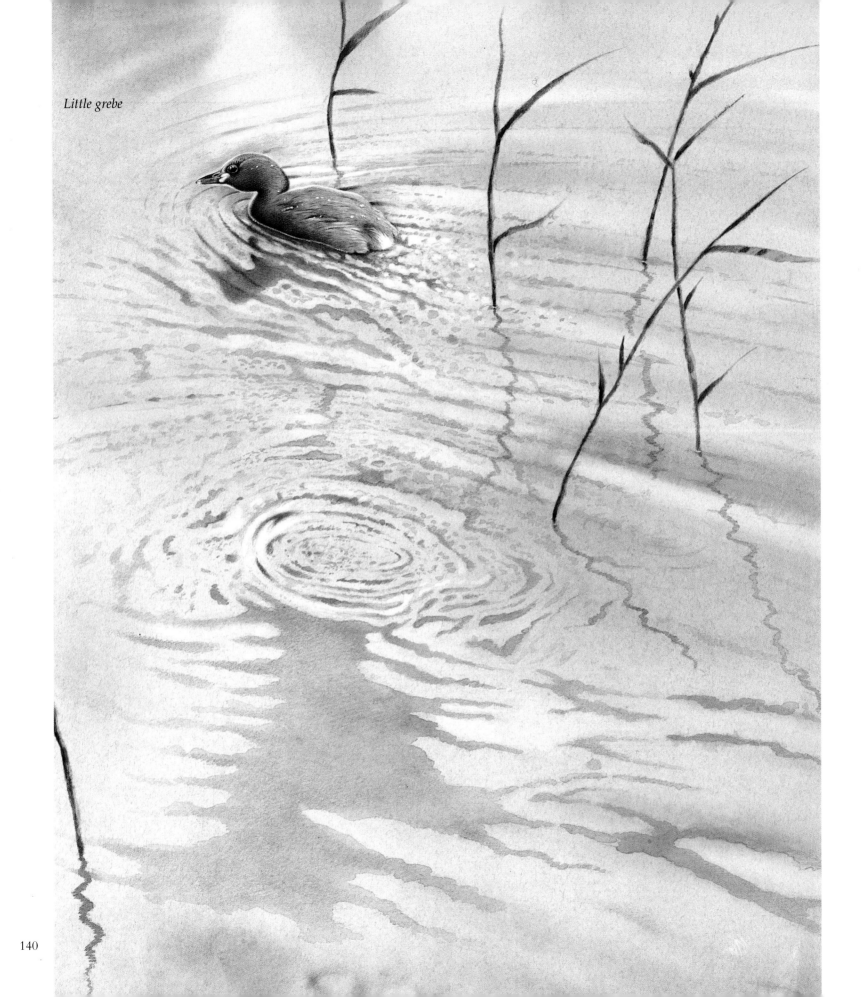

Little grebe

140

Moving Downstream

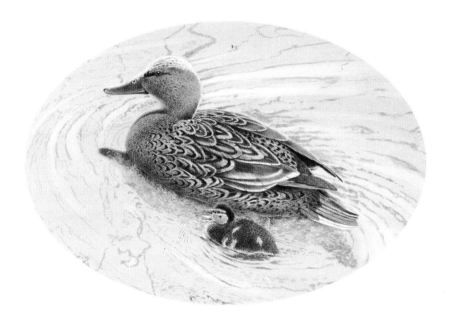

Brother Piscator, my friend is an honest Country man... a most downright witty merry companion that met me here purposely to eat a trout, and be pleasant, and I have not yet wet my line since I came from home: But I will fit him tomorrow with a trout for his breakfast, if the weather be anything like.

The Compleat Angler – Isaac Walton

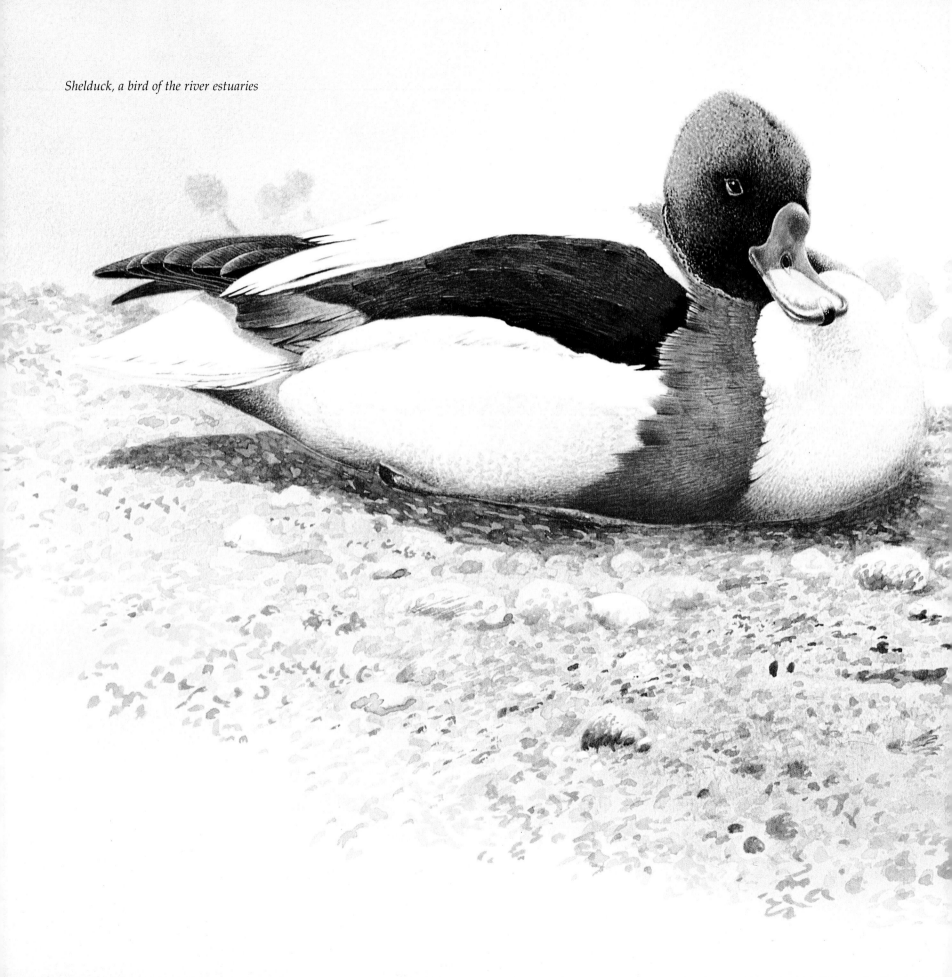

Shelduck, a bird of the river estuaries

The largest cannibal I ever caught was on the Walkham about a mile above Huckworthy Bridge. During my 'drift downstream' I had rented a cottage by the bridge, and naturally enough I had secured the fishing as well. This particular stretch of river was very overgrown, not just with coppiced hazel as it was upstream at Woodtown, but with the thick almost impenetrable gnarls of rhododendron, twisting and curling into the very stream itself. Penetrating light would press its way through the thick green mantle finding its way on to the water; a spot here and spot there. Even in these dark and moody places our ubiquitous brownie could thrive. There were one or two pools where the roots had become so interwoven that small diversions had begun to form in the stream itself. In one such place a mini ox-bow had been created, with a deeply undercut bank forming the pool; it was here that on a Sunday afternoon stroll that I had stopped to peer quietly over the bankside and into the undercut.

The day had been mild but windy with white scudding clouds moving across the sun. I lay on the bank and crept forward slowly, shielding my eyes from the intermittent glare with one hand as I did so. Fish watching requires the same skills of time adjustment as night vision, so I just lay there quietly for a few minutes whilst my eyes become accustomed to the underwater world into which they were peering.

After a while I began to scan the riverbed below; I could make out two large rocks with a scattering of smaller ones.

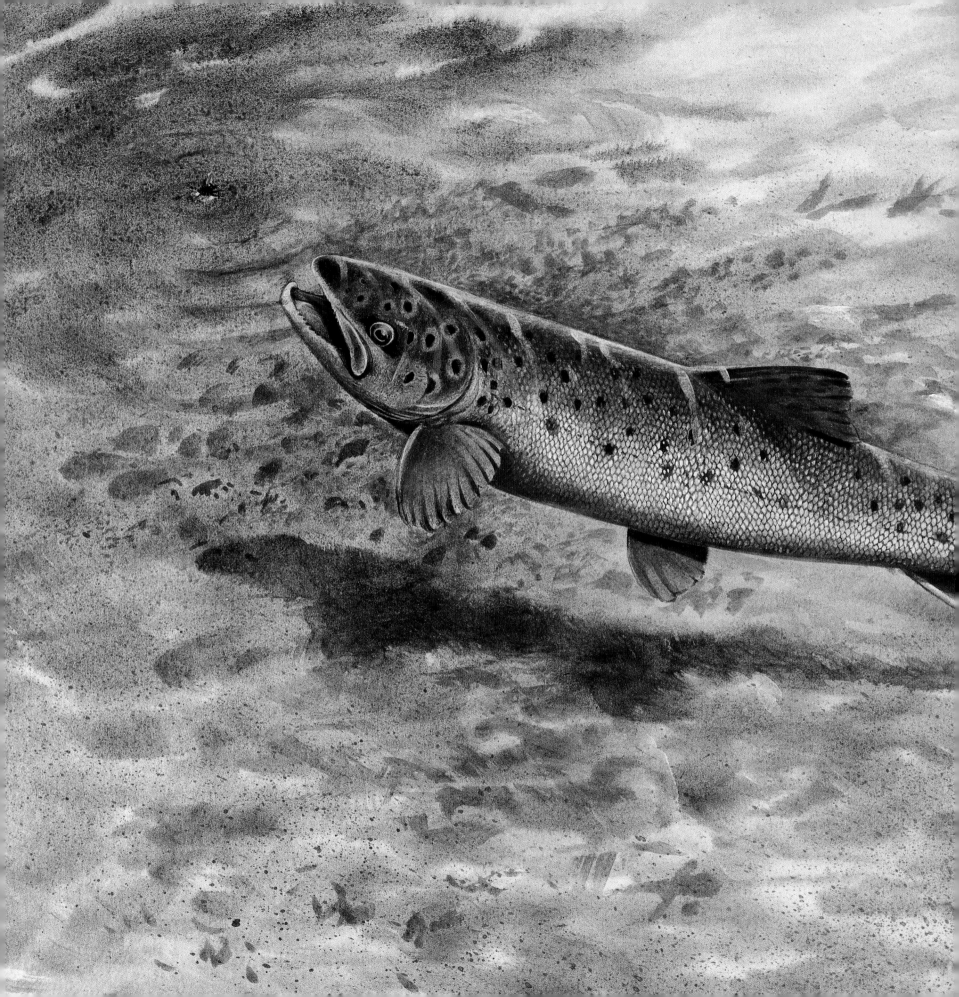

Brown trout

These formed the main part of the pool, one or two roots left naked by the waterflow twisted down among the rocks. Looking into this dark mass I began to notice a tiny movement behind one of the rocks, and staring more intently I recognised the familiar shape of a fish's tail, not just any tail, but a huge paddle of one, swaying majestically in the stream. I knew it was a trout, but at first I thought it must be a sea-trout up from the tide and resting before the next move upstream. But slowly over the next few minutes the fish dropped back slightly off station, and I could now see the anal and adipose fins. The adipose fin was a deep red colour and the anal fin had a distinctive white leading edge and a slight convex shape to it; I knew now that I was looking a brown trout and because of the convex edge on the anal fin, probably a male, but this was a monster! Guessing the size of the fish in the water is difficult at the best of times, but with previous experience to hand, I levelled an estimate of 1½–2 lbs and this would indeed be a giant for a stream like this. Backing off gently I left the pool quietly and made my way back to the cottage, all the while my mind racing with thoughts about how and when I was going to pit my wits as an angler against those of this old campaigner.

It was early April and the weather had been typical, with days of wind and rain followed by days of quiet calm, when early brimstone butterflies could be seen flapping from their ivy winter roosts. Because of the overgrowth it would be impossible to fly fish this stretch, so I had to find another way. In the early days I would probably have

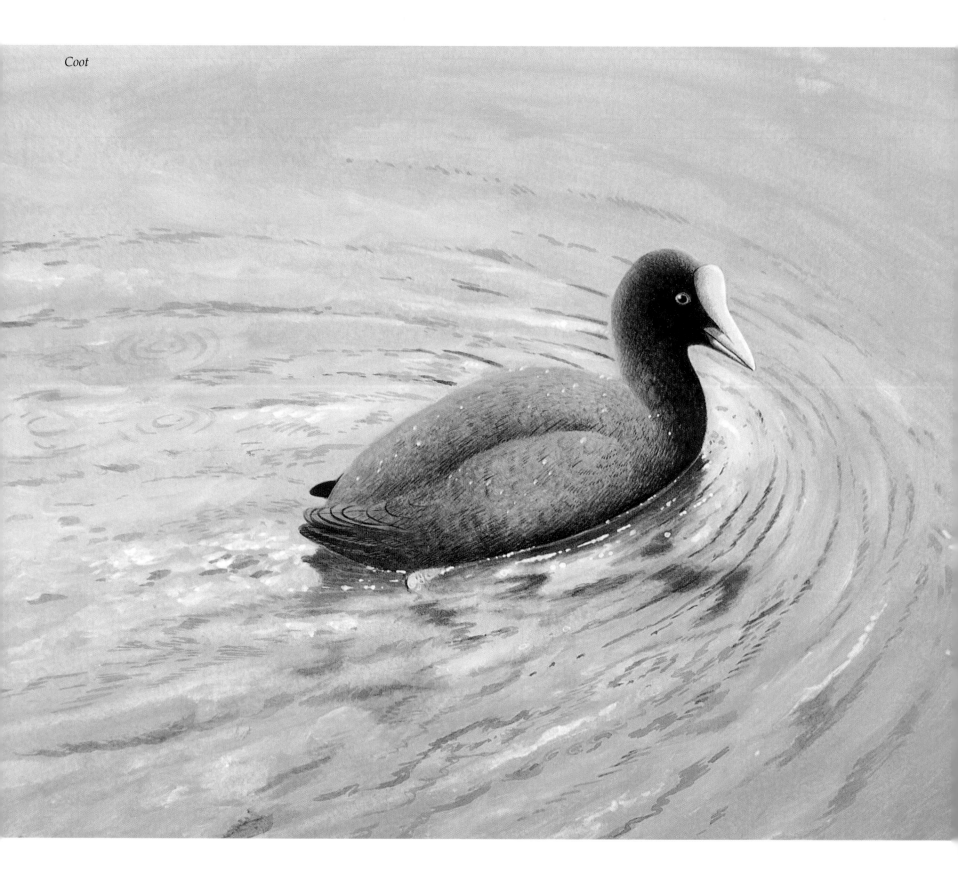

resorted to a night line and a big worm, but things had moved on, I no longer needed to catch this fish for food and therefore this method would give me no satisfaction whatsoever. My only way would be to try him with a lure, what type of lure didn't really matter; the problem was going to be getting a cast into this most awkward of spots. The next problem was going to be when? This wiley old trout had got to this size by being a lot cleverer than his smaller cousins and if I threw the lure box into the water and told him to choose his own, he would probably throw it back! He'd seen it all; I had to find a game plan that would catch him off guard.

The following week passed with no dramatic changes in the weather until Friday, when the heavens opened, the river rose by three feet and swirled and crashed under Huckworthy Bridge. Salmon and sea-trout smolts had begun their annual migration downstream and a spring spate like this would serve to accelerate the journey much, I would imagine, to the annoyance of our friend the trout, who I am sure would be used to rich and leisurely pickings at this time. I had one chance only I reasoned, when the river had fined down sufficiently to allow partial visibility to return, he may well be tempted to grab at smolts that passed his way, without overdue examination. I looked through my lure box and

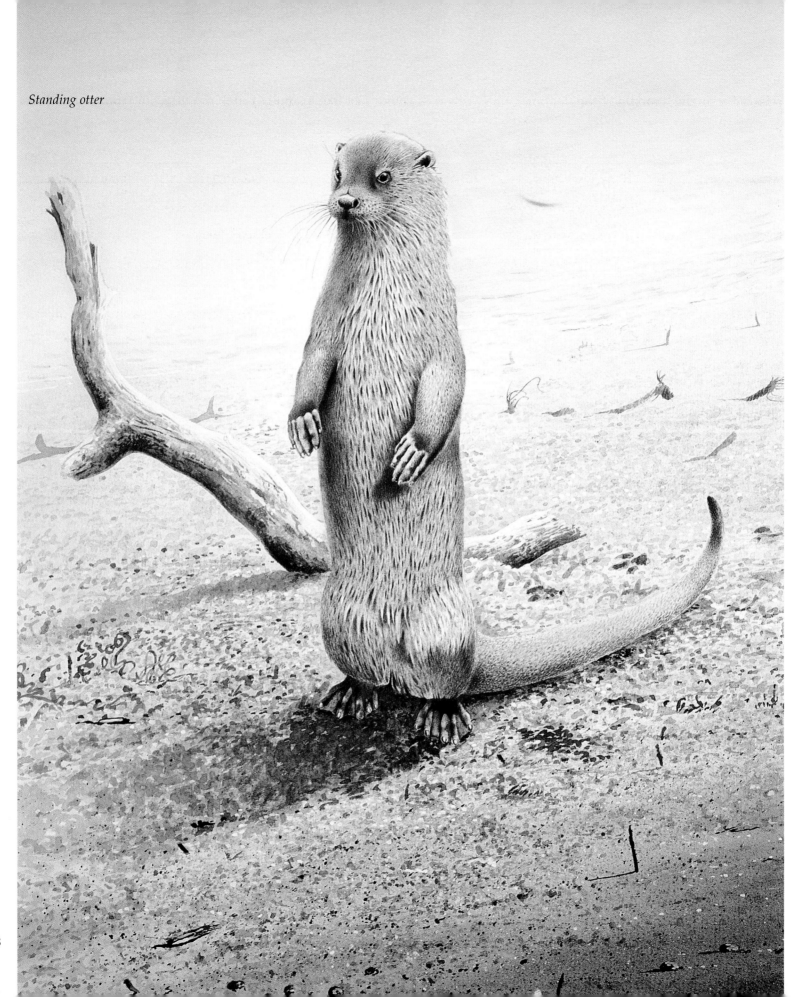

selected a smallish rapala of the floating variety, silver in colour just like a smolt. I took my little spinning rod and reel and headed for the river.

Arriving at the pool, I climbed over the roots and on to the far bank, crouching on a rock. The colour of the water was just right, enough colour to allow some visibility but not clear enough to see the bottom. I practiced a few little swings with the lure in the direction of his lie, with all the overhanging branches however, it seemed hopeless! Suddenly it came to me; I would 'long-trot' the lure down to him and then at the crucial moment start my retrieve and hopefully encourage our friend to seize the moment. Long-trotting is a method used by coarse anglers to introduce a bait to fish such as roach, chub etc. A float is used to drift downstream, line being let off the reel without hindering the progress of the drift, therefore presenting the bait in a natural way.

On my first drift down the lure snagged on a piece of loose wood and despite my efforts to free the hook, it held and so I let both the wood and attached line float past the lie before gently coaxing it back to me, undisturbed. I tried again and this time the rapala floated perfectly over him, I started my retrieve, a few turns of the reel and it was over him; nothing happened. A few turns more however and I saw a broad yellow flash as the fish followed the lure out into the mainstream. Good! I'd managed to get him away from his lie, my only concern was that he'd seen the lure and recognised it for what it was. I reeled in the rest of the way and just sat watching for a while; suddenly I saw the flash again followed by a splash as he grabbed a smolt that had ventured too close. Damn! He's just eaten, how long would it be before he will move again?

Nothing happened for a further half an hour, so I decided to give it another go, and this time the lure sailed perfectly over the lie, a quick tug to get the diving blade working and I started my retrieve. I say started, I got one handle turn into it and bang – he was on! What followed seemed to take forever, but in truth probably took no more than a few anxious minutes. He tail walked across the stream and crashed into some vegetation under the far bank, I held firm and gently coaxed him out into the mainstream once more, this time he bored and sounded towards his own lie. I couldn't let him do this because once he reached those roots I felt sure he would get my line around one – I threw the little rod to one

side and applied as much pressure as I dared; fortunately everything held and slowly but surely I began to get the better of him. A couple of minutes later and he was nearly ready for the net. My first attempt failed as I tried to draw him over the rim, he kicked off again into the main flow, but I knew he was nearly beaten because this last effort was only half-hearted, one more try and I had him beside me on the bank. A small 'yes' of self-congratulation and I gave him the *coup-de-grace*, popping him into my creel.

Standing up for the first time in what seemed like hours, I stretched my legs and started to head back. I knew he was big but as I didn't have a spring balance with me, I could only guess at his weight, which I put at around 2lbs. As it turned out I was spot on, but I didn't add on the weight of the three salmon smolts that he regurgitated in the creel on the way back! If added on this would have made him 2¼lbs, easily the best wild trout that I've caught on Dartmoor.

Art Imitating Nature

You could easily be forgiven for thinking that I spend my whole life with a fishing rod in my hand, but sadly this couldn't be further from the truth. Painting for a living is a hard discipline to follow and in order to pay the bills I have had to keep my nose firmly to the grindstone when the work was there to do; my style and technique has also meant that I have had to almost constantly 'bone up' on wildlife and the environment in order to stay ahead of the game.

Watching wildlife is one way of doing this, and by watching I mean just that, I don't mean going to a zoo or a wildlife park and banging off half a dozen photographs without really looking at the subject; these days I see lots of 'so called' paintings of wildlife as seen through a camera lens!

Cuddly little tiger cubs looking perfect in every way, every hair in place and good enough to eat! Ask yourself this – when was the last time you saw a fox cub

Grey seal studies

looking down into the water
but out of stabbing range

Little Egret studies from the s...
plumes. I watched this bird...
25.4.002 — Mick Netor...

...window... a bira spending breeding
about... an hour through the 'scope

Egret studies

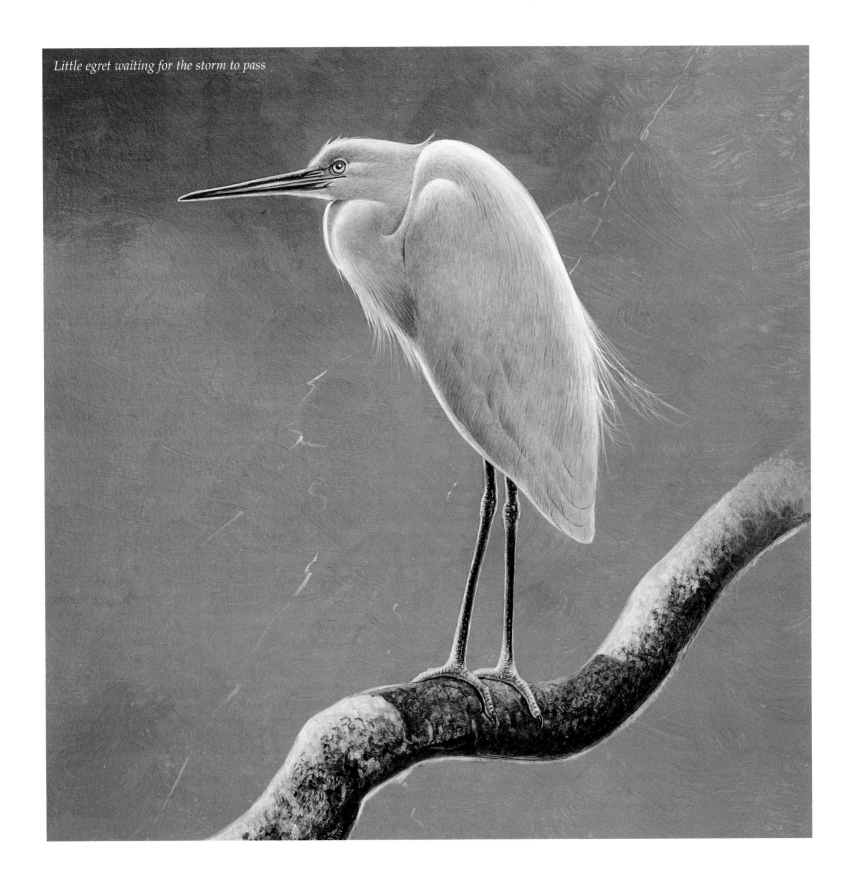

Little egret waiting for the storm to pass

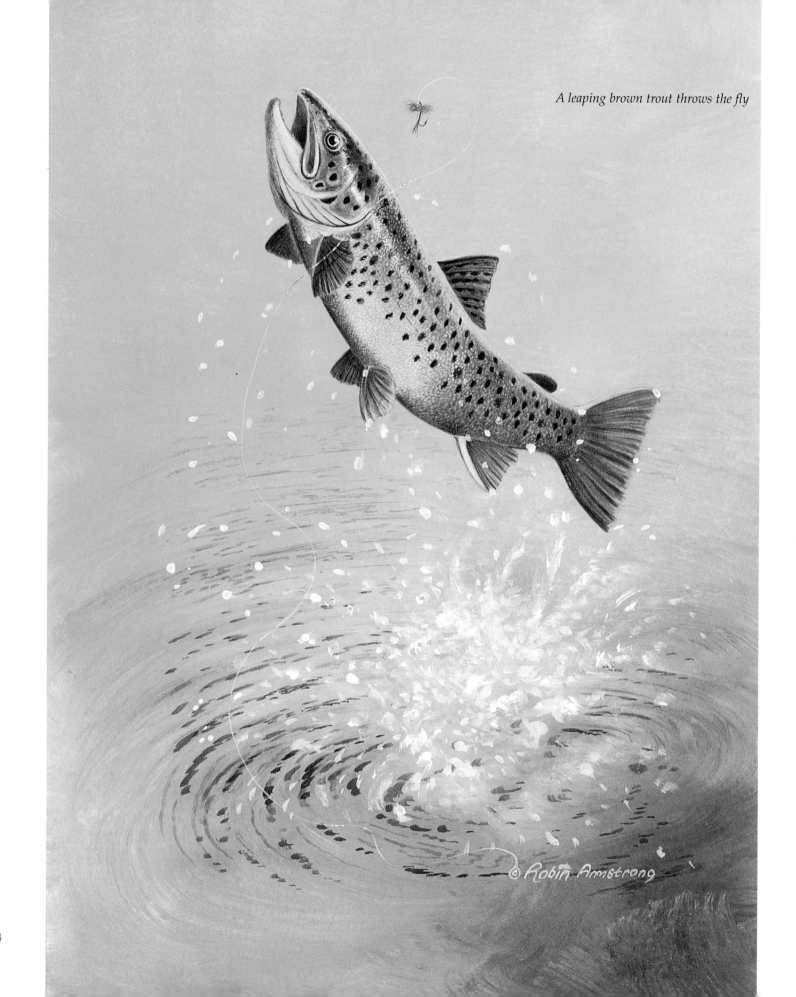

A leaping brown trout throws the fly

© Robin Armstrong

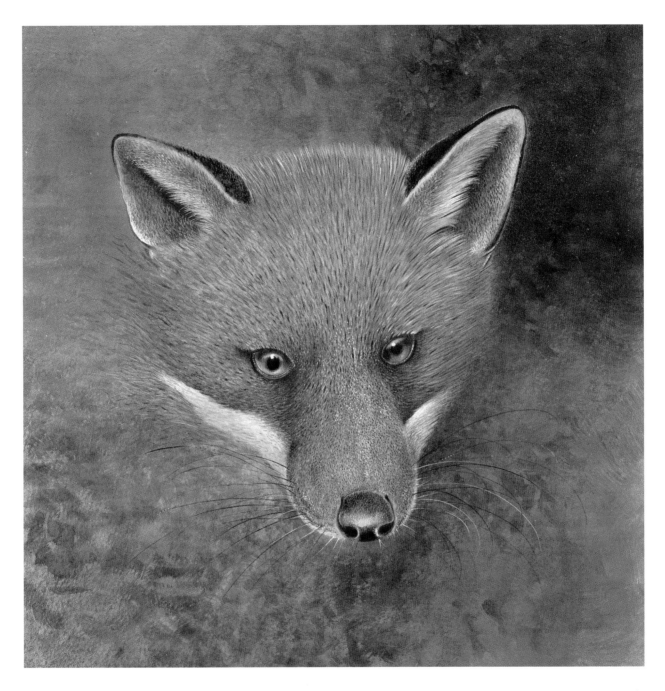

looking as though it had just come from Vidal Sassoon's? They are usually covered in mud, often with a bit of ear missing, caused by a scrum with a brother or sister, and yet the public appetite for such sentimental subjects seems insatiable. Print shops that call themselves galleries are full of mother-and-baby pictures of everything from giraffes to hippos, all done directly from photos. Put on a pair of wellies and come with me downstream to where the dipper flies and soak up not just the sights but also the sounds, the smells, and most of all the atmosphere.

Just as Dartmeet is a honeypot for visitors to the Dart, so Grenofen is for visitors to the Walkham Valley. The tiny ancient bridge that spans the river carries many thousands of vehicles and pedestrians each year, and yet even here, where man has stamped his seal in an indelible way, wildlife can be observed in a truly natural environment.

Walking downstream from Grenofen along the riverbank will bring you into contact with everything that the river has to offer, not perhaps on a Sunday afternoon in August, but certainly at six o'clock on a morning in June!

Dippers are an obvious sighting; fiercely territorial you will see the males flying back and forth over their 'patch' calling for other dippers to stay away. Get down to about halfway between Grenofen and Double Waters, and on the right-hand bank you will come to an outcrop called Ravens' Rock. Although it must be some time since that bird nested in so public a place, nevertheless Ravens' Rock now teems with other life, lichens and mosses, ferns and insects. Wrens go about their daily foraging for insects; and here is a place to look for pied flycatchers, a small colony having been established in recent years. By the river itself you will see trout rising and if you are lucky you may see, by peering into one of the pools, a shoal of fresh-run sea-trout, lined up like soldiers, waiting patiently for the rain that will send them on the next stage of the journey upstream.

Watching wildlife in this way is so much more important than some guided tour because it allows the viewer to formulate his or her ideas as to why things are as they are. Don't misunderstand, being shown around a safari park or a bird sanctuary in a group can be great fun, especially if you can be shown things that you haven't seen before. What I am advocating however is that just once in a while you leave the bird books behind and just go and mingle.

It was on one such walk that I first met Andrew Spedding. 'Spud' as he was known to his friends, had recently bought a small farm, Heckwood, a mile or so above us at Woodtown. As in a lot of cases, looks can often be very deceptive, as I had Spud down as a public schoolboy who had moved to the country with perhaps his inheritance and a part-time job in the family firm of solicitors. His tall, boyish figure, topped by an unkempt mop, and bottle-bottom glasses, seemed to convey the appearance of someone who rarely travelled far from home! How wrong could I be?

As the months went by I saw Spud a few times but by no means regularly, but as we got to know each other better, we realised that we shared similar country passions. I discovered that Spud was in fact a professional adventurer, sailing being his main forté. He would be hired by all manner of people to deliver yachts to exotic places. On one occasion, having just

Grayling etching

sailed single-handed across the Atlantic he returned to his local in Birdham, Sussex. Walking into the bar after weeks of being at sea he was greeted by the barman who asked, 'Usual Spud?' Without a single reference to what he had just done, such was his modesty, he replied 'Yes please, Tom,' and taking his pint he went and sat in his usual corner and started reading the newspaper.

Part of Spud's land bordered the Walkham and being just that little bit further upstream the geography of the river was different; long pools, glides and undercut banks made way for a series of what can best be described as 'pots and guts', dropping levels rapidly. Here a small, turbulent pool would give way to a narrow run and so on until it levelled out when it reached Major Roleston's stretch at Holetown.

In low conditions these little holding pools could harbour some very good sea-trout and also salmon, as well as a good head of brownies. The fish would tuck themselves well in under the rocks, some of which are huge, laying there

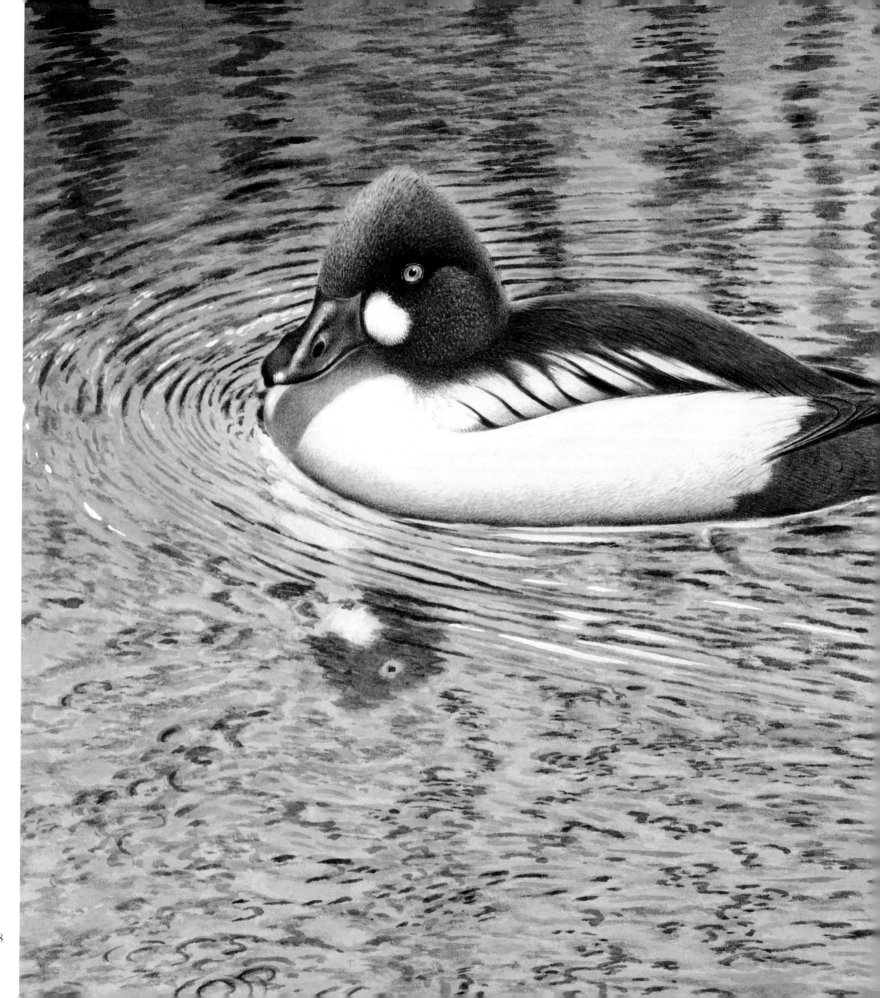

Just occasionally we get treated to a real one off on our Dartmoor rivers, and one such case involved this magnificent male goldeneye in full breeding plumage.

My friend Graham Mabbot is lucky enough to live beside the Plym near Bickleigh. A retired police dog handler, Graham and I worked together many times when I was a river warden.

On day he rang to say that he had a goldeneye on the sea trout pool outside his cottage. Somewhat sceptically I went down straight away and sure enough he was right! The bird seemed almost tame, suggesting it could have been an escapee from some wildfowl collection, but in any event I was able to get some really good sketches before it flew off and headed towards Plymouth.

Goldeneye drake

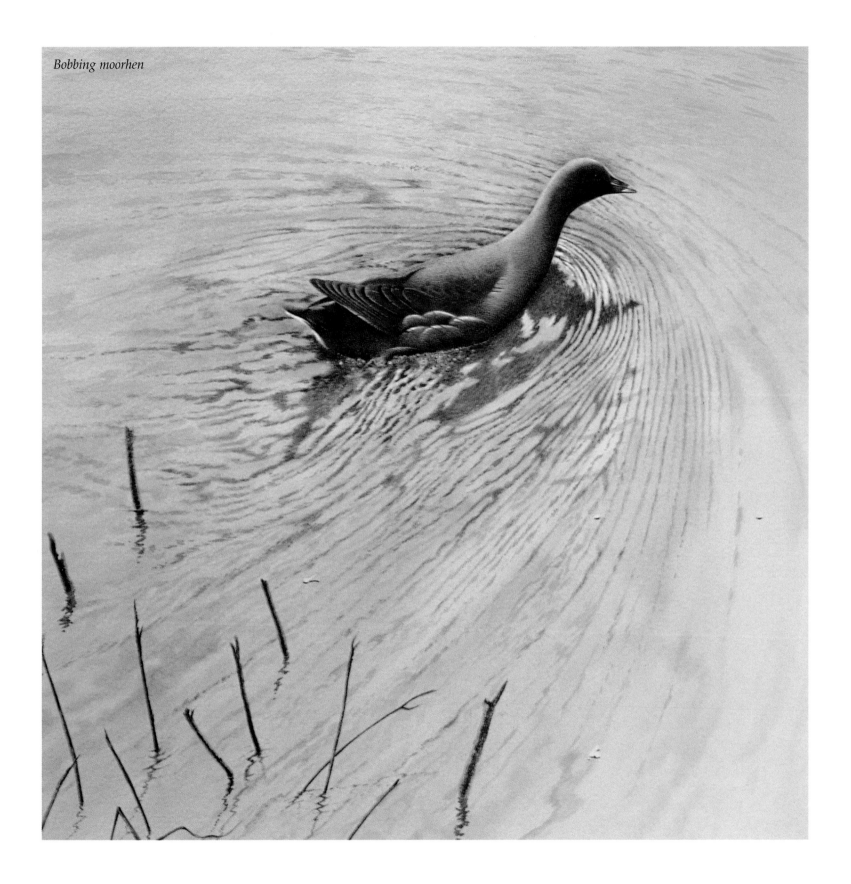

Bobbing moorhen

160

undisturbed (apart from the threat of poaching) for many weeks at a time, the highly-oxygenated water bringing blessed revival into their travel-weary bodies.

When rain comes however, these quiet places can change in the blink of an eye. What was previously a crystal bab-bling brook, becomes a mighty surging torrent, crashing and boring its way from the high moor to the mid-land and estuary below. You can no longer hear the sound of birdsong, or anything else for that matter, only the deafen-ing roar of the river as it forces itself into nooks and crannies unapproached in normal conditions. Roots, trees and rocks them-selves are sometimes picked up as though they were ping-pong balls and hurled unceremoniously towards the sea.

For many years I just assumed that when these conditions prevailed, migratory fish would stir, point themselves in an upstream position and run like hell until they reached the next resting place. You wouldn't expect to see very much during a heavy spate other than the debris collected by the flood on its way through Heckwood Gorge. However, after years patrolling the banks at these times, I came to the conclusion that what the fish actually do is to sit tight during the main deluge and then, when it passes and begins to wane, they venture out from their safe haven and begin a series of pool hops. I've also noticed that the amount of suspended solids in the water has a significant effect on the willingness of salmon and sea-trout to move upstream.

Heckwood is a great place for wintering woodcock, the little coppiced hazel clumps and soft leafy floor make ideal sanctuary for these fascinating wading birds which used to be regular breeders on Dartmoor. Latterly they seem

to be confined to being winter visitors, and when lying up they can be almost invisible against their forest floor background, a fusion of dark and light flecked plumage making woodcock, along with perhaps the nightjar, one of nature's cleverest pieces of camouflage. These hazel copses are also home to a now dwindling British population of dormice. I remember seeing them in the Teign Valley in the early days quite regularly, when Brian Letts would show me the 'day nests' that they occupied during bouts of inactivity. Nowadays, they have joined the ever-growing list of animals that will continue to decline unless we do something decisive about retaining suitable natural habitat.

Many creatures rely upon these tiny surviving areas of habitat in order to survive themselves. I remember back in the late 1970s cutting a thumbstick from a blackthorn copse above Wardbridge. It was the wrong time of year to cut a stick really because the sap was rising, but because we are not nearly as good at remembering where things are, like squirrels with

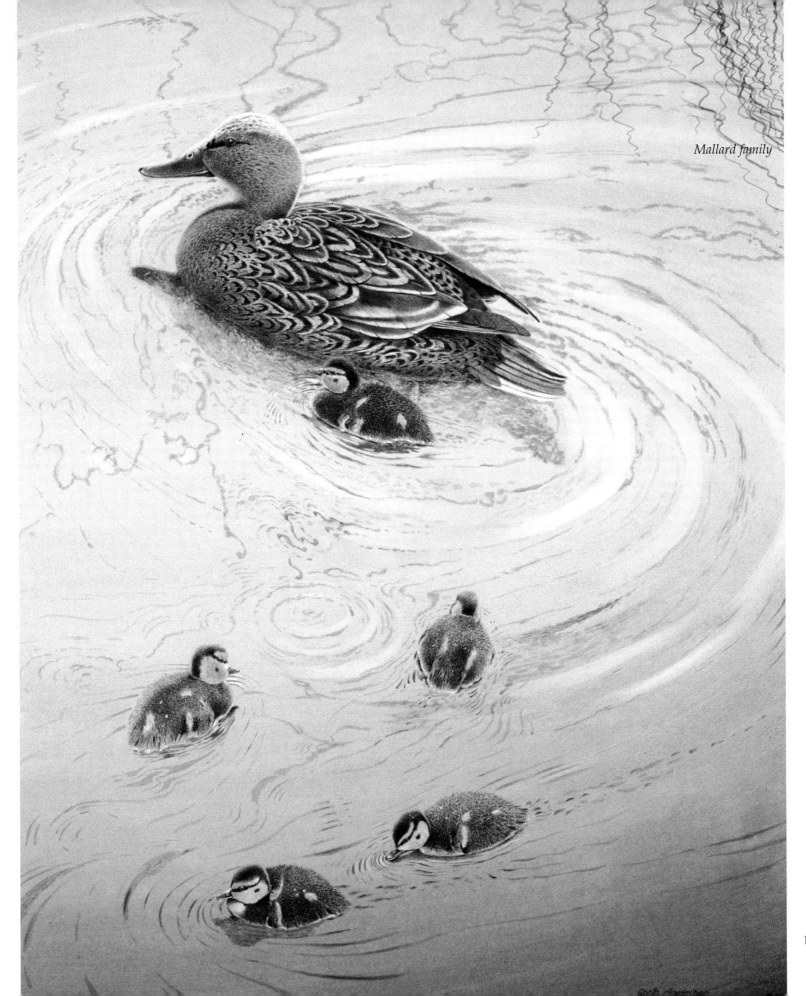

Mallard family

Young moorhen

nuts, my policy about the best time to cut walking sticks is when you see one!

As I was cutting my stick a small butterfly alighted on one of the leaves just in front of me. I stopped what I was doing, and watched as it gently opened and closed its wings as the light changed. I had little difficulty in identifying it because butterfly watching has always been a passion, and I was delighted when I realised I was looking at a brown hairstreak. These timid little butterflies often go unnoticed because they tend to fly in the topmost parts of the blackthorn clumps on which they lay their eggs. I watched this little chap for five minutes before he fluttered off and melted back into the bushes.

As always with a new wildlife sighting I was as excited as I was the first time I saw the sea! I went home to the studio and sketched the scene straightaway, noting the way the hairstreak had positioned itself on the leaf; this would make a good picture.

That evening I rang my friend Angela Rippon, who lived just down the valley. She was working on a TV series called 'In The Country' with Phil Drabble, and that wonderful countryside artist Gordon Benningfield, knowing that she'd be interested and that she would tell Gordon who was an expert in painting butterflies. A week or so later I received a charming letter from Gordon, along with a pencil drawing of a blue butterfly on a harebell, which I had framed and hung in my studio, where it still is today! I remained in contact with Gordon over the years until tragically he died prematurely.

I kept a close eye on the brown hairstreak colony; not telling all and sundry, just a few discreet friends, including Spud. The close association between that clump of blackthorn and the butterflies was obvious, illustrating perfectly the theory of

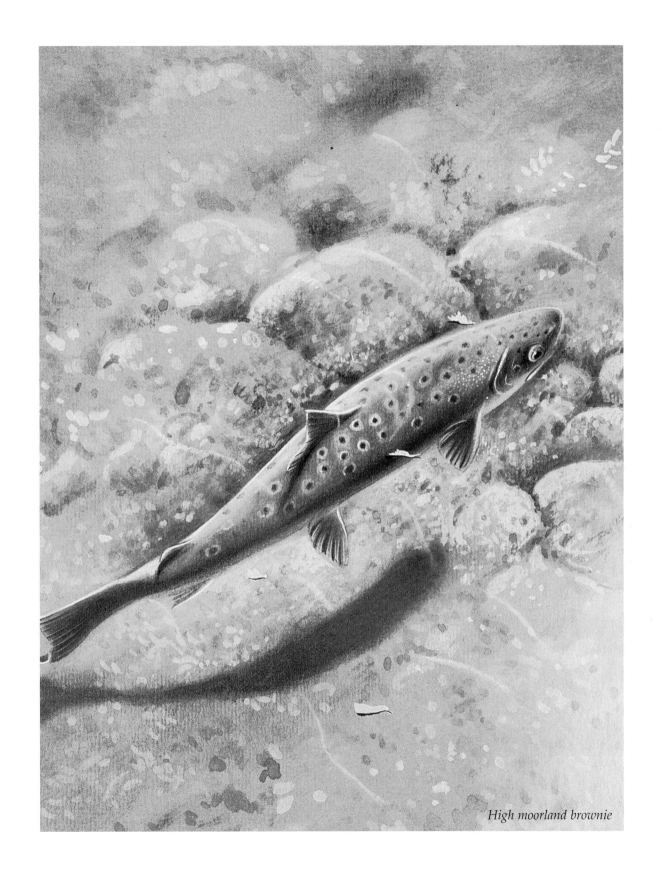

High moorland brownie

interdependence, so perfectly in fact that when the farmer decided to clear the field and the clump was felled, the butterflies disappeared never to be seen again on that site. If you multiply this one instance by all of the others that occur in our countryside, then it becomes clear why some of our plants and animals are disappearing from our tiny island at an alarming rate.

The Gillie Who Became a Lord

Spud and I fished the Walkham together on many occasions, mostly at Woodtown and Heckwood, but just occasionally we would venture a little further downstream. Mr and Mrs Pawson, who had the fishing downstream of Grenofen, would let most people who asked nicely fish their stretch and, as I was the warden for a while, that included me.

One of Spud's close friends, George Villiers, was staying at Heckwood and wanted to fish for salmon. The upper reaches were going to be hopeless because although we had recently had a good flood, most of the fish in the top beats had moved on. I knew that we'd had some fish fresh in from the estuary because I had spent time that week at Lopwell, watching them negotiate the fish ladder. George, it transpired, was a full-blown belted Earl who on succession would become Earl of Jersey.

Somewhat daunted by this, my first introduction to him saw me slightly confused as to whether to curtsy or call him m'Lord. Any trepidation I may have had, however, was soon dispelled as he shook me firmly by the hand and beamed at me saying, 'I love the painting you did for Spud, it's full of life.' From that moment on George Villiers became a friend, and this remained the case until his untimely death a couple of years ago.

I suggested that if we were to stand any chance of a salmon, then the stretch down from Grenofen would be our best option. So having cleared it with the Pawsons, the three of us set off for the river. Knowing the pools and runs well, I had a fair idea where any resting salmon would lie, and my game-plan was to put his Lordship in the likeliest places. There is some-

thing enormously gratifying about putting someone in touch with their first salmon, and despite his blue-blooded background, George had yet to achieve this 'first'.

We tackled up in the Pawsons' drive, Spud electing to fish the fly. I thought that George would stand more of a chance with a spinner because the water was fining down just nicely after the rains. Moving downstream, Spud went ahead with the fly rod, trickling a little orange tube down and through the pools, whilst George and I followed down with the spinner. As gillie for the day, I also carried a fly rod just in case the river fined down too much for the spinner.

If ever there was a situation in which I could wish a fish to take then it is one such as this. As a lifelong angler I am aware of that magical moment when it becomes apparent that you are attached to a wild salmon for the first time, and I so wanted this to happen for George. As we moved from pool to pool the sun began to push light through the trees, making for a lovely walk downstream. I had put on a 2-inch rapala plug for George to use, as the unique swimming action can be very tempting to salmon in these conditions – salmon and sea-trout do not actually feed whilst running upstream to spawn, but seem to fall prey to a kind of impulse either from feeding at sea or from their juvenile days in freshwater.

When we got to Ravens' Rock we met Spud coming back upstream; he hadn't caught a salmon but had managed to land a nice sea-trout of about 3lbs. He had seen a salmon, however, in the pool just above a place called Hole in the Wall, named by poachers because one could look through a large gap in the rocks and into the pool below. This fish said Spud 'had gone off like a rocket' when his shadow crossed the pool.

George had by now perfected his skills with the spinning rod, and was dropping the little lure and temptingly taunting it back just a little faster than the flow of the stream. I suggested we rest the pool for a while to let the fish resettle, and so bidding our farewells to Spud, who was heading upstream, we 'hopped' one pool and fished the one below Hole in the Wall. At this point it was the boundary between Grenofen and Bucktor on the left and Buckator on the right. The river here is largely uninterest-ing from a fishing point of view, being a series of channels running between deeply undercut rocks and, although fish would lie here, it would be the devil's own job for an angler to present a fly or a bait sufficiently well to give the fish time to take it. George was determined however to give it a go and after a series of miscasts managed to land a bait or two, well enough to fish the run.

By now our fish in the pool above had been rested and George went up to try a stealthy approach on his own, while I stood taking my time at the pool he'd just left. I was still carrying the fly rod and more by instinct than anything else, stripped

Framed egret

off a couple of feet of line and popped the fly into the throat of a little stickle. As soon as the fly touched the water, 'bang!' – all hell let loose. I was into a fish and a salmon at that, in the most unlikely of places, and worse still my fishless companion had just left the pool!

Some anglers get smitten with anger and jealousy when their companions catch fish and they don't, and I didn't know how George would stand on this one, especially as I was acting as gillie and guide for the day. I wanted to shrink into the ground, but the salmon was having none of it.

It tore crashing and leaping up and down the pool, and not suprisingly aroused George's attention on the pool above. He walked back and jaw wide open said 'What the...?' and stood watching as I tried to control the frantic salmon. Whenever I get into a fish in these circumstances I try and get myself downstream of it. This is because control is the key element in playing salmon, allow the fish to get downstream and you are lost. The strength of the current coupled with the awesome power of one of nature's most streamlined creatures and you are fighting a losing battle.

As luck would have it, I managed to get downstream and although the fly reel was singing like the proverbial bird, with the fish boring this way and that in an upstream direction, he was doing all the work. Ten minutes saw me still trying to coax him towards me with no success, but I was still downstream of him and so in control. He rolled once on the surface and both George and I caught sight of him for the first time. 'It's bloody enormous,' said George. 'Just look at it'.

He was quite right, it was big, by far and away the biggest salmon I had seen to date, a very rough 'guesstimate' had me thinking 18-20lbs, possibly even more! With the fish showing no real sign of tiring, I decided to change my tactics. If I could somehow get the fish to move into the pool below without losing my downstream advantage then I was sure that I would be able to get more control over the situation. I walked downstream with the rod held high above my head and applied as much pressure as I dared without risking a break on the 10lb leader.

He came with me; slowly at first and then as we got to the throat of the pool more quickly, being pushed by the current between the two rocks that defined the entry into the pool. By now George was standing beside me offering all the advice on how he would land the fish! Just for a few moments I eased off the pressure, for no other reason than pure fatigue; my arms were aching from all the pressure and tension of having been attached to this leviathan for twenty minutes. When I had regained my composure I tightened up on him once more, this time however the resistance was less. I could feel him

Mallard

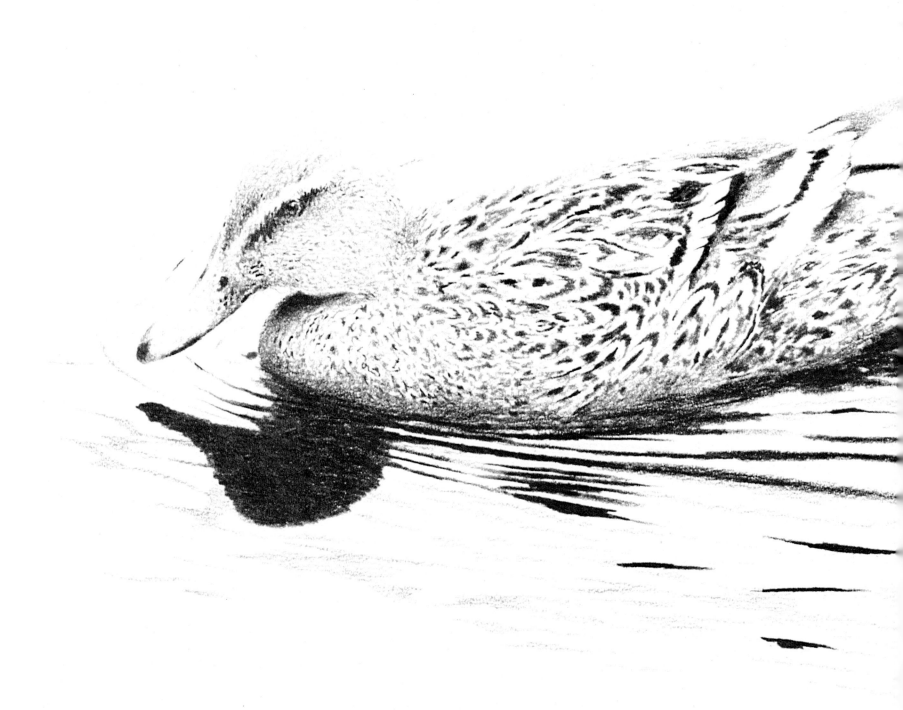

giving way as the combination of pressure and current began to take their toll. Five more minutes and he was at the tail of the pool where the water was quieter, rolling gently in the stream. George asked me if I was ready for the net. 'Yes, my man.' I said cribbingly as the big salmon slid over the net rim, and George carried it ashore and put it on the bank, well away from the water's edge.

We both looked in wonder at the mighty fish as it lay exhausted on the grass. It was a male, its huge kype already developing and, although not stale, the gorgeous red spawning livery had begun to appear on his flanks. I popped him into a weight sack and hooked up the spring balance, the needle thumped down to just a tad under 19lbs, my biggest salmon ever to date, and a worthy adversary indeed. I decided then that I wasn't going to kill him and together George and I gently held him, head-upstream, until the lactic acid in his body that had built up during the fight, died away. With a mighty 'thwack' of his tail he swept up into the pool from which he had come, probably a lot wiser from the lesson he had just learned.

All the talk back at the Peter Tavy Inn was about how his Lordship had been made gillie, and the gillie became the lord! And George never did let me forget it!

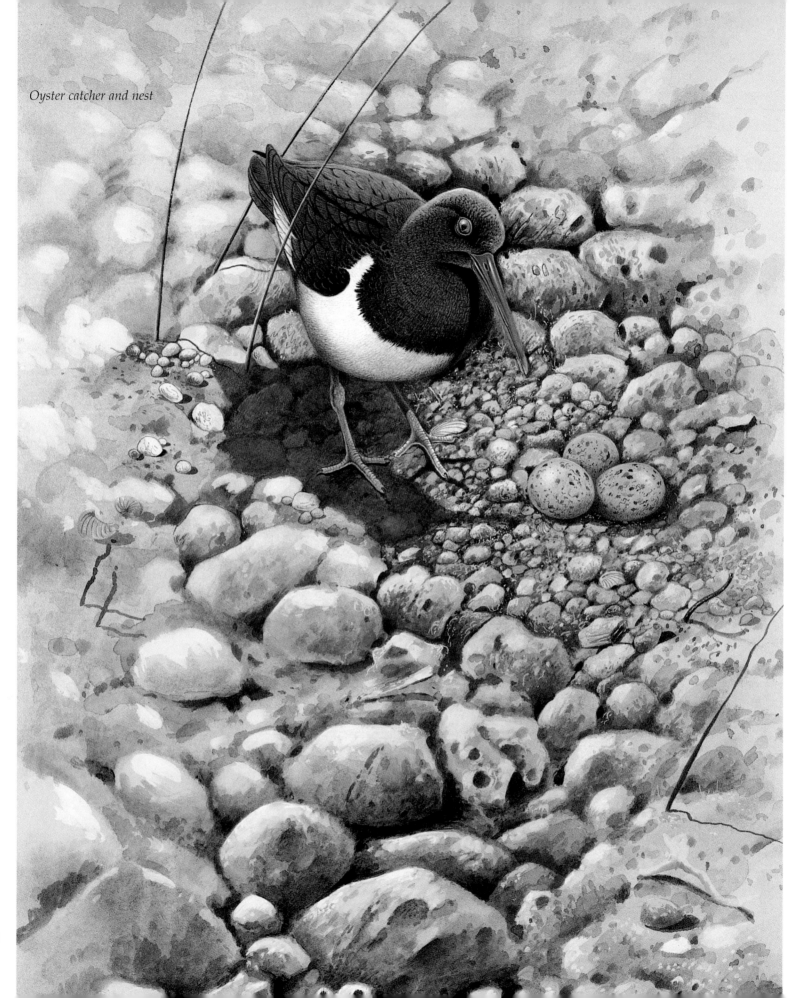

Oyster catcher and nest

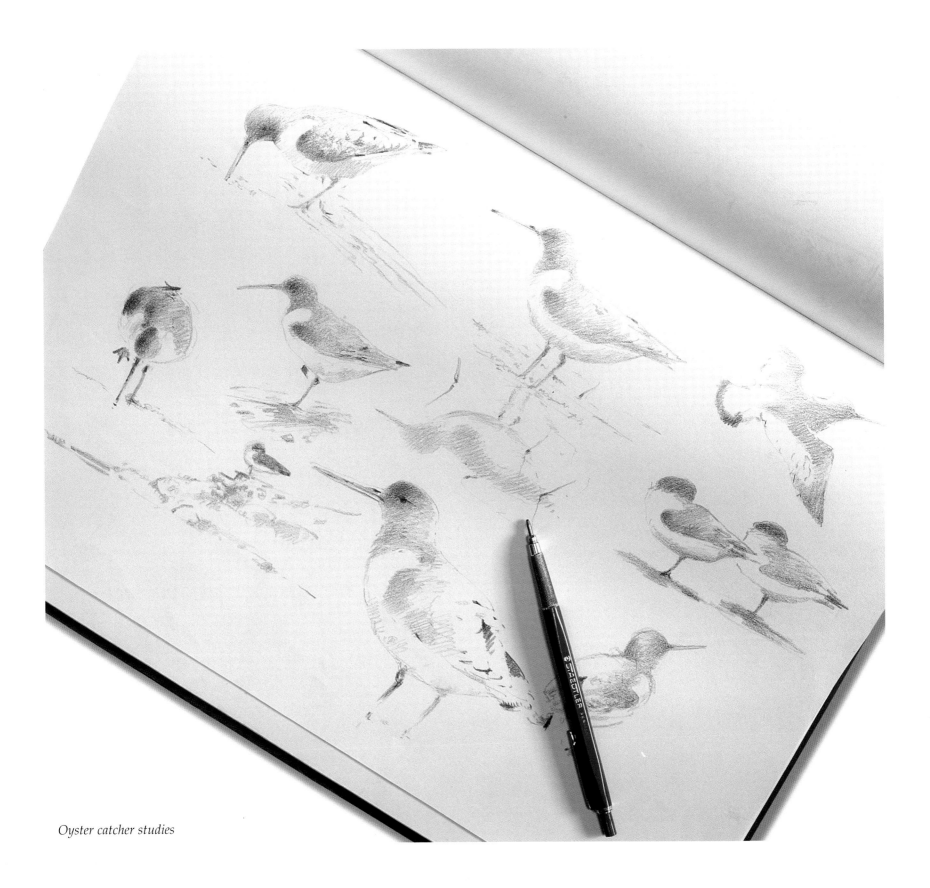

Oyster catcher studies

Butterfly sketches

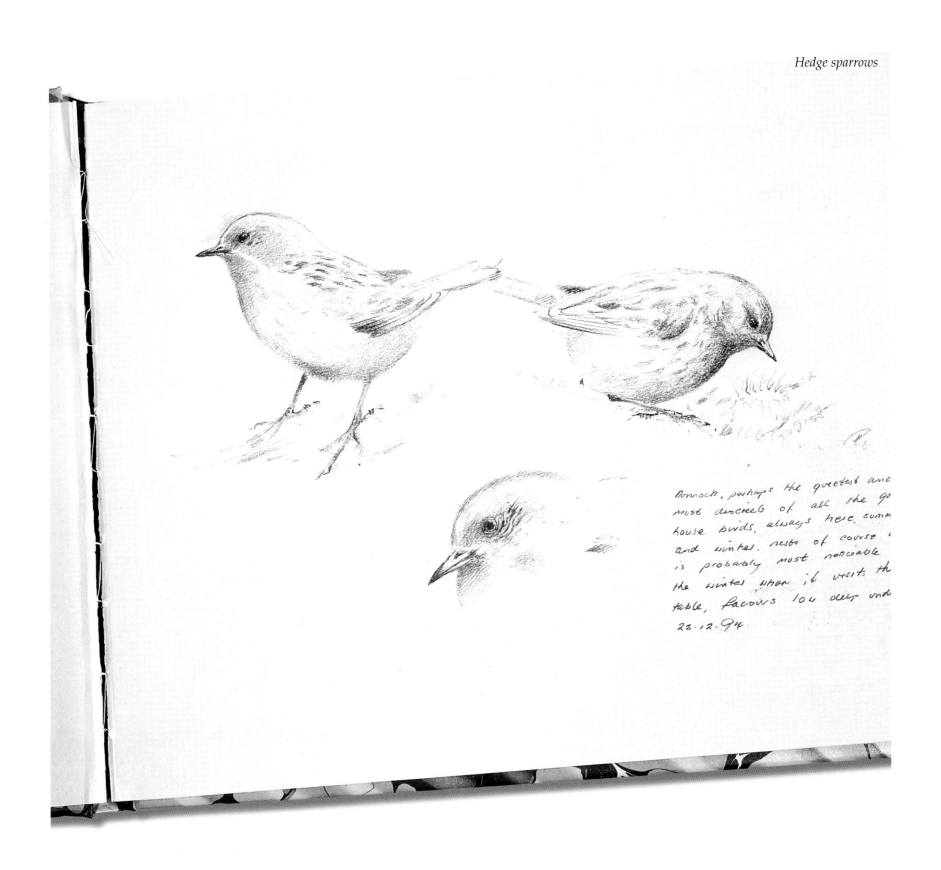

Dunnock, perhaps the quietest and
most discreet of all the ga
house birds, always here, summ
and winter. rests of course
is probably most noticeable
the winter when it visits th
table, favours low deep und
23.12.94

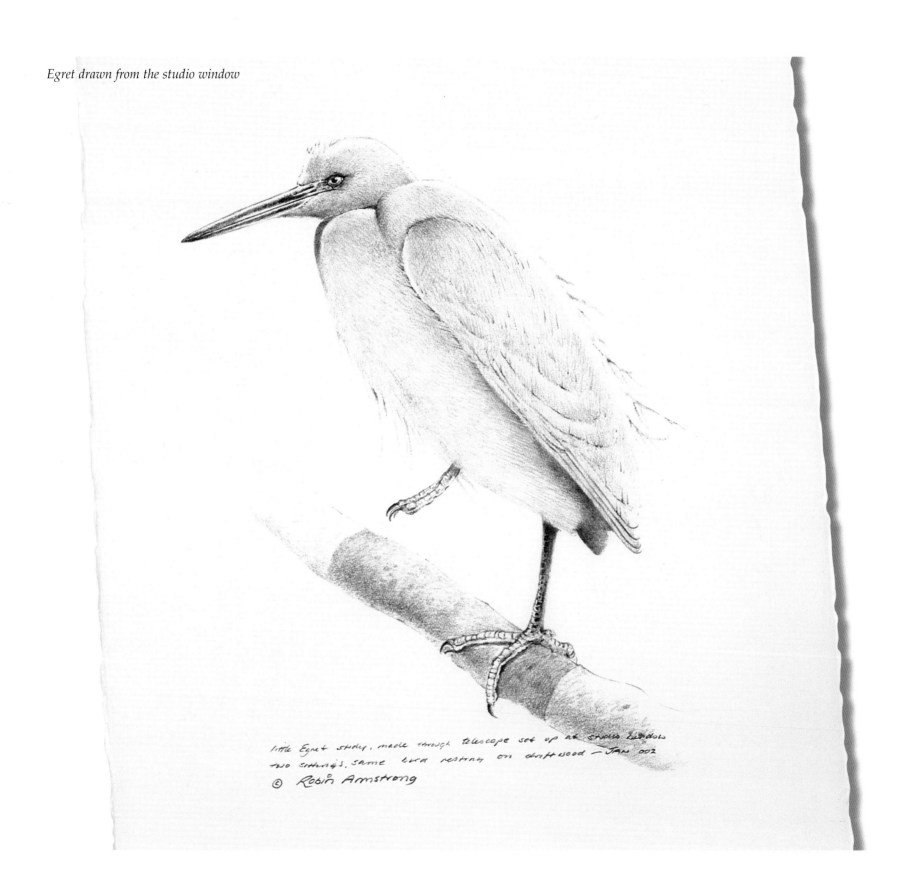

little Egret study, made through telescope set up at studio window
two sittings, same bird resting on driftwood — JAN 002
© Robin Armstrong

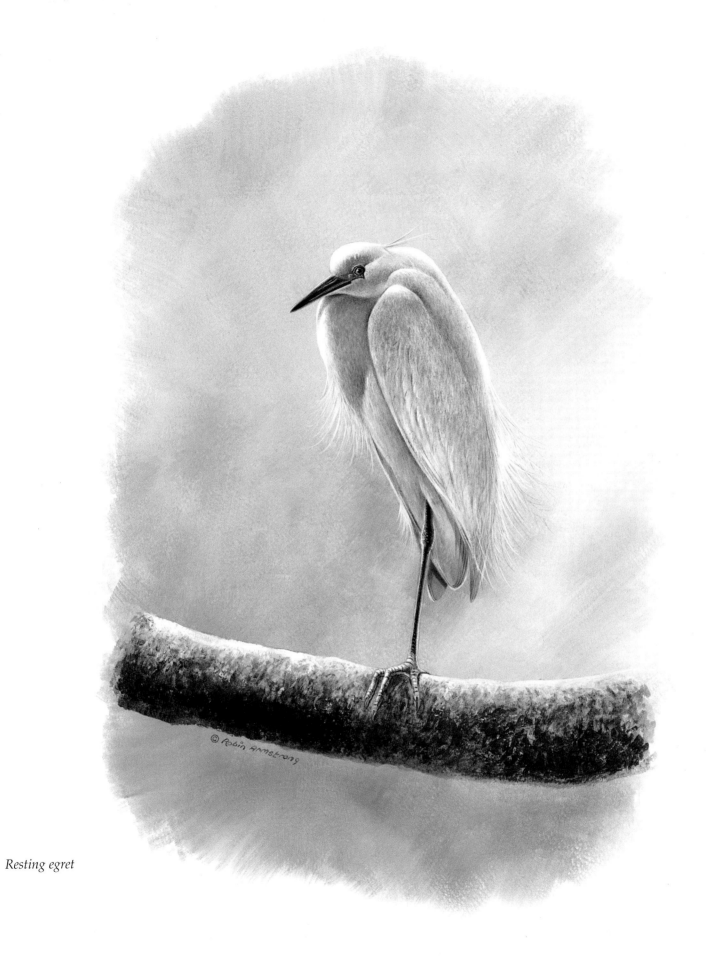

Resting egret

The Garden House Studio

Down to the Sea and Beyond

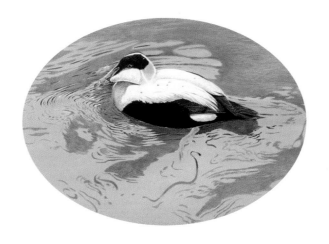

Beneath the brow of moorland tors,
Slow winds her rivers to the sea;
And echoes of the past come down
Deep valleys veiled in mystery

<div align="right">

A Dartmoor Idyll – Joseph Pears

</div>

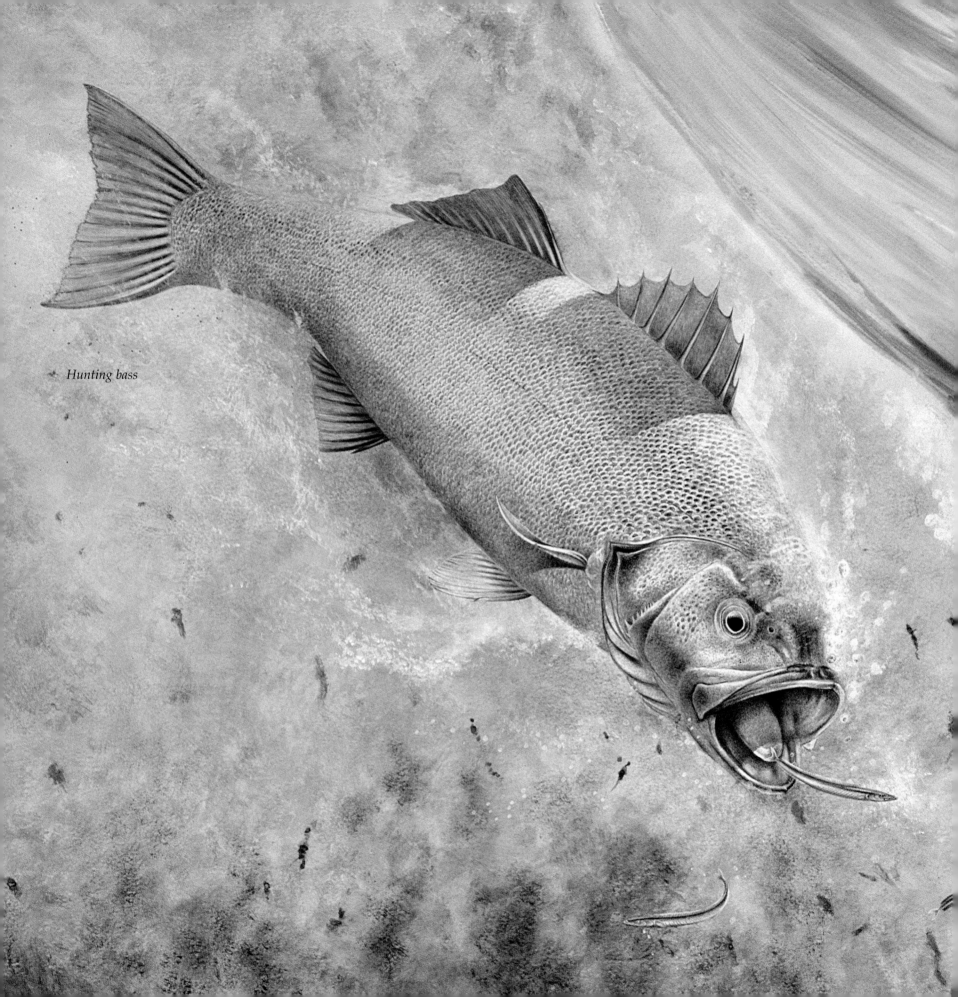

Hunting bass

Our Dartmoor river estuaries are all wonderful havens for wildlife, providing shelter and diverse habitat for birds, fish, mammals and insects, as well as we humans. The recreation industry is enormous here in the South West and often our river estuaries are the very focus of that attention. Dartmouth itself, for example, plays host to thousands of sailing enthusiasts every year, with river moorings and property prices rising almost beyond control in recent times.

Many other places have become tourist honeypots for man, and the obvious pressure on the natural habitat is sometimes too much. Wherever large numbers of people gather then pollution occurs. There are many types of pollution, not just water contamination, but air, litter, noise and industrial, all of which to some degree or other will put our wildlife and habitat under threat.

Where I have my studio at Lopwell, on the Tavy, for example, we are at the end of a great water shute of human discards, and when the mighty Tavy is in flood the mess that ends up here in the estuary has to be seen to be believed. Everything from plastic bags to supermarket trolleys, from trees to polystyrene foam. Once it arrives in the sea everything that isn't biodegradable just gets shunted around by the wind and the tide. There is almost nowhere in the world now that can honestly be described as pollution free. I well remember a few years ago sailing to Spitsbergen and back, along with Spud, thirty other adventurers and an SAS guide, on a three-masted

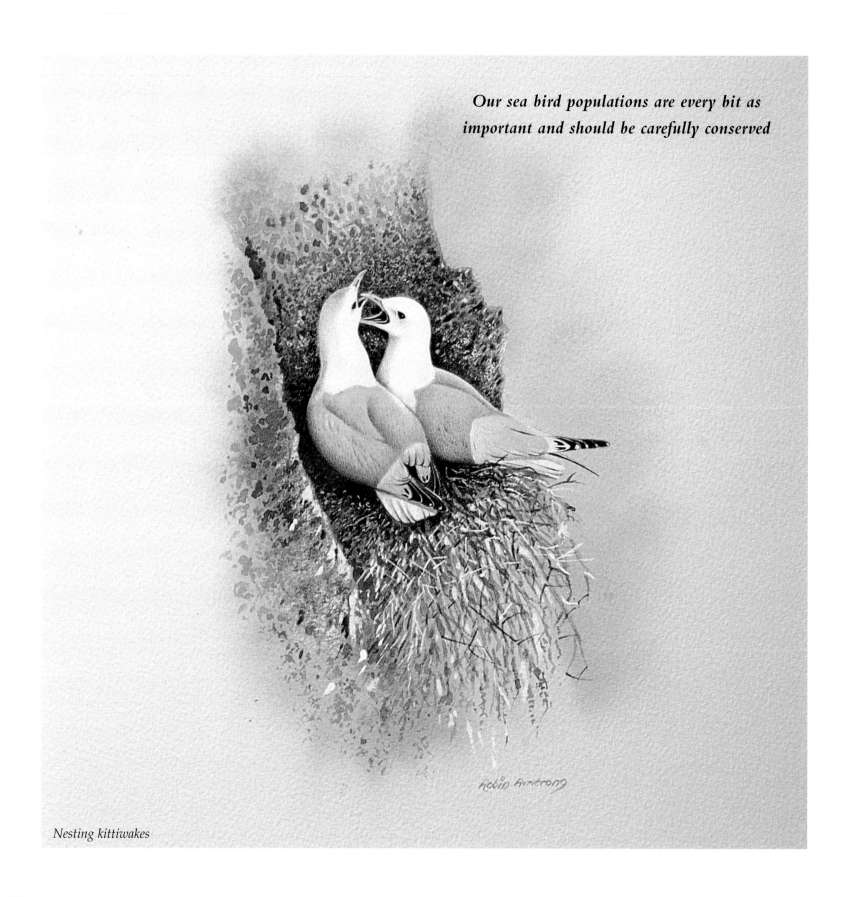

Our sea bird populations are every bit as important and should be carefully conserved

Nesting kittiwakes

182

schooner skippered by Robin Knox Johnstone. When we got there we formed some shore parties and went for a hike in one of the most remote regions in the world. It was June and the arctic summer had just begun, the wild geese were arriving and the vast sea-bird cliffs at Longyearbyen were thronging with the sound of millions of resting sea birds. We all met up at one of the many glacial beaches after the walk to compare notes about what we had seen. Spud's group had gone across a glacier for some four miles, which is quite far enough when the going underfoot is sloshy and sticky with the snow melt. When I asked him what they had seen he replied 'Plenty, me old thing, we saw geese, reindeer and even found a polar bear kill, but we didn't see any humans.' Then with a wry grin he produced from his anorak pocket a plastic bag with the word TESCO on it, 'but they've been here,' he said prophetically!

So there is every good reason to be particularly careful as to how we dispose of rubbish in our estuaries, not only because it looks unsightly but also because once in the open sea it can literally end up anywhere in the world.

I love the water birds of our lower rivers and estuaries. Moorhens are my favourite but coots run a close second. Stand and watch them as they go about their business and you'll be rewarded with some remarkable behaviour; watch them as they pick among the reed fringes and squabble amongst themselves – as youngsters they are just great! If you want to see chicks with attitude then just focus on a mother moorhen and her brood. The huge feet, which are specially adapted for walking over lily pads and other surface vegetation, make them look almost Chaplinesque. When young they look like little balls of fluff with cocktail sticks stuck in them!

Coots are more matronly with their young, herding and goading them into safe, and out of unsafe, places whilst at the same time keeping an eye out for any danger which may threaten the family.

Ducks too are really great to watch, even the ubiquitous mallard will keep you entertained whilst dabbling and dibbling around. I enjoy seeing rarities but I've never been a seasoned 'twitcher'. We have had an American ring-necked duck here at Lopwell for the past two winters, and I have watched from my studio window as the bird watchers cross the tide and go up the lake above to tick this rare visitor.

Winter in the low reaches can bring in avian visitors from many parts of the globe. Every year sees new rarities added to the British list, I suppose partly because of global-warming the climate is milder than elsewhere in the country, and so visitors from milder or even subtropical climes find it attractive here.

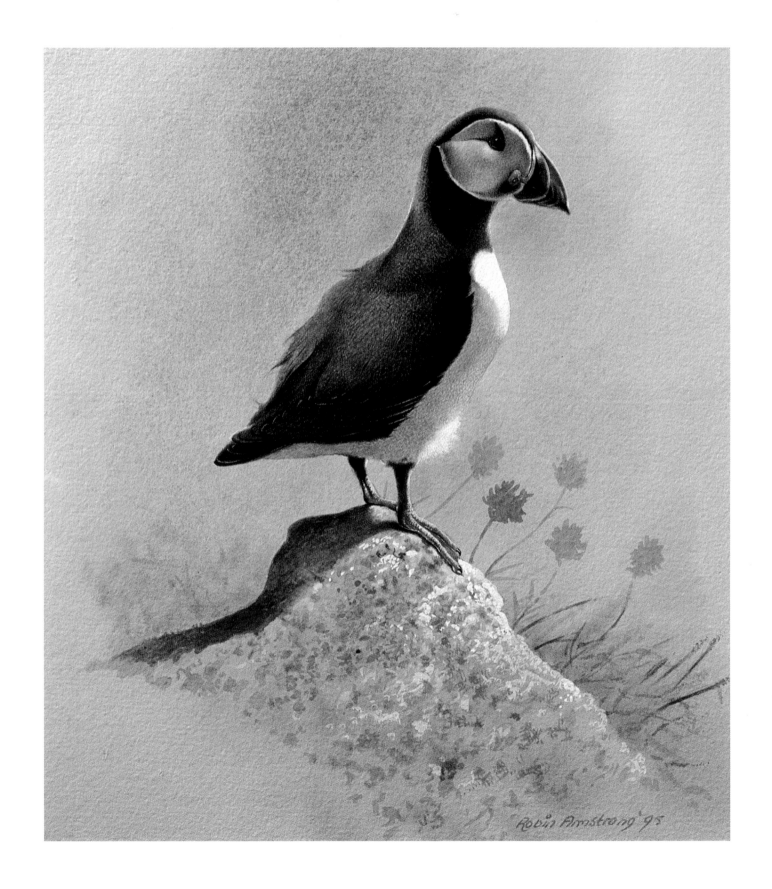

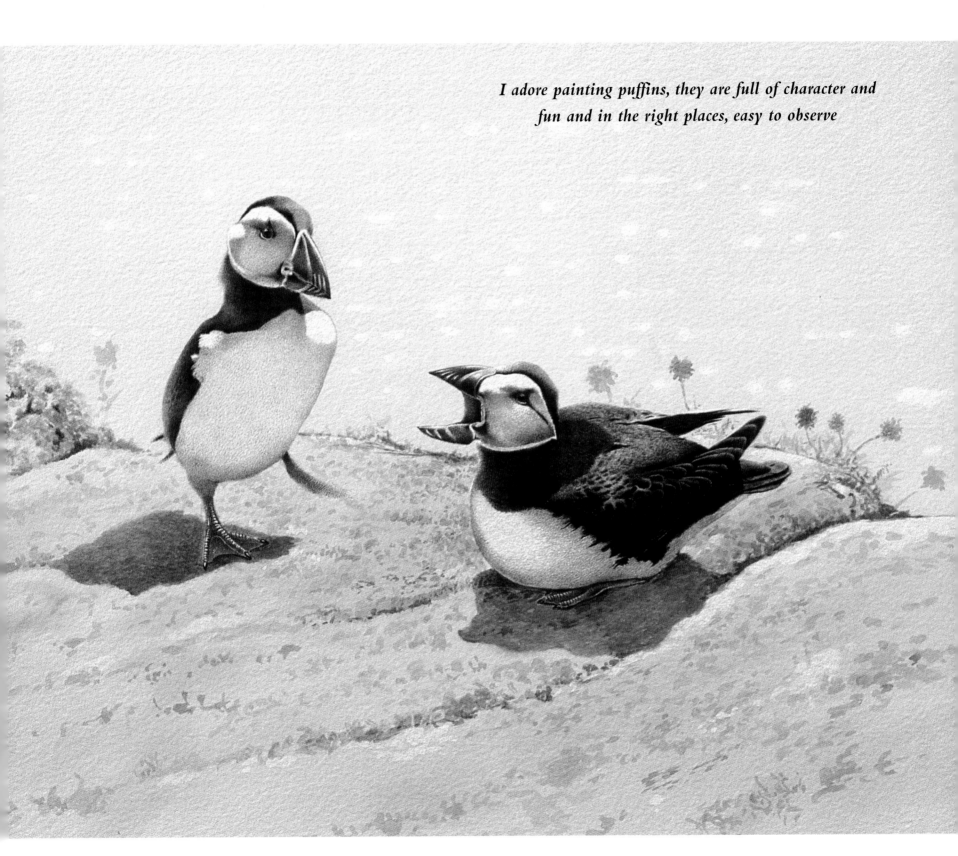

*I adore painting puffins, they are full of character and
fun and in the right places, easy to observe*

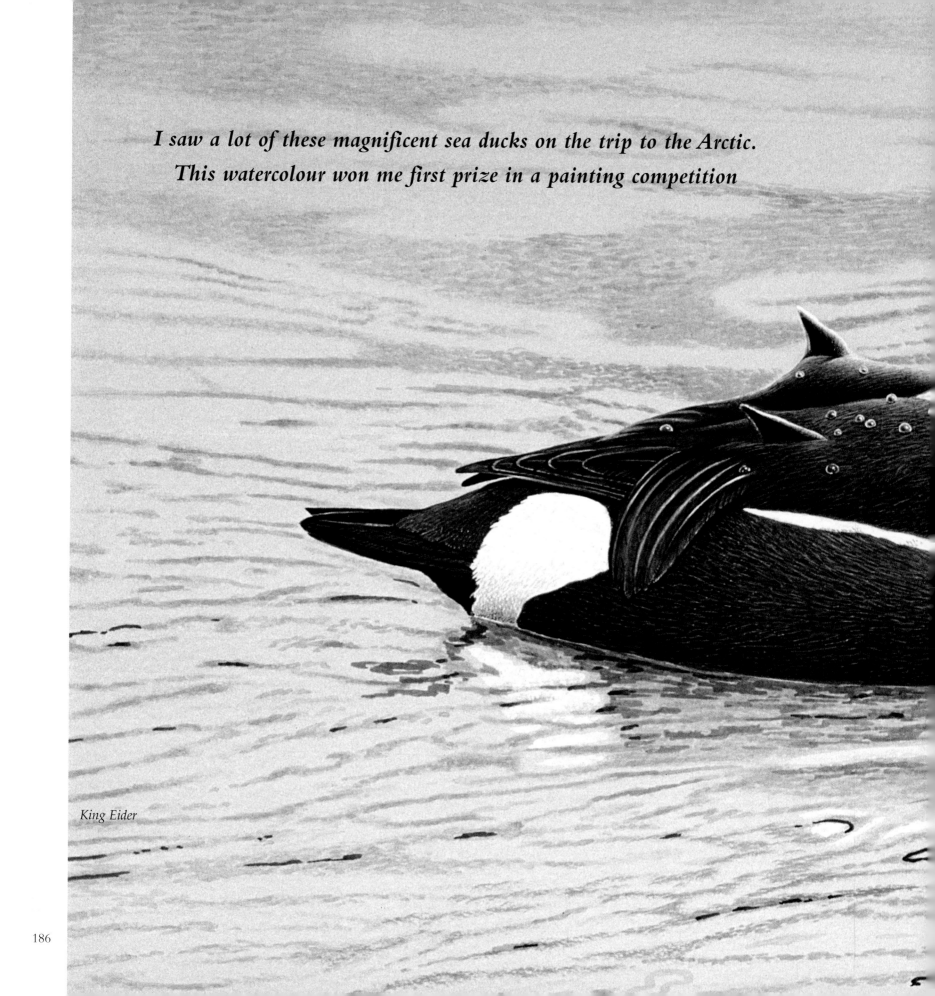

I saw a lot of these magnificent sea ducks on the trip to the Arctic.
This watercolour won me first prize in a painting competition

King Eider

186

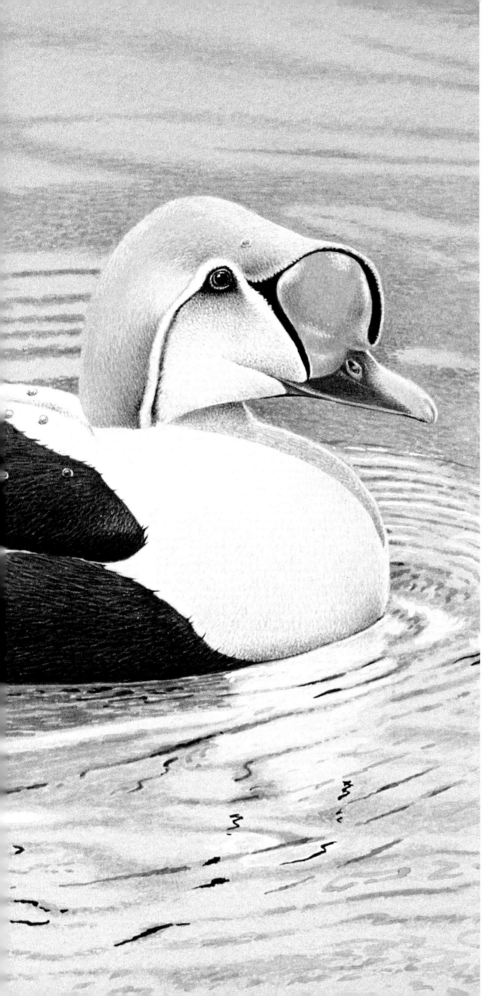

Sea ducks have always fascinated me both as an artist and a naturalist. Eiders in particular are a favourite. We get them here as stragglers in the winter but they breed in the north and then on up into the arctic, building ground nests of the famous eiderdown. I've been lucky enough to have stayed on the tiny island of Barra, the most southerly of the inhabited islands in the Outer Hebrides. Here the eiders nest in quite large colonies on one or two of the outlying islands.

Of all the rivers running off the moor, the Taw is perhaps the most urbane, slowing as it does before reaching Barnstaple, and then meandering majestically until it collides with the Torridge in the great tide rips and currents of Bideford Bar. Before reaching this point it runs through lowland farming country and here the low flows and extra soil make the river a good home for coarse fish; roach, chub and dace can all be found in the slower moving Taw. The habitat here is also good for birds such as the kingfisher, because the high-sided soil and sandbanks offer good nesting sites for this little jewel of a bird.

Our estuaries are vital in the chain of survival of one of our slowest growing food fishes, the bass (*Dicentrarchus labrax*). They provide shelter and nursery areas for the juvenile fish, known as school bass, and food is plentiful. Given the space to mature they finally migrate to the sea properly as shoal bass weighing 2–5lbs, and remaining in shoals they are often the victims of mercenary drift netting, entire shoals being scooped up as one.

Drift netting was once carried out in the estuary itself, the targets often being the small August sea-trout sometimes called 'harvest peel'. Thankfully under the Salmon and Freshwater Fisheries Act this practice was made illegal, but the excuse then given by the netsmen was that they were fishing for mullet (which wasn't illegal!) resulting in sea-trout, immature bass and mullet all succumbing to this practice.

I worked as a Fisheries Warden at the time and it was decided that something just had to be done about the situation. Firm evidence would have to be the key element if we were going to bring about some form of legislation to protect our estuary fish stocks. We knew as a team that the work would be painstaking and frustrating but it had to be done. Knowing the perpetrators well was perhaps even more frustrating because every time we did a net check, tempers usually flared. Each time we checked a boat, a full report was entered and, slowly but surely, a complete dossier was submitted. The end result was that a complete ban was implemented on all drift netting within the estuary, allowing the young bass to thrive and the sea-trout to run unhindered up the rivers to spawn.

Here at Lopwell the seasons seem to change so quickly; hardly have the sand martins arrived than we seem to see them overhead, gathering in numbers to prepare for migration. One bird that has adapted completely to our estuary environment is the beautiful little egret. When I was young this bird was a rarity in Britain, only occurring as an occasional visitor to the extreme South East. But now, forty years on, they occur in some numbers on most of our southern estuaries, but no matter how many times I see one, I still get excited and always reach for the binoculars or telescope. Most days I can see them from my studio window; both a pleasure and privilege.

Feral introductions can in some areas cause considerable upsets in the overall balance of nature. Mink first became a problem back in the 1950s, the first escapees coming from a farm at the head of the Teign, and before too long they had established territories along most of our Westcountry rivers. As highly efficient predators they proffered a threat to their cousin the otter, not just competing for food, but also by taking young otter cubs. Trapping and shooting was carried out on a large scale and today mink numbers seem to be under control.

Canada geese have also multiplied in large numbers and now in some places are regarded as enemy number one. Large parks and gardens suffer the most from 'goose pollution', but here we have a hidden pool on which they thrive, flighting out at dawn and back again at dusk. One day perhaps we will learn that to interfere with nature and introduce alien species into an environment where they do not belong is a mistake that should never be repeated.

Watching the tide come and go daily as I do, is probably the most satisfying way of learning about the fish, animals and birds that I know. There is always something different going on, whether it is the arrival of a new pod of salmon or the grey mullet dimpling at low water. On big spring tides we have a resident grey seal that follows the fish upstream as far as the weir; some fishermen complain about him, saying that all of the fish are under threat. I really don't think that this is the case as in two years I've only seen one salmon caught by him; he mostly takes mullet, of which there are thousands!

Resident mute swans stick rigidly to their territories (we have two pairs) that can be seen gliding across the dam at sunset, echoing the tranquillity of the place.

The Dartmoor river has run its course here and will soon become lost into the great ocean beyond. Just as the rains which fuel the river will come again, we also know that there will be another tide tomorrow.

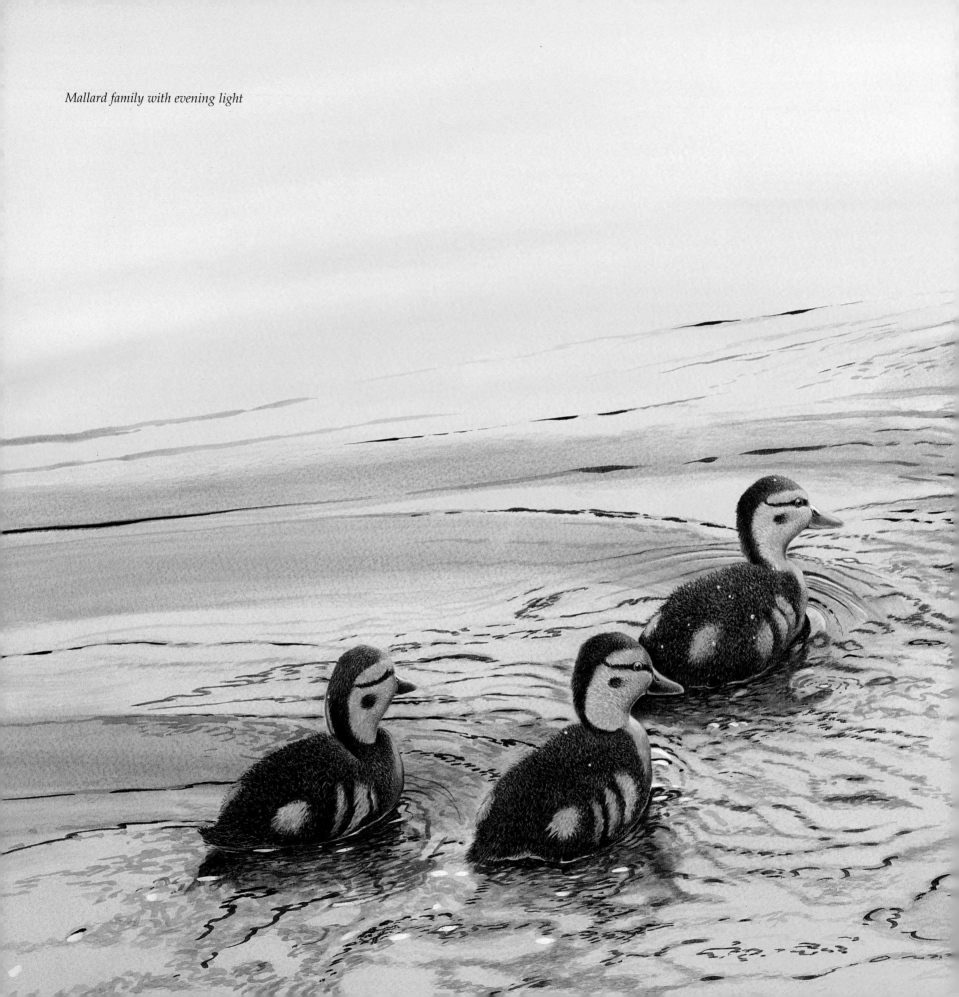

Mallard family with evening light

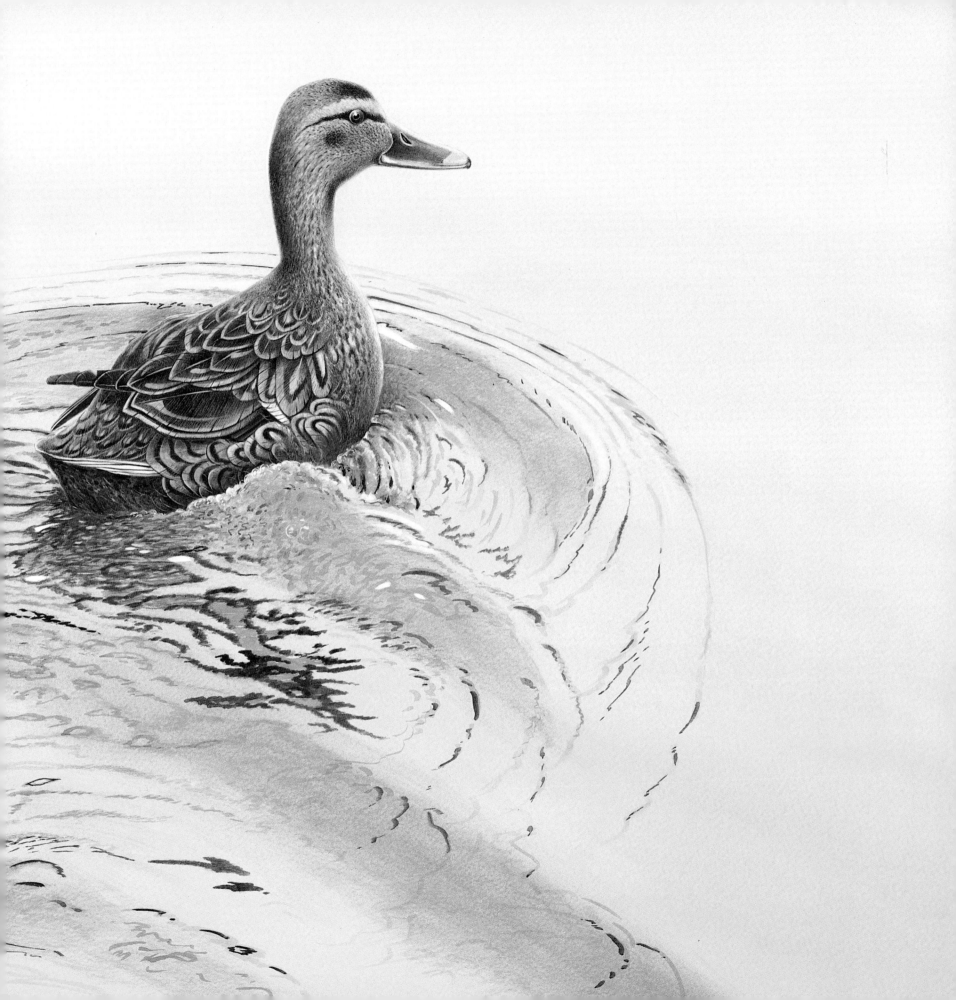

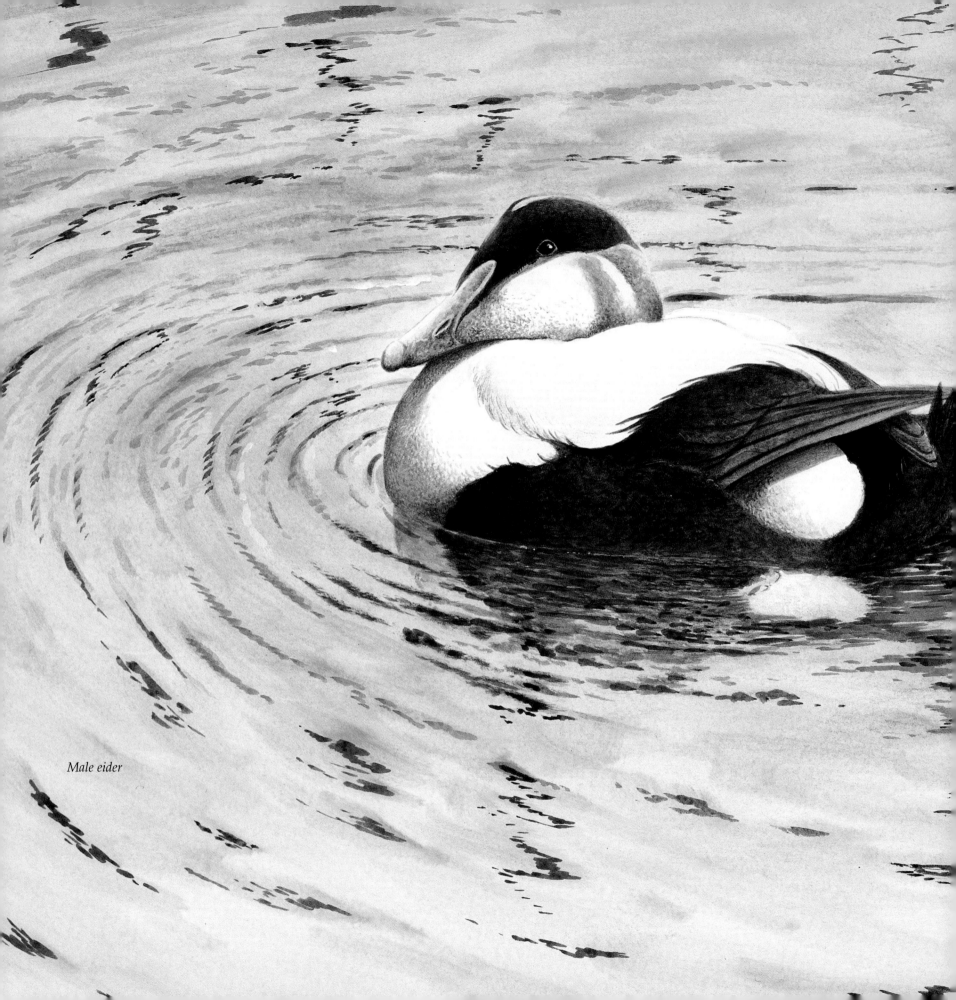

Male eider

I have deliberately included the pictures
of sea ducks and seabirds, even though they have
little to do with Dartmoor rivers. Maybe it's a
timely reminder that the oceans also harbour
beautiful wild creatures and that our river
systems rely upon the sea and vice versa!

193

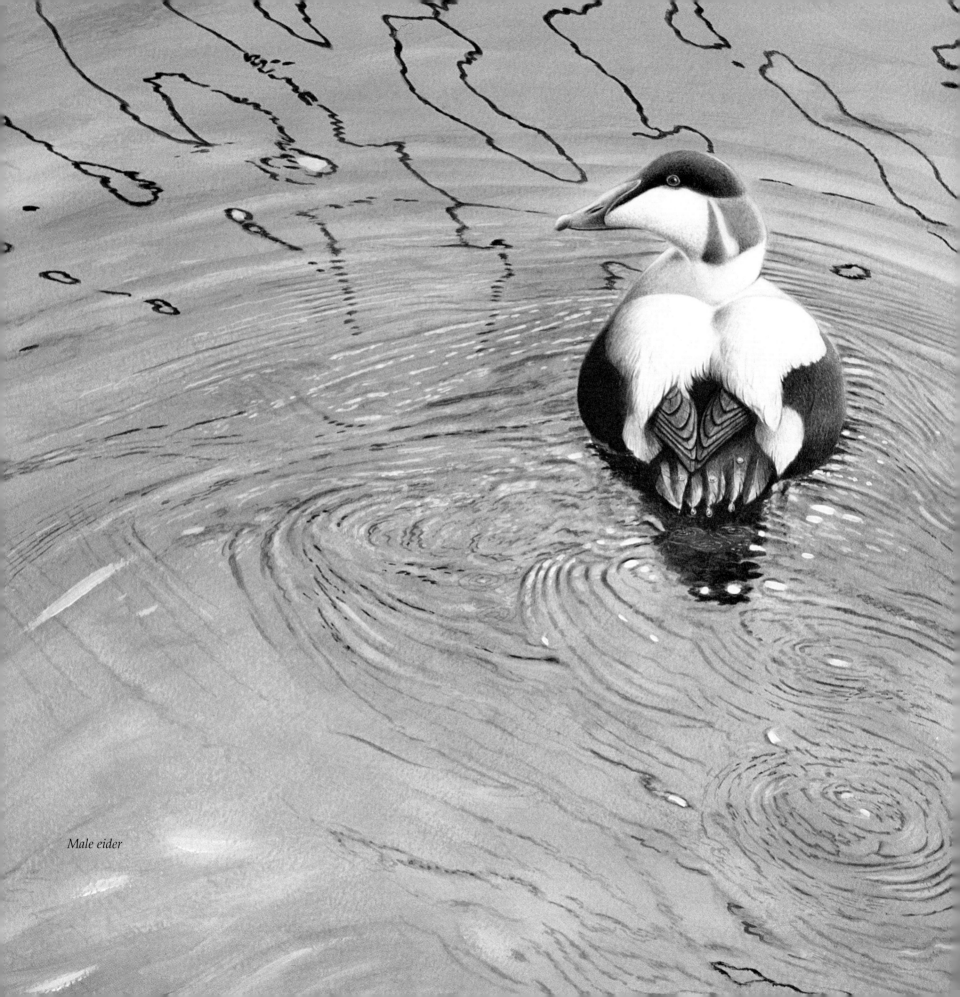

Male eider

Global changes are continuing at an alarming rate and sea ducks such as this drake eider may no longer be able to rely on the High Arctic to provide the adundance of food necessary to support healthy populations. Likewise our migratory salmonids may also be deprived of the rich feeding grounds currently available off the coasts of Iceland and Greenland.

195

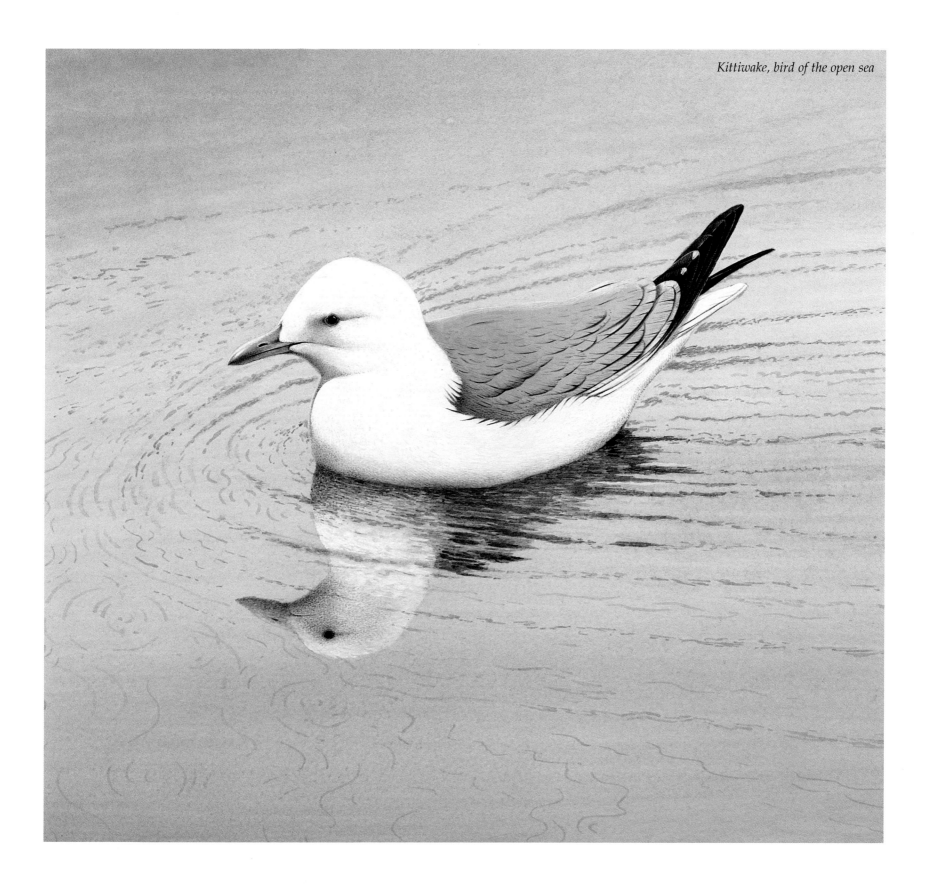

On Painters
and
Painting

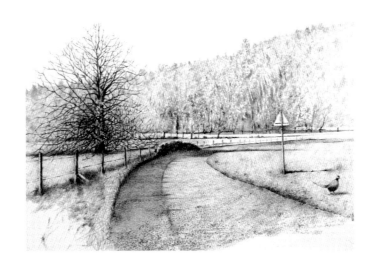

Garden House Studio interior

Wildlife art can be traced back to the Stone Age, when man first depicted the animals that he used to hunt for food on cave walls, and although these early works were somewhat rudimentary, it was still relatively easy to distinguish which animals the cave drawings were supposed to represent, showing that man's skills in the art of observation were highly developed even in prehistoric times.

Over the centuries, since these early times, probably because of the interdependence between animals and man, animals have always featured strongly in painting and drawing. Leonardo himself drew animals as well as humans, and the great Albrecht Durer produced some breathtaking examples of wildlife art, taken directly from nature. His famous study of a crouching hare could only have been drawn from life and it remains even today one of the most inspirational pieces produced in early times.

When the early explorers started to map the globe, an artist would often be taken along to paint and record any new 'finds' that the explorers came across. There were obviously some good artists and some not so good, as evidenced by a number of these early studies. Quite a lot of guesswork and exaggeration can be detected.

Moving on to the age of the great pioneers, the quality of zoological and wildlife art could depend on how good a shot you were; everything was slain in order to satisfy the curiosity of the public at home. The bodies or hides were either being shipped back in preservative, or more usually drawn in detail on site and discarded. This would certainly account for the rigidity and lifelessness of most of the early works, having not seen the subjects move would have left most artists stumped as to how animals articulated.

Even the great Audebon worked from dead subjects, and the huge life-sized paintings, although beautifully crafted, often lacked life and spirit.

It wasn't really until late Victorian times that painters started to question the way in which wildlife painting should be presented. It was artists such as the Swedish painter, Bruno Liljefors (1860-1939), who pioneered the painting of wildlife from nature itself. Although he was a wildfowler, Liljefors would paint the landscape, the forest and the sea, and would place his subjects strategically within their known environment. Influenced very much by the painter Anders Zorn (1860-1920), he was always ready to tackle new horizons, and would always refer back to nature itself. His paintings are full of life depicting atmosphere and weather, and while some of his studies of birds, such as eider ducks, were painted using his own

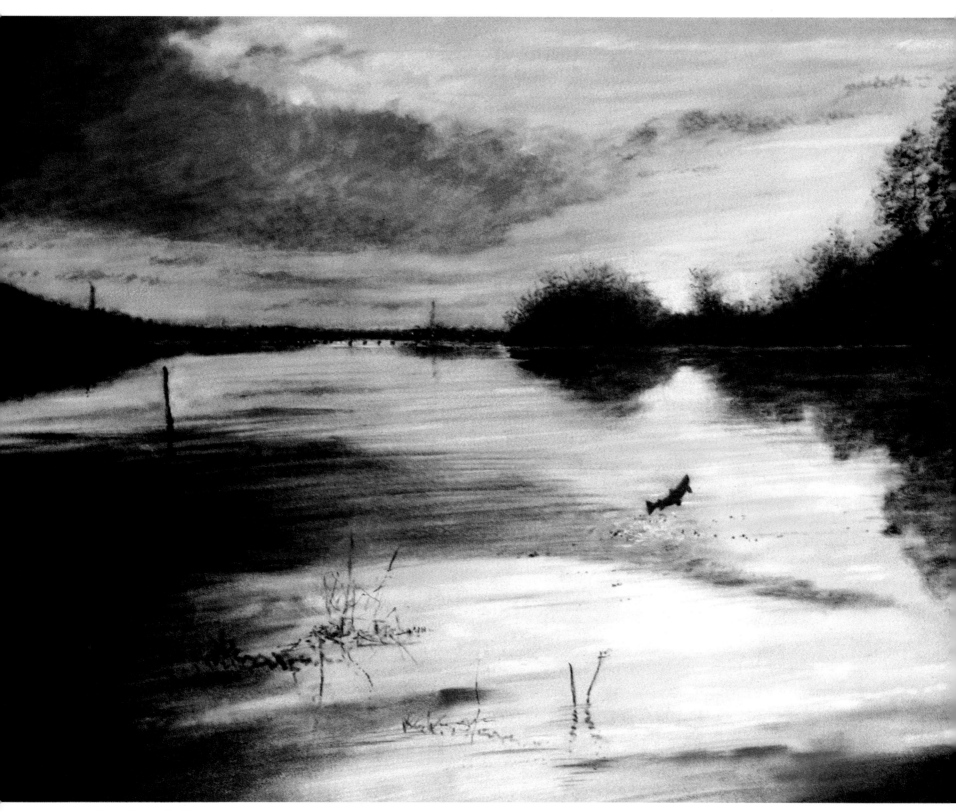

Sunset over the Tavy estuary

photographs, this didn't translate as the 'swipe-art' that we see so much of today. Like a lot of the impressionists, Liljefors was always willing to try new aids to enhance the work he already had in his mind.

Following on, or should I say running parallel to Liljefors, were the German Joseph Wolf, the Dutchman Keulemans, and Britain's Archibald Thorburn. It has to be said that the aforementioned were mainly employed to produce bird illustrations for the lavish books and monographs sought after by the bibliophiles of the day.

Wolf and Thorburn were both sportsmen and adenturers, who would impart life and soul into the hundreds of paintings executed for the art trade and private clients. Thorburn in particular was brilliant at conveying the atmosphere of some wild and lonely place and would qualify even his smaller pictures by adding some detail such as a particular plant or perhaps some fungi to identify the location or season. Thorburn's father had been a famous miniaturist and so Archibald had been schooled as an artist, and his drawing skills were unsurpassed, even today with all of the high-tech equipment we have to observe nature, I see little work which is as fluent and masterly as Thorburn's.

Once the Victorians had shot their fill, then artists started to revert to studying live animals in the wild. Societies and conservation groups were springing up everywhere. The RSPB became an influence and Sir Peter Scott (once himself a wildflowler), founded the Wildfowl Trust, all helping the move away from seeing animals as exotic curiosities to a wish to understand them as separate creatures within a global environment. The remit on wildlife had changed from that of a sporting bias to one of celebration.

Artists such as Charles Tunnicliffe were in great demand for book illustration work and new talent was arriving all the time. Even so wildlife art has, for some reason that escapes me, often been viewed by the critics as a lower form of art than mainstream, perhaps because at some time or other its popularity with the masses and its largely figurative form have left little to the imagination.

In his day, Tunnicliffe was a power unto himself; he had been elected as a Royal Academician but flatly refused to be drawn into any other way of painting than his very own. His book illustrations were famous across the globe, and in all during his long and distinguished career he worked on more than eighty! Tunnicliffe worked in almost every medium from oils to etchings. The resulting work was dramatic and very different from anything that had been seen before, it raised many an eyebrow amongst members of the 'old school' who thought that such work had no place in the world of zoological illustration.

Another painter to have broken all the rules was the New Zealander Raymond Harris-Ching, he first came to the attention of the public when he provided the illustrations for the *Reader's Digest Book of British Birds* in the late 1960s. These drawings were dramatic and instantly recognisable but attracted a lot of criticism for being too imaginative.

Outspoken and undaunted, Ching carried on plying his art in the only way he knew and took the establishment head-on. It wasn't long before his magnificent pictures became sought after by every serious collector of wildlife art there was, the technique of producing vigorous pencil drawings and following up with subtle washes of watercolour or oil became his very own. The work of Raymond Ching captured the imagination of many up-and-coming artists including Terence Lambert, Mick Loates, Neil Cox and myself, to name but a few. In 1988, when my second book *Split Cane and Sable* was published, I was asked by Claude Berry, then one of the directors of Ching's Gallery, The Tryon, to send a copy for Raymond to add to his collection. Raymond's kind letter in response remains one of my proudest possessions to this day!

Always a trailblazer and never afraid to follow his intuition, Ching could create nightmares for his gallery directors. I remember Claude telling me how, on one occasion, he called Ray and asked him if there was any chance of one or two fresh paintings being sent up as he had an important collector coming over from the States. Always happy to oblige he packed up his current favorite pictures and had them delivered. When Claude opened the package, he found to his astonishment that Ray had sent him oils of an American alligator and a quite remarkable portrait of a giant fruit bat hanging upside down in a mangrove! When questioned about this choice, Ching proclaimed that the fruit bat was 'the best picture I've ever done!'

Other artists who have captured the headlines since the 'revolution' are people like Gordon Benningfield, Roger McPhail, Lars Jonsson and Bruce Pearson. There are many others, all of whom are prepared to declare their talents by using their own very identifiable technique.

Benningfield produced some wonderful work in his tragically short life, pioneering the painting of butterflies in the wild and creating many books about countryside matters. Looking closely at a Benningfield watercolour, with all its splatters and dabs and decorative blotches, one could be forgiven for thinking perhaps that here we have some kind of happy accident! But no, every mark was carefully orchestrated combining to create a beautiful and individual piece of art.

Roger McPhail is perhaps the best known of today's countryside artists, his masterly drawing skills, backed by a wicked sense of humour, set him head and shoulders above anyone in the world of sporting art. Versatile and courageous with

The Studio interior at Lopwell

his brush, he is able to capture the 'jizz' of almost any scene that he attempts to depict. In recent years he has moved on into the world of oils and, although he still produces a lot of work in watercolour, oils have become his forté.

Lars Jonsson is a Swedish painter who has followed in the footsteps of the great Bruno Liljefors. Self taught, his work is widely collected and his skills are much admired, especially amongst other artists, including myself. His best-selling book on European birds is now a standard. In 1983 he published a book called *Bird Island: Pictures from a Shoal of Sand*, an account of his time over the period of one summer on a small island off the Swedish coast. The resulting work is possibly one of the freshest and most complete accounts of an artist working from birds in the field that has ever been produced. Jonsson's oil paintings are often on a grand scale, usually based on a moment in time and light. In *Birds in Art: the Masters*, published by the Leigh Yankey Woodson Art Museum in 1990; Jonsson is quoted as saying:

> *I think there is so much more we can do as artists, instead of blaming the art establishment. It is part of our work as artists to question what we are doing, to criticize ourselves, to see what more we can do. Wildlife art that does not reveal some-thing about the artist is seldom significant. I don't think we have ever touched the limitations of what painting wildlife might be about.*

Bruce Pearson is one of a number of artists who come into the category of 'sketchbook painters'. These would include Keith Brockie, Darren Rees, Michael Warren and David Daly. Pearson's work is vibrant and fresh and his colour notes and musings, along with the marks made by his pencil or brush, combine to make a picture which is both pleasant and spontaneous. He has travelled widely and produced several books on bird-watching abroad. His large-scale works in either watercolour or oil have an acute sense of wilderness, the subject usually only being featured as a tiny part of the overall composition.

The artists I have written about are just some of my favourites, there were many more in the past and there are many more today who are producing work of the very highest quality, work which in itself is a pure celebration of the living creatures and landscapes of our natural world. I haven't even mentioned the Americans, some of whom have taken this most diffi-cult of disciplines into new dimensions.

In my own work, and without wishing to disagree with Jonsson, I would say that it's almost impossible to get it 'right'. Getting it right often means that you have nothing left to prove, and with nothing to prove you have nothing to aspire to!

Over the years I have tried not to pigeon-hole my work too much and, apart from the celebratory aspect, I have always kept at arms length from self-appraisal. But in a book such as this which is full of the fruits of my own labours, it would be foolhardy not to include these few words of explanation as to how and why I choose to paint the subjects that I do. In *Angling in Art* by Tom Quinn, the author expresses his views about my own work: 'Armstrong's pictures are romantic and vaguely impressionistic,' but I have to say I have never thought about my work in that way, and it just goes to show how each of us is capable of interpreting the work of others in different ways.

In *Dartmoor River* we have a collection of paintings, drawings, and musings by one individual, covering a period of some thirty years. The pictures speak for the thousands of hours of pleasure the moorland rivers have given me during that time and continue to do so today.

As I write these final words and peering through my studio window, I can see a little egret stalking fish on the far bank, a small group of mallard dabbling on the low water mark and a solitary black-headed gull standing on one leg on the sandbar. Just a collection of wildlife you may say, but to me these cherished sitings are the culmination of years of watching and waiting, and to have arrived at a point in life where such things can be observed on a daily basis is the realisation of a dream come true.

We may all be travellers on this earth, but while we are here it is our responsibility to look after the resources made available to us by nature. We have raped the continents, emptied the rivers and seas and polluted the air, and yet we still continue to pass the buck!

The rivers and streams of Dartmoor will still be here when we are gone. Let us just hope that, in years to come, the little brown trout on the high moor can be enjoyed as much by those to come as they have by this one very lucky individual.

SCULPTURAL ENDPIECE

The basic skills for working on sculptures are much the same for those used in painting; the base line is as always an ability to draw.

Some artists find it easiest to 'work out' of a solid block, to 'carve in', and some find it more satisfying to model 'out'.

For my part I prefer the latter, working in hard wax and slowly building up the shape as each layer of wax is added. For smoothing the shape once achieved I use kitchen scourers and white spirit. I cut out fin shapes from thin sheet aluminium and attach these to the main armature with a spot of superglue and then overlay a fine screed of wax.

The working drawings are frequently referred to during the process of building up the piece, otherwise it becomes very much a hit and miss affair.

As with painting the secret is knowing when to stop. Once you have achieved what was in mind at the beginning is as good as time as any.

angled spigot

Pre-drawing for ... rising to take ... an old Ley from within the ... and adds ... Ivy root gives the ... to the base

Position of eye in relation to maxilliary bone

underside showing trout rises to the ...

Pectoral "tensed"

m above showing curve to left, final
il tip flip to left also

set of dorsal fin

No "wrist" in tro

14 - 16 for trout
11 - 18 " Salmon

tled curve as

typical tail shape for trout plus
large adipose fin, nearly always
red in wild Brownies

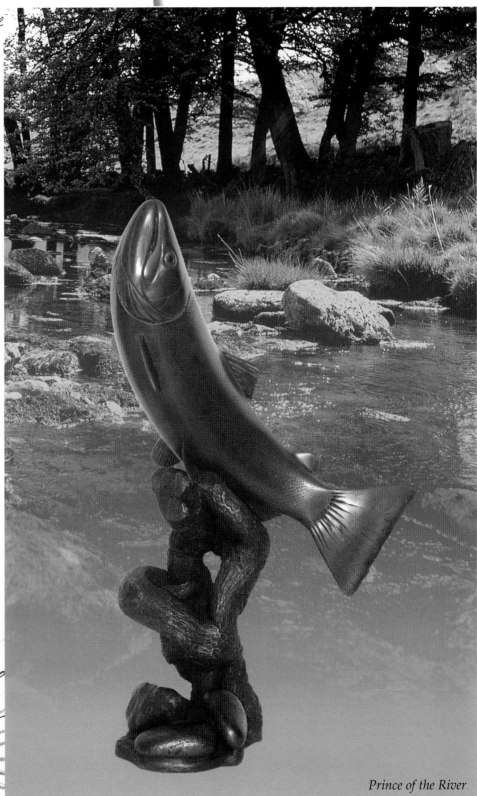

Prince of the River

207